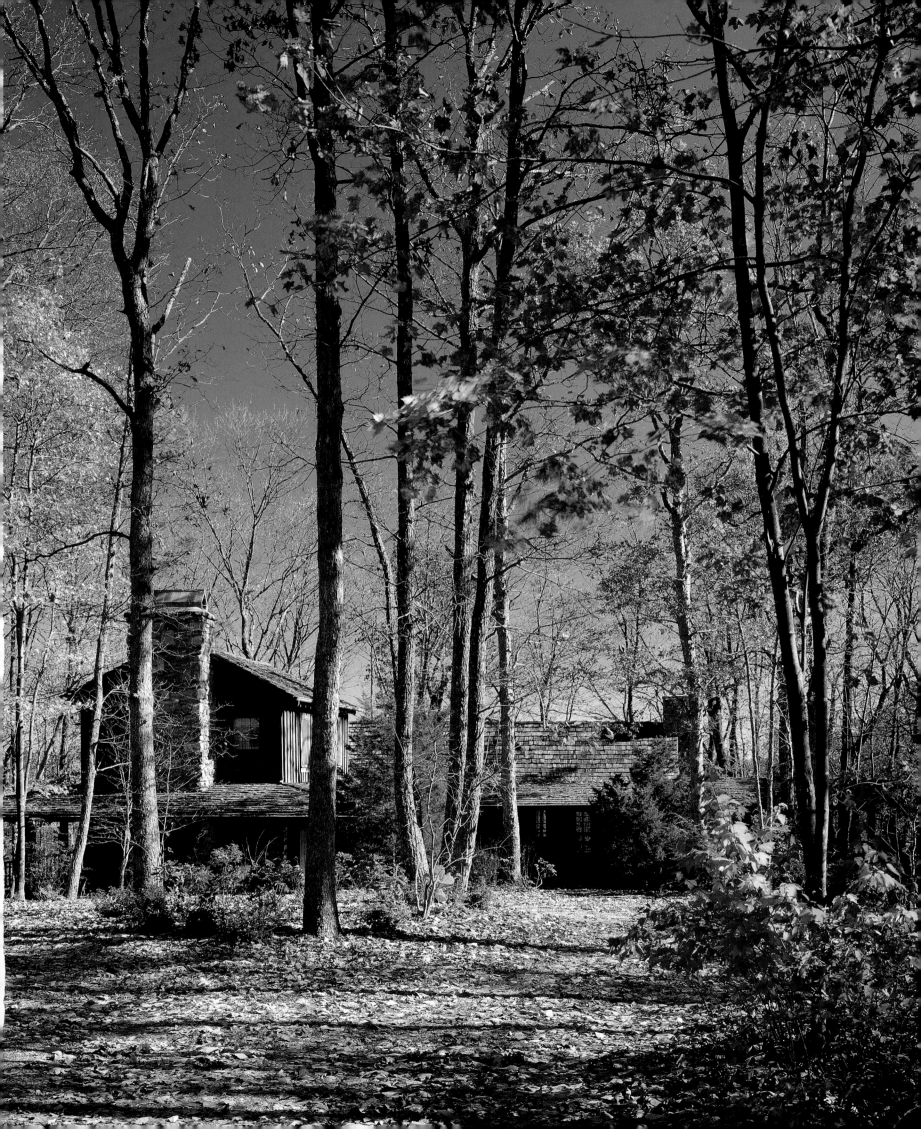

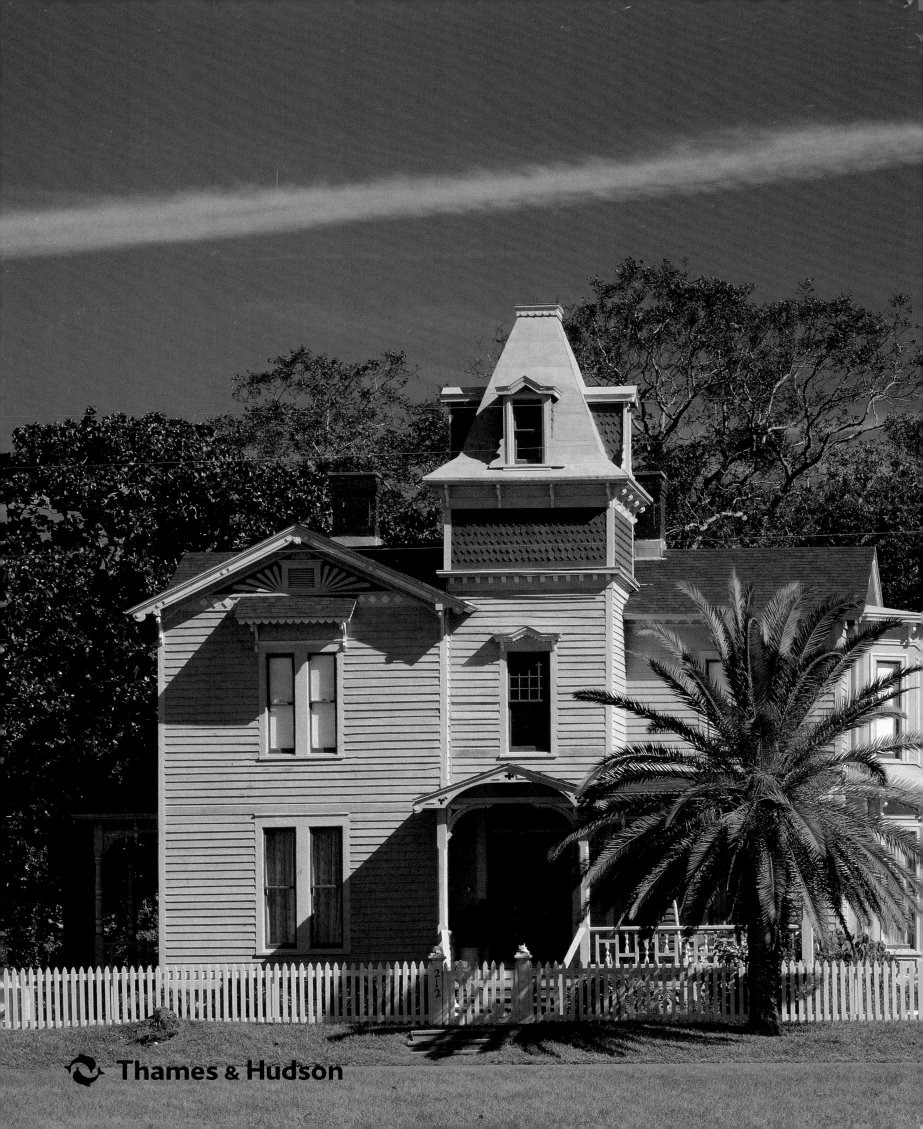

Thames & Hudson

The
Most Beautiful Villages
and Towns of the South

BONNIE RAMSEY
Preface by LISA NEWSOM
Original Photography by
DENNIS O'KAIN

with 253 color illustrations
Produced in association with *Veranda*

HALF-TITLE
For over a century residents of Southern cities have retreated
to the cool summers and log cabins in Beersheba Springs,
Tennessee, atop the Cumberland Plateau.

TITLE PAGES AND THESE PAGES
When nineteenth-century cruise ships docked at Fernandina
Beach, Florida, they created a wave of island visitors that
continues to the present.

© 2000 Thames & Hudson Inc.
Text and photographs © 2000 *Veranda*
Map © 2000 Jack Scott

First published in hardcover in the United States of America in 2000 by
Thames & Hudson Inc., 500 Fifth Avenue, New York, New York 10110

Library of Congress Catalog Card Number 99-69559
ISBN 0-500-01999-1

Designed by Liz Rudderham

Printed and bound in Singapore by C.S. Graphics

Photography Credits
All the photographs in this book were taken by Dennis O'Kain
except those for the following towns and villages, which were taken
by a number of individual photographers: Fredericksburg,
TX – James Fox; Galveston, TX – Fran Brennan; Pleasant Hill,
KY – Paul Rocheleau; St. Francisville, LA – Barry Lewis;
Waterford, VA – Richard Robinson; Waxahachie, TX – Richard
Bradley; Virginia Horse Country – John Hall.

Contents

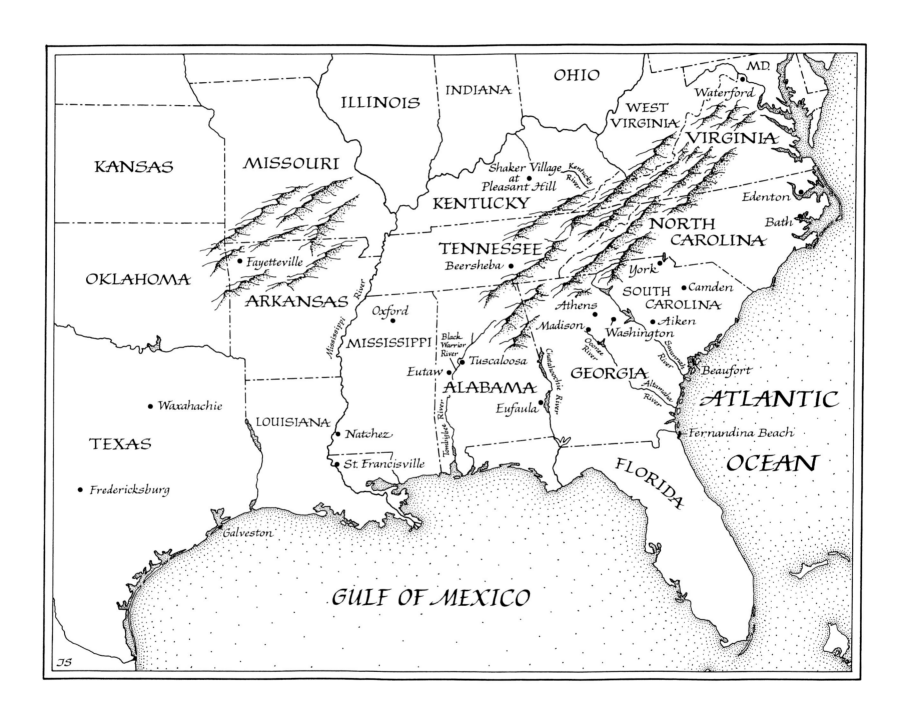

Preface

From an early age I have loved and admired legendary Southern traditions, both mythical and real, historical and contemporary. Literary giant Eudora Welty once commented, "A known past and a sense of place open the doors of the mind." We appreciate what has gone before, but there's more to the American South than magnolias, plantations and misty bayous. Along with this nostalgic vision, there exists a New South, just as charming and gracious, filled with interesting, talented people, lovely homes and natural beauty. Nowhere is that more apparent than in our historical villages and towns. Many that were previously featured in *Veranda* magazine are now preserved in this beautiful volume.

Most communities in the fertile Southern landscape were rooted in agriculture. Many developed regional or national historical significance, while a simple, often cultured, small-town charm distinguishes others. Like Thomasville, Georgia, where I was born. Its fortunes over the years reflect the same vagaries visited upon many historic places. The success of cotton plantations in the area ended with the Civil War. Soon afterwards, high-society health resorts prospered, only to decline when Florida was developed. The plantations became vast quail-hunting retreats, and today my hometown is humming with conservation and preservation activity.

In a revitalizing population shift, many people who left their hometowns and gained fame and fortune have now returned. Others are newly encountering the delights of small-town living. In a number of communities there is a legacy of handsome buildings. Rapid progress may have bypassed some areas, allowing original structures to remain intact. These architectural gems are being rediscovered, revered and lovingly restored. I applaud the extraordinary efforts of so many dedicated preservationists.

The spirit of the South endures. And while we are inextricably bound to the past, we are equally dedicated to the present and future. Long ago, visionaries assumed that by the beginning of the twenty-first century we would have abandoned the past in favor of the sleek and modern. Instead, we take comfort in the good life of small towns and pride in preserving our heritage.

Lisa Newsom
Founder and Editor-in-Chief
Veranda

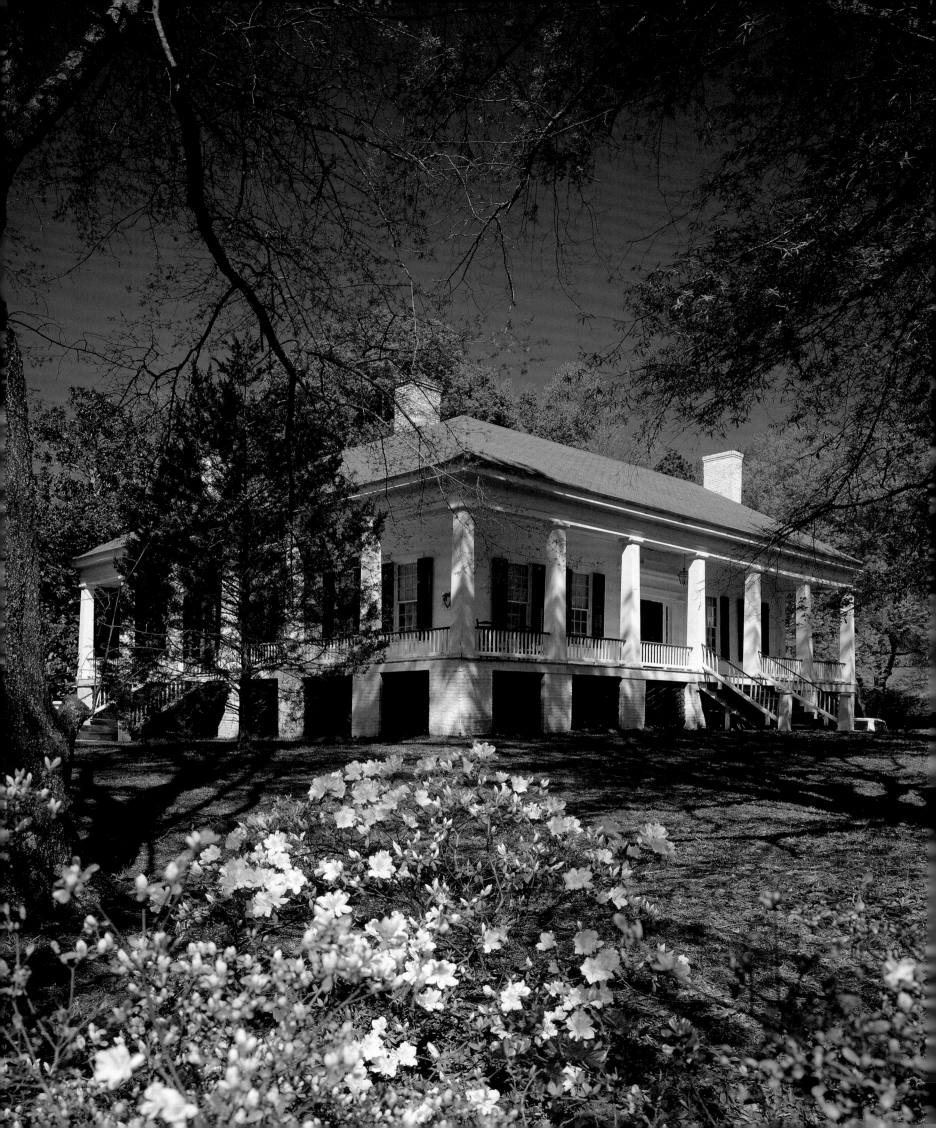

Introduction

The recorded history of the South is short compared to that of the rest of the world, four centuries at best. Family trees for the most part are traced to other continents; those roots planted deep in Southern soil can only be Native American. But in spite of its youth, the South is a region of widely divergent landscapes and peoples, bound by rich traditions that make it unlike any other. Eccentric and haughty, yet gracious and hospitable to the core, Southerners are willing for the most part to come down off the veranda long enough to invite the world in to share their music, their food, their architecture and their cultures.

Those broad front porches are most easily accessible in the small towns and villages of the South, many of which appear in this book, where the first question asked of newcomers is often, "Where are you from and who are your people?" Most people who ask do so with a healthy, tongue-in-cheek drawl. This question is the Southerner's mantra, and, once asked, conversation can begin.

Place names, like family names, are important to Southerners, for they echo the broad diversity of origin ranging from European to African to Native American. Romantic names like LeBlanc in predominantly French South Louisiana, Meusebach in the German-populated Texas Hill Country, and the unmistakably English ring of Camden in South Carolina's Olde English District reveal either a town's or a person's lineage.

Indian names pepper the map of the South. The rhythmic Tuscaloosa, an early capital of Alabama, is derived from the Choctaw Indian Chief Tushkauloosa's name which means "black warrior." The Native American name for Buffalo Creek inspired the name of Waxahachie, Texas. Natchez, Mississippi, is named after a tribe of sun-worshipers. As European settlers forced indigenous populations west, these engaging names often remain the only traces of the Native American in a land he once called his own. Today, in downtown Camden, South Carolina, King Haigler, Native American friend to the town's first settlers, still watches over the community

Annual house tours and pilgrimages bring visitors to many Southern towns. The Murphy-Dunlap-Dennis House (opposite), 1843, is a regular on tour in the fall in Eutaw, Alabama.

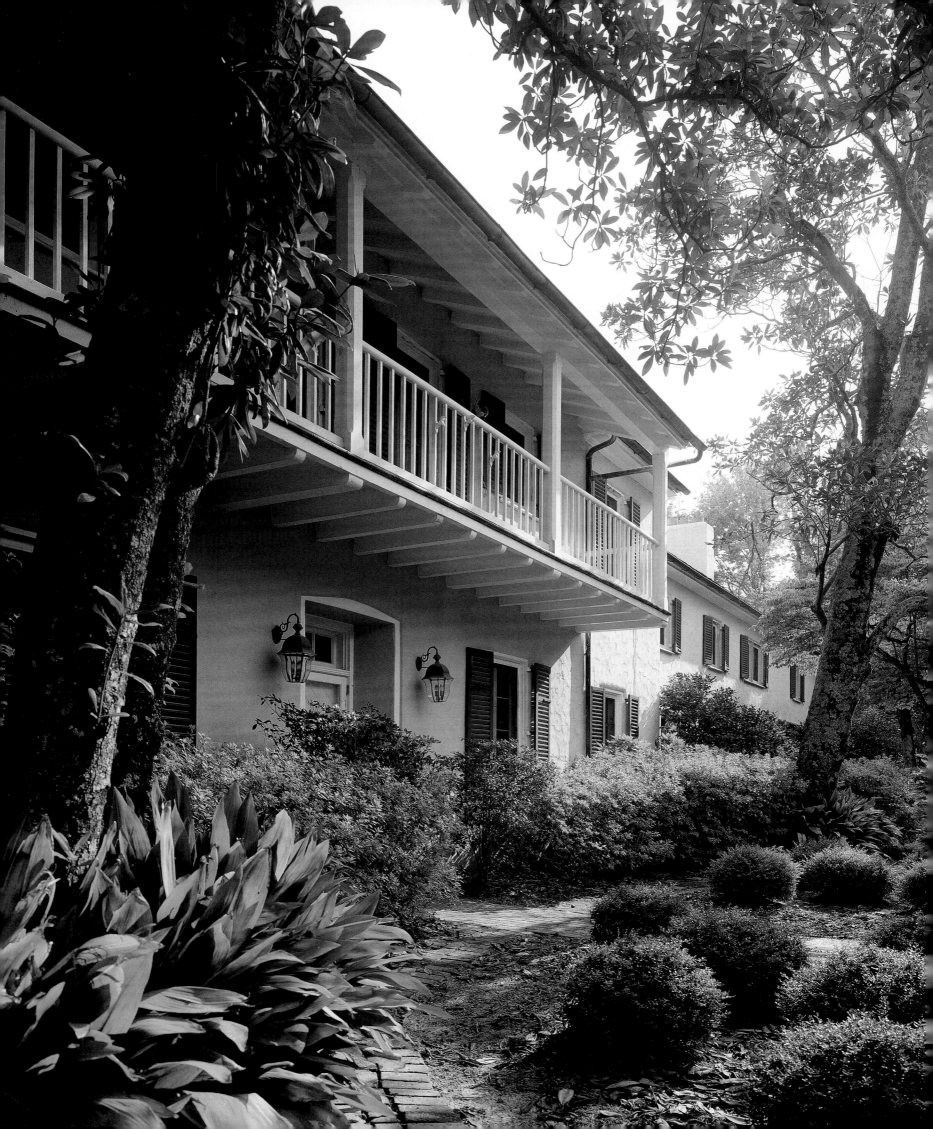

in the form of a five-foot weather-vane, a sentimental icon of a more peaceful time.

Despite the usual hardships encountered by early colonists in the seventeenth and eighteenth centuries, deciding where to settle in the South was relatively easy. The South naturally divides into four geographic regions, each with its own personality. The miles of shoreline following the coasts of the Atlantic Ocean and the Gulf of Mexico provided natural harbors for the first arrivals. The rich soil of the Piedmont, stretching from Virginia to Georgia, established the South's agrarian tradition that endured until the 1930s. The profusion of rivers in the South and the rich bottom land surrounding them made the Mississippi and the Black Warrior attractive to those leaving the Carolinas or Georgia for what historian W.J. Cash calls the "wave of frontier upon frontier" in search of more fertile land. The Upcountry, the deep interior and the mountains, ranges from the Blue Ridge chain in Virginia to what is fondly called the Texas Hill Country.

The first wave of Europeans established small colonies near the Atlantic Ocean on the east coast and the Gulf of Mexico on the southern coast. British influence is unmistakable in coastal towns such as Edenton, North Carolina, one of the first towns in North Carolina. The English dominated the Atlantic coast to Florida where Spanish influence began, continuing on into the westward waters of the Gulf of Mexico.

Most of the new towns were established with the labor of African-American slaves. Slavery in America lasted for over 250 years, ending with the ratification of the Thirteenth Amendment to the U.S. Constitution in 1865. The descendants of these slaves have become interwoven in the fabric and culture of the South so that today the mayor or sheriff of many of these towns is as likely to be the grandson of a slave as of a slave owner.

Tiny Amelia Island, named for the daughter of England's King George II, off the east coast of Florida, illustrates the South's cross-

This Monterey-style house (opposite), *known as the Pink House, has one of the best addresses in Aiken, South Carolina. It is on Easy Street. A flag flies outside this Fernandina Beach home* (above) *in preparation for the Fourth of July celebrations on Amelia Island which culminate in fireworks on the beach.*

The people of the Shaker Village of Pleasant Hill, Kentucky, lived a communal life apart from the world (opposite). Their whirling and trembling in exaltation at religious meetings, literally "shaking off their sins," prompted the Shaker name.

cultural beginnings, for it is the only U.S. territory to have been ruled under eight flags. The French, English, Spanish, Patriots of Amelia Island, Green Cross of Florida, Mexican Rebel, Confederate, and the United States flags all flew over Amelia, and still fly today over the Eight Flags Inn in downtown Fernandina. Locals are fond of saying that "the French visited, the Spanish developed, the English named and the Americans tamed it."

Gradually, the Southern planters' restless search for fertile land worked its way inland to the Piedmont region. Residents from areas such as Pennsylvania or Delaware moved south to the Piedmont from other American colonies. Some of these settlers anticipated greater freedom of religion, as in the Quaker settlement in Waterford, Virginia, founded in 1733. Similarly, on a plateau near the Kentucky River, Shaker missionaries began the settlement of Pleasant Hill. Today, in this largest of all restored Shaker villages, visitors can sample food made from Shaker recipes and study original Shaker furniture and architecture.

From these small towns in the Piedmont and coastal areas, the colonists fought the Revolutionary War to obtain independence from Britain. Residents of York and Camden in South Carolina's Olde English District declare that the area is "where the South won the Revolutionary War" because of the numerous battles fought in the area.

After the Revolution, new territories along the Mississippi River or near Alabama's Black Warrior or Chattahoochee Rivers opened up new and fertile land. A generation later the sons and daughters of the Piedmont moved even farther west to clear more cotton land in Texas and Arkansas. Former President Lyndon B. Johnson's family was part of this migration when his family moved by wagon train from tiny Maxeys, Georgia, to Texas in the 1840s.

Cotton, first introduced in the South as early as 1790, brought unimaginable wealth throughout the region as people either grew cotton, sold it, shipped it, or manufactured it into material. The

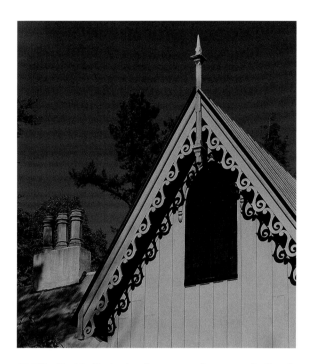

The Gothic Revival style was popular across the South in the late nineteenth century, inspiring trim such as this adorning the gable of a house in Beersheba Springs, Tennessee (above). Gothic, too, is this old arsenal, a veritable fortress in Beaufort, South Carolina, which now serves as the town's museum (opposite).

serviceable and simple lines of the South's popular Plantation Plain style homes of the early nineteenth century were abandoned for the more impressive Greek Revival homes in the building heyday leading up to the late 1850s. It was this wealth that gave rise to the grand mansions that grace the landscape in towns like Madison and Eutaw. Residents of cotton-rich Piedmont towns like Madison, Georgia, saw houses like Bonar Hall being built in 1832, and gossiped endlessly about imported plants for the house's exotic orangery or the copper roof arriving from England. Boats returning up the Black Warrior River to Eutaw, Alabama, in 1857 carried imported treasures such as Italian marble mantels for Kirkwood, Eutaw's last pillared mansion to be built before the Civil War.

And inside these houses lavish parties flourished. One affair equal to the surroundings was held at D'Evereux, the mansion in Natchez where presidential candidate Henry Clay was fêted, as party legend has it, in the glow of a thousand candles. Natchez, which had been flourishing in the cotton boom of the early 1800s, was by mid-century one of the wealthiest cities per capita in America, prompting Natchezians to call themselves "people of the world first."

The Civil War brought the South's opulent era to a halt with an economic despair as conspicuous as the golden days had been before the war. Mary Boykin Chesnut's journal, kept while she stayed at Mulberry, her in-laws' home in Camden during the war, was later published in the twentieth century as *Diaries from Dixie*. It is considered one of the most famous of all Civil War chronicles. Camden was spared from the Union forces' torch by pure luck. The town escaped destruction when a fortuitous rain shower left the the town's buildings too wet to burn.

Scattered throughout the South are reminders of the Civil War, the period most Americans agree is the worst moment in the nation's history, when the nation itself came apart. The world's only double-barrel cannon stands in front of the city hall in Athens, Georgia, shot once, and with a misfire, but heralded today by Athenians

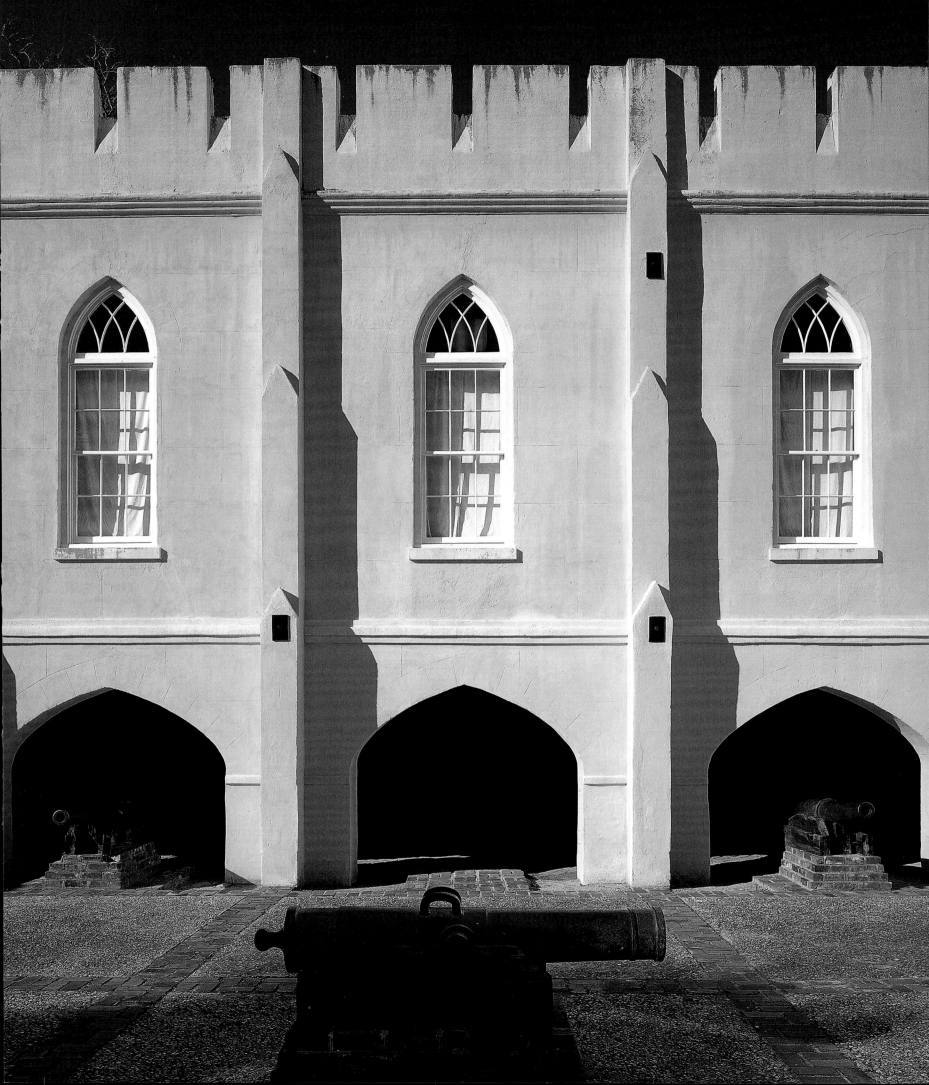

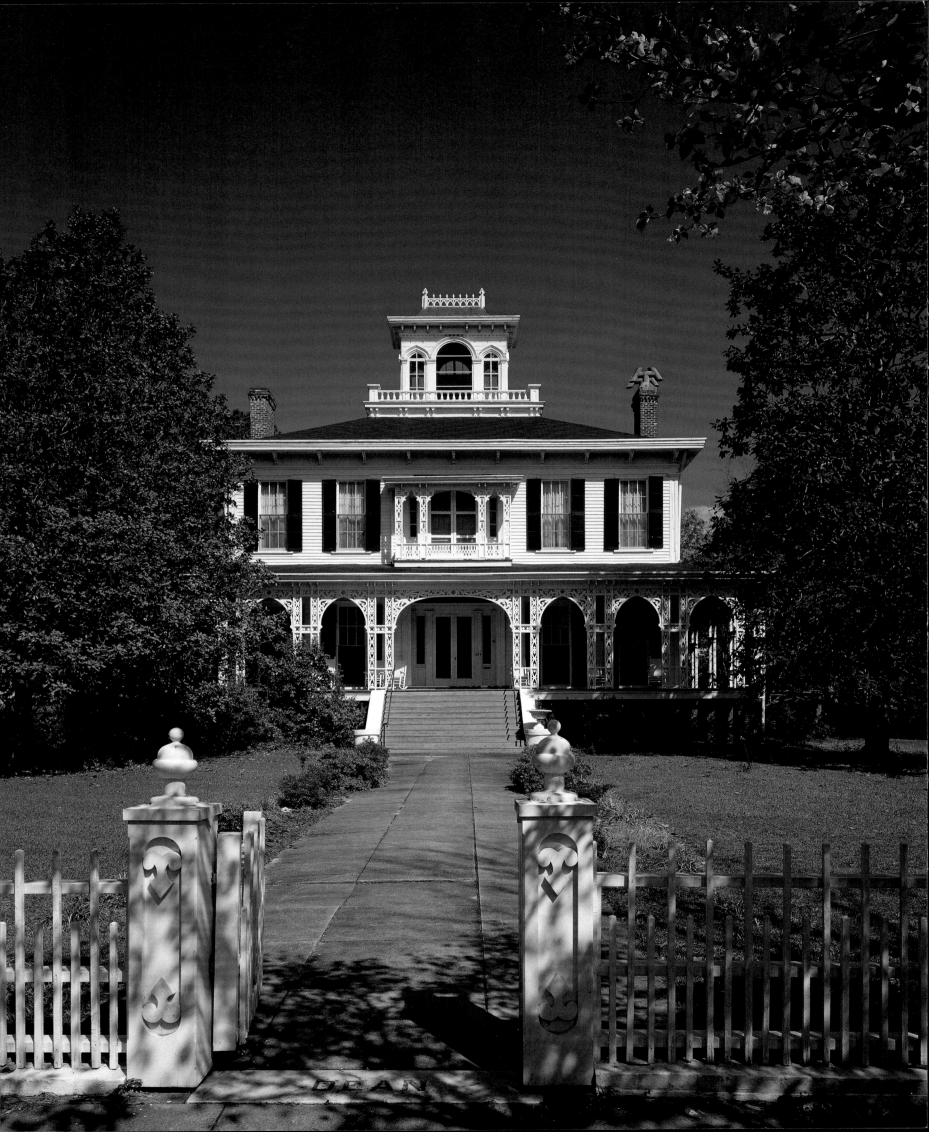

for its uniqueness, despite its inability to discharge. Determinedly pointed north in a bed of yellow flowers, the cannon is, as the environment it occupies, eccentric. Each December in Fayetteville, Arkansas, the Civil War battle of Prairie Grove is fought over and over in a historic reenactment. The battle's results, however, never change.

Southerners are quick to point out that after the war there was little money either "to tear down or build up." Benign neglect ensured architectural integrity for almost a century. If early on it was the economy that saved the towns of the South, later it was largely National Historic Register designation and local preservation commissions.

While the Victorian building craze swept the South after the Civil War, towns like the mountain village of Beersheba Springs, Tennessee, experienced rebirth as summer resorts in one of the South's newer cash crops, tourism. Beersheba Springs particularly gained a foothold when the Methodists built an "assembly" there to enjoy the cool Appalachian summers of the Cumberland Plateau. Located in resort areas near mountains or lakes throughout the South, these camp-like religious assemblies offered the righteous a summer sanctuary.

Hundreds of miles away, two other Southern towns were developing a vigorous post-bellum economy with the arrival of Yankee tourists by railroad and steamship. In 1875 New York's Mallory Steamship Line introduced tourists to Fernandina Beach on Amelia Island. Only twenty years later, this seaside village was hailed the "Queen of Summer Resorts" or the "Newport of the South," and a sizable Victorian district sprang up around the downtown area.

The 1890s saw the beginning of a wave of wealthy visitors from the North discovering Aiken, South Carolina. The "winter colony," as they were called, discovered a terrain whose natural landscape lent itself to polo matches, steeplechases, and leisurely rides, not to mention squash, tennis, and golf. Horses arrived by railroad car

Dean-Page Hall, 1850, is a classic Italianate house in Eufaula, Alabama (opposite). *Its builders, like so many of their neighbors in river towns across the South, could scan the river for incoming boats from the belvedere atop the roof.*

The pointed arch windows of the Episcopal Church of the Advent in Madison, Georgia, bring a Gothic Revival touch to the historic neighborhood surrounding the church (below).

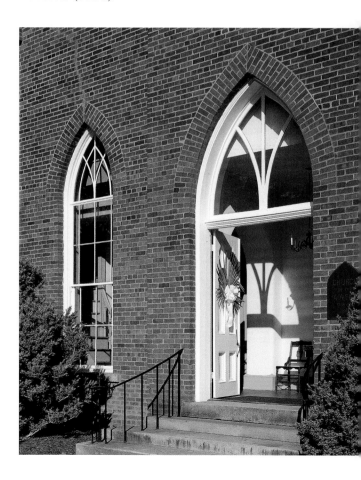

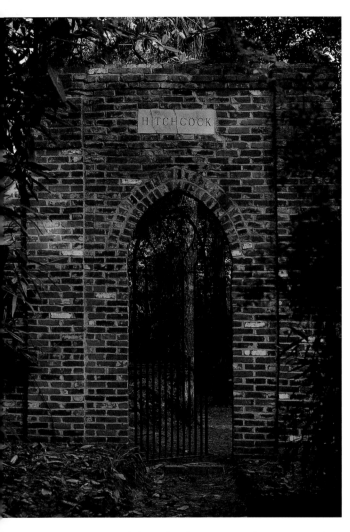

The secluded Hitchcock Cemetery (above) *is in Aiken, a small town in the gently rolling Sand Hill District of South Carolina.*

Houses and gardens across the South reawaken with the arrival of spring (opposite), *heralded by a blizzard of white dogwood tree blossoms and an accompanying blaze of azaleas.*

to winter in Aiken while their wealthy owners enjoyed rounds of parties on into the twentieth century.

Sports have always been the lifeblood of the South, whether an aristocratic game of polo or an afternoon of bass fishing. If a crowd in the South is not assembled in the name of the Lord, it will probably be gathered for football. College football is still worshipped in towns like Oxford, Athens, or Tuscaloosa on a fall Saturday afternoon, and discussed for hours on end until Tuesday when they start talking about next week's game. In between sport seasons, weekends are filled with events such as the Catfish Strut Festival in South Carolina or Mardi Gras parties in Natchez and St. Francisville.

It is difficult to deny the presence of the South's sprawling cities like Atlanta or Charlotte. These urban giants host international Olympic games, develop e-commerce, cheer professional sports, and live for the next ring of a cellphone. But the towns and villages of the South in this book are the ones that are often miles away from the interstate and probably do not even have an airport, places where Southerners and their guests are still enjoying themselves today. They are eager to take visitors through their gardens, open up their houses for Pilgrimage tours, and talk for hours on end to complete strangers. These communities appear in this book as they developed across the South, from the coasts, through the Piedmont, along the rivers, and to the Upcountry. And along this Southern path, the visitor can savor the stillness of cemeteries, the echo of hoof beats from the South's equestrian arenas, and the hush of Southern gardens and perhaps be inclined to agree that, though the South is not so old, its hospitality is ageless.

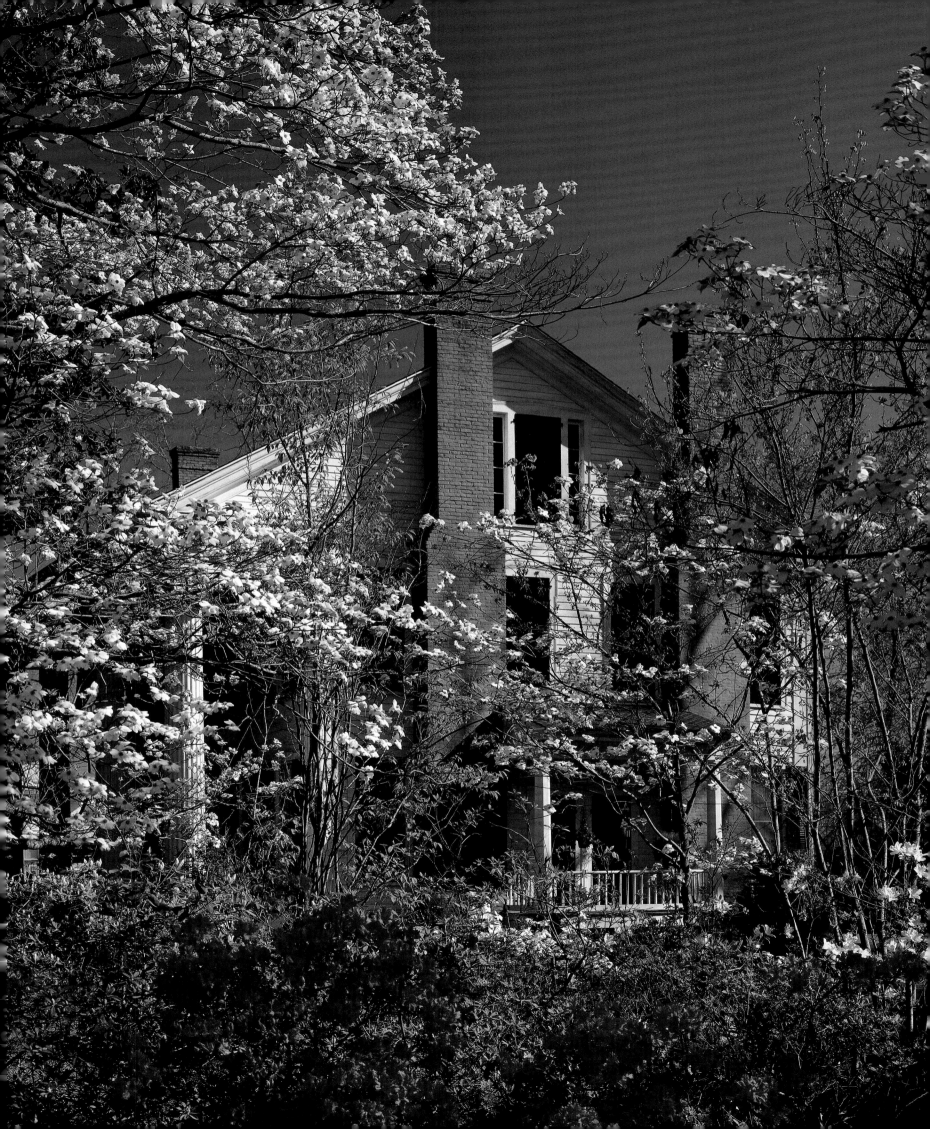

THE COAST

Among the earliest North American settlements, the coastal towns of the South, both English and Spanish in origin, were first and foremost eighteenth-century trading centers. As many as 827 ships left the port of Edenton, North Carolina, between 1771 and 1776. Two centuries later, economic viability for these towns was ensured as they evolved into seaside resorts such as Fernandina Beach, Florida, and Galveston, Texas, combining the beauty of late nineteenth-century Victorian architecture with the freshness of salt breezes. Despite threatening decades of hurricanes and ominous visits from legendary buccaneers like Blackbeard and Jean Lafitte in the nineteenth century, these coastal villages cling stubbornly to their place near the water.

The architecture of these towns accommodates balmy climates. Southern orientation of houses along the Carolina coast takes advantage of sea breezes and views of the marsh and water. Raised foundations elevate indoor living areas to receive cooler breezes in the Carolinas as well as in the "raised cottages" of coastal Texas, Mississippi, Louisiana and Alabama. Low-pitched roofs were designed to avoid hot air entrapment in the attic area. The most important feature, however, is the porch. If the tides of these coastal towns are their lifeblood, then the porches are the heart. Often sheltering two or three sides of a house, porches range from the eighteenth-century double portico of Beaufort's Tabby Manse to the gingerbread trim adorning the late nineteenth-century Howard Carnes House in Galveston.

Early building materials in towns like Bath were mostly wood, but the peculiar use of tabby, a cement-like mixture of the plentiful sand, water, lime, and oyster shell, was necessary near some of the Sea Islands because clay for brick-making was not used there until 1820 or 1830. The word 'tabby' is thought to have been derived from the African word tabi. *Its inspiration in the Carolinas was Spanish Colonial architecture in places like Amelia Island, where only a few tabby ruins remain today.*

Little changes in the historic districts of these coastal towns. Tourists and tides come and go, but the magnetic appeal of these old houses near the sea endures.

For hundreds of years the restful waters of Edenton Bay (opposite) flowing into Albemarle Sound have inspired the people of Edenton, North Carolina.

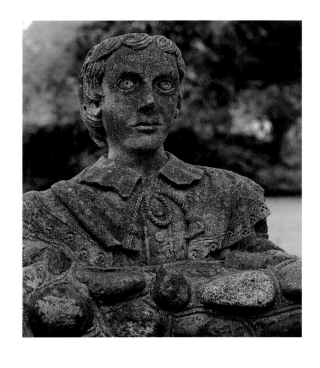

Bath

NORTH CAROLINA

THE TINY COASTAL VILLAGE OF BATH, a treasure-trove of late eighteenth-century and early nineteenth-century American architecture, is home today to only two hundred residents. The town's size, however, in no way diminishes its importance in the history of Colonial America. Bath is North Carolina's first town, dating back to 1705 when it assumed prominence as a port of entry with its choice location on the Pamlico River. Eighty years later, in 1785, when the seat of Beaufort County government was moved to Washington, North Carolina, Bath's importance as a trade center subsided.

The bust of an Anglican bishop (left) ages gracefully in the churchyard of St. Thomas' Church, constructed in 1734 and considered the oldest existing church structure in North Carolina. The Palmer-Marsh House (below and opposite), typical of the Southern Colonial style of architecture, is particularly noteworthy for its 17--foot-wide double exterior chimneys and slender windows.

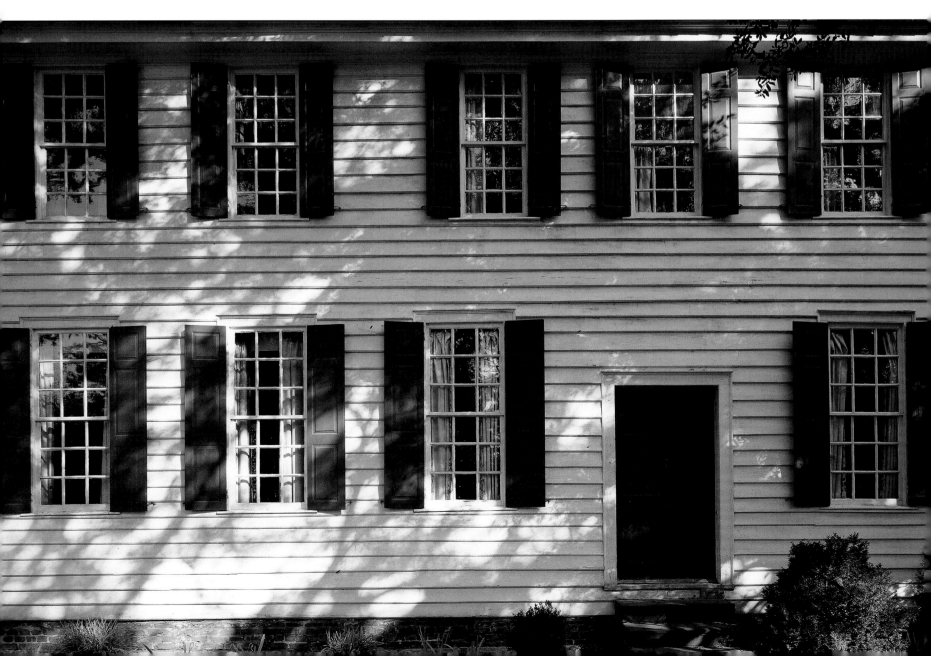

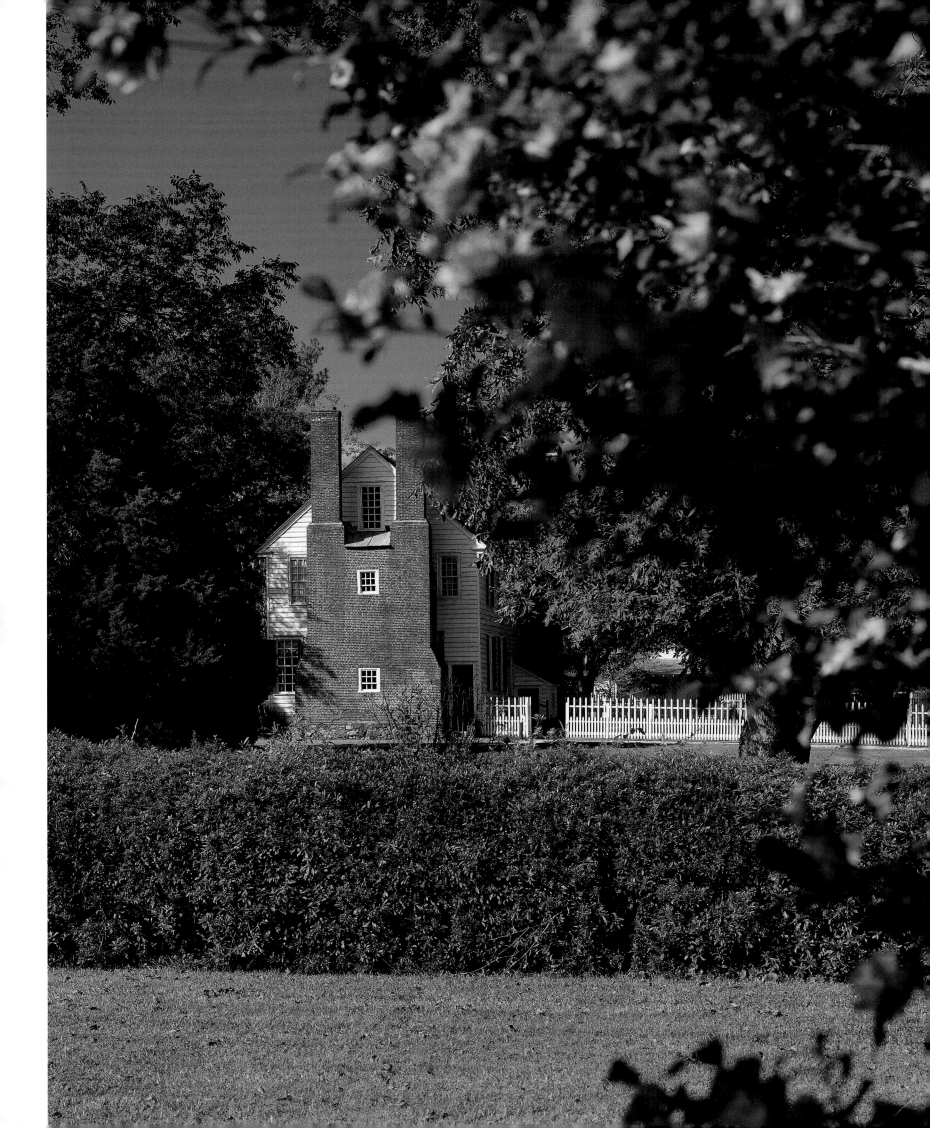

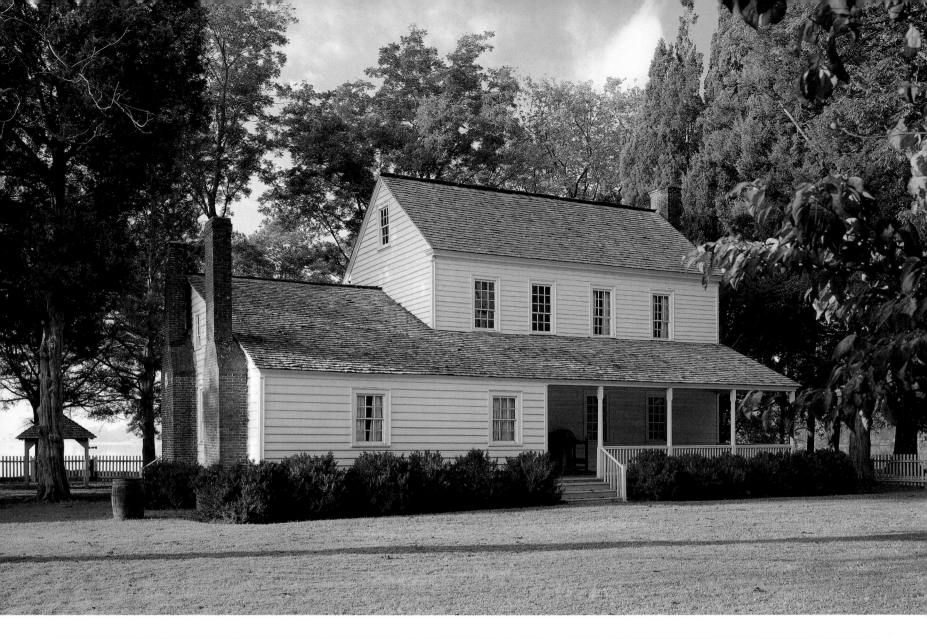

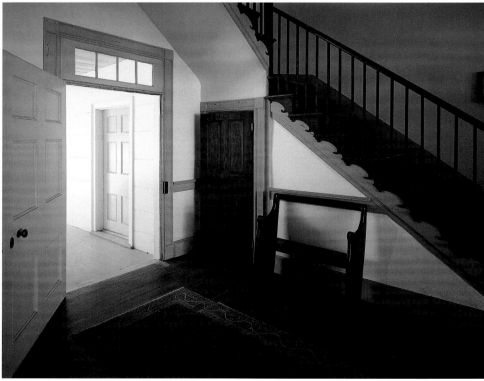

The Bonner House (opposite) *was built in 1830 and is furnished with American antiques. The house is located on a peninsula between Bath Creek and Back Creek, with a view of the Pamlico River.*

Three structures in Bath today are a microcosm of that early colonial life. All are meticulously preserved and open to visitors through the auspices of the Historic Bath State Historic Site. Next to the Visitor Center at Historic Bath is the Van Der Veer House, *c.* 1790, where artifacts and exhibits highlighting Bath's history are on view. A National Historic Landmark, the Palmer-Marsh House, 1751, is notable not only for its age, but for the incredible size of its 17-foot-wide double chimney. The newest house owned by the Bath Historic Site is the Bonner House, *c.* 1830, overlooking the Pamlico River.

North Carolina's oldest church structure, St. Thomas', was constructed in 1734 and continues in use today. Thirty years before its construction a library of one thousand books was sent to St. Thomas' Parish from England, thus making it the state's first library. Today a visit to Bath itself is not unlike a turn of the pages of one of those old books, or a quiet moment in the church where Bath's civilized heritage exists almost three hundred years later.

The two-hundred-year-old St. Thomas' Church (right above) *has solid brick walls two feet thick. The Van Der Veer House* (right) *was built around 1790. It has been meticulously restored and today houses exhibitions and artifacts recounting the history of Bath.*

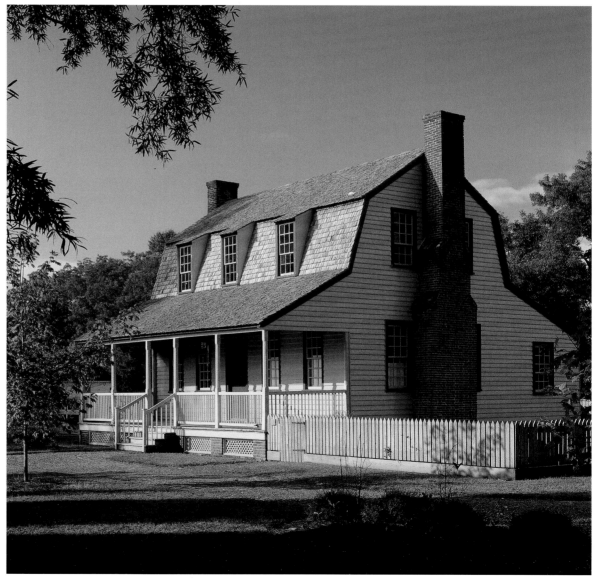

Edenton

NORTH CAROLINA

ON THE SHORE OF THE LARGEST freshwater sound in America, the pristine and charming town of Edenton, North Carolina, was founded in 1712 and incorporated in 1722. Its history and its architecture are both intertwined with eighteenth-century Colonial America. Named after Provincial Governor Charles Eden, Edenton was the first capital of the province of North Carolina before the area became a royal colony in 1729.

During the early part of the eighteenth century, large plantations were built in what is called the Albemarle area of North Carolina, named for the river. The port town of Edenton grew prosperous shipping corn, tar and fish, and historians estimate

The infamous pirate Blackbeard was rumored to roam the waters off Edenton (right) *in the early eighteenth century, when ships carrying rum and salt were arriving from the West Indies. Other trade reached early Edenton by ships arriving from colonies to the north. The town's aura is as timeless as the stone of this garden statuary* (below).

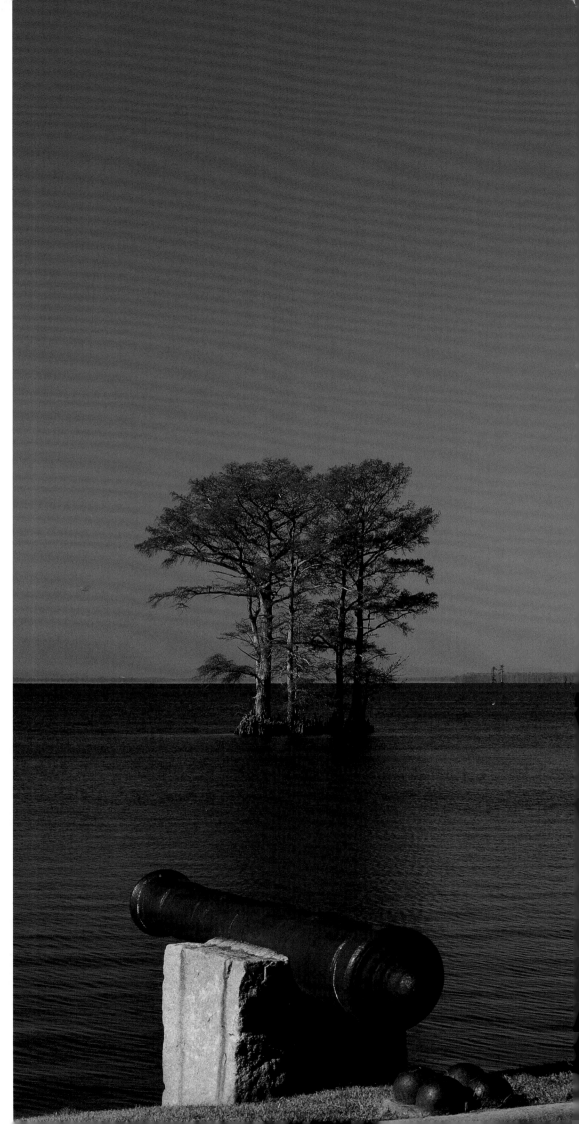

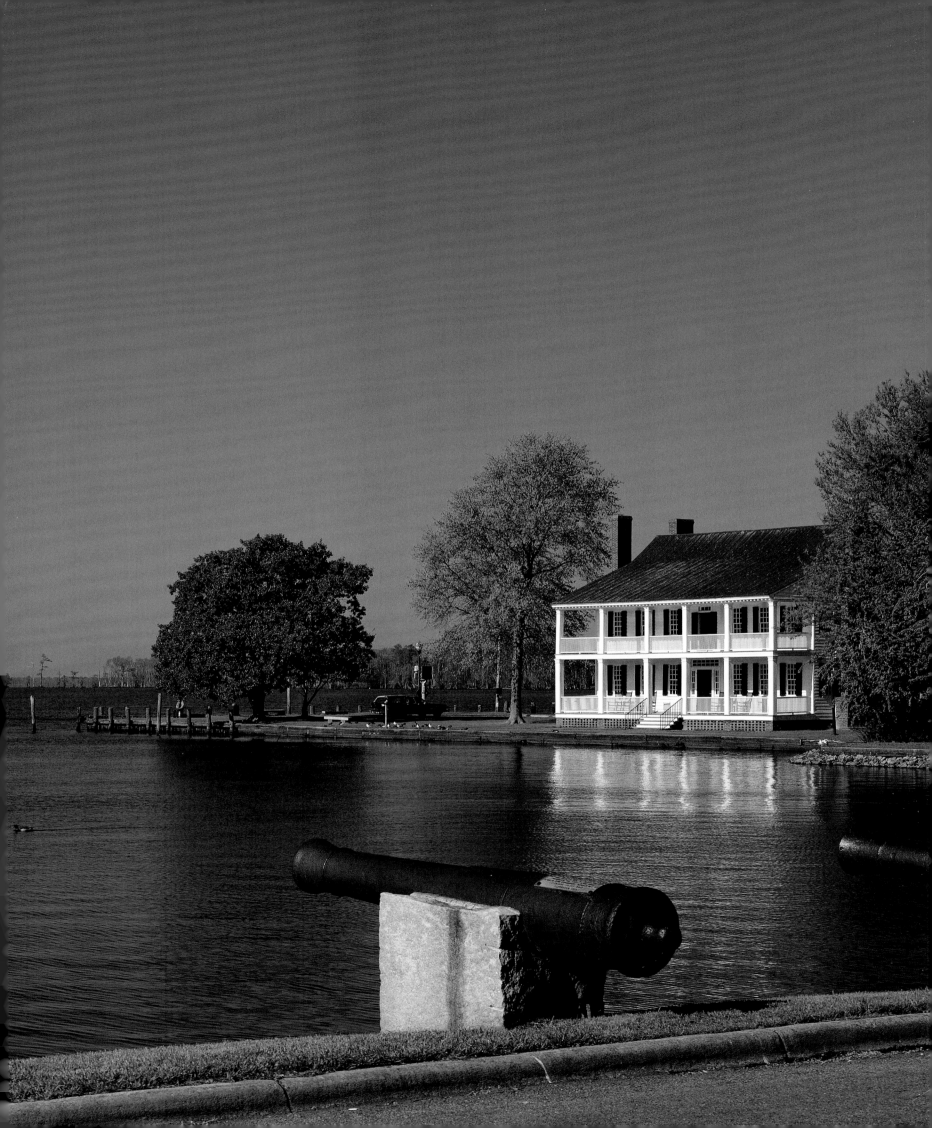

that by the mid 1700s there were fifty houses in Edenton. One, the Cupola House, 1758, is a treasured local landmark and has also earned the distinction of National Historic Landmark. The Chowan County Courthouse, 1767, also has National Historic Landmark status and is considered to be America's best remaining example of a colonial courtroom. St. Paul's Church, *c.* 1736, and the James Iredell House, 1800, are other local sites which make up what some architectural historians call North Carolina's most prestigious collection of eighteenth-century buildings.

The Barrow Hole House (left) was built in the mid eighteenth century. It was moved to Edenton in 1983 and today looks very much at home in its adopted city. The James Iredell House (below), 1800, is one of Edenton's historic sites on the guided walking tour which originates at the town's Visitor Center. Another important stop on the tour is Edenton's signature structure, Cupola House (opposite). Built in 1758, this landmark overlooks Edenton Bay.

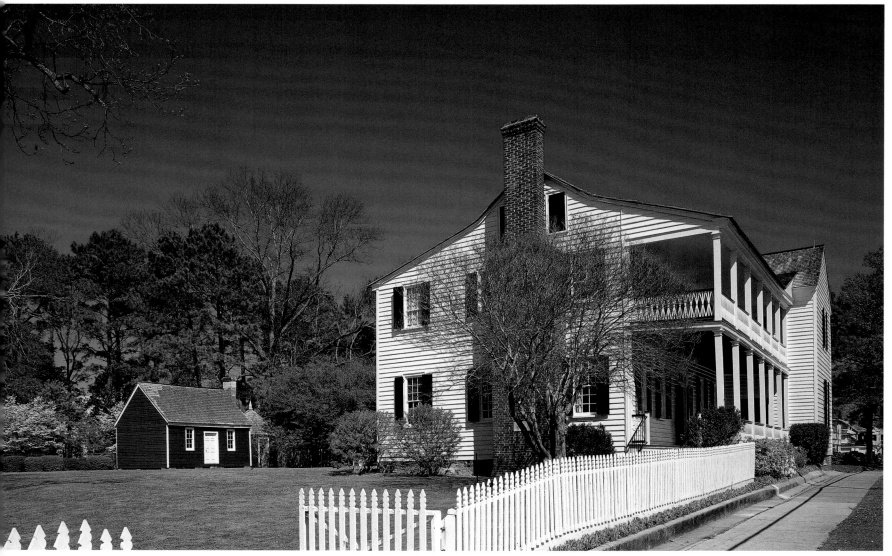

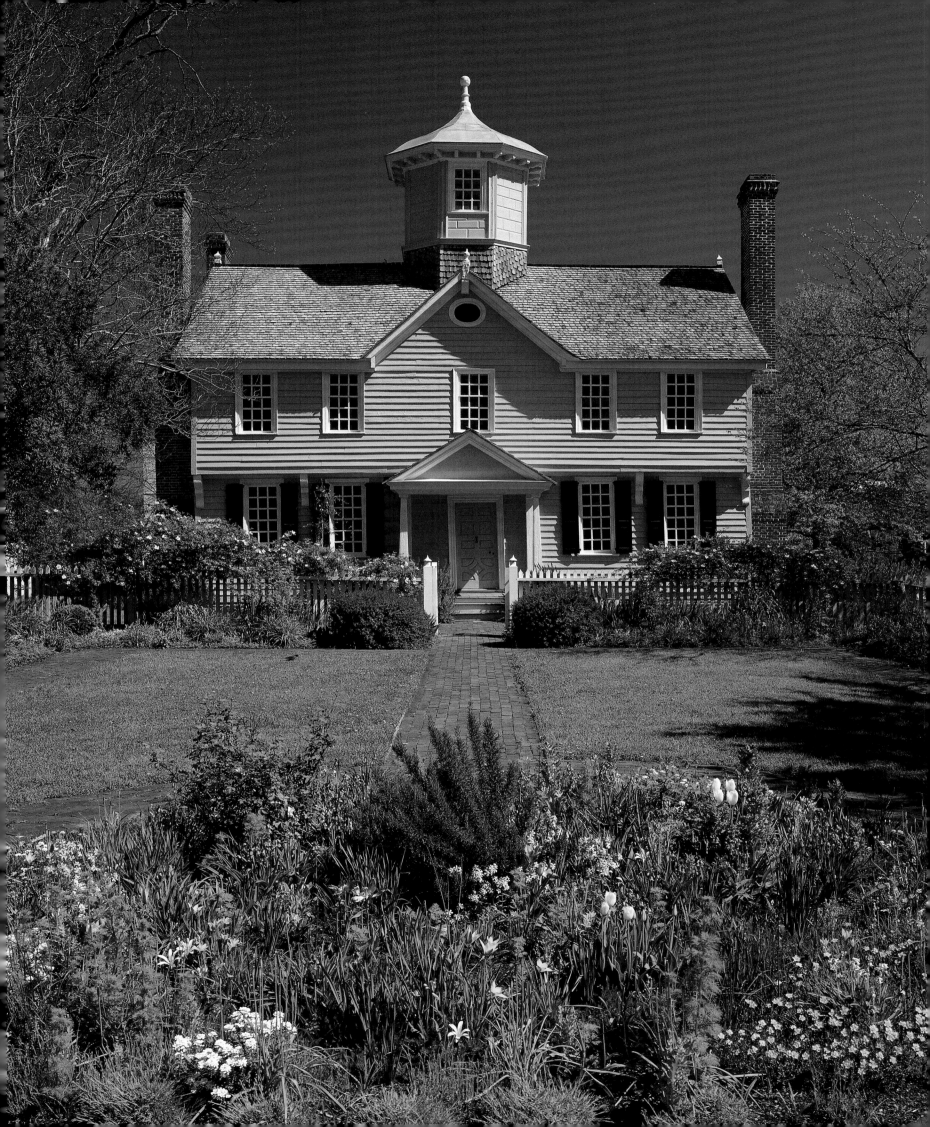

*A*mid the wealth of colonial architecture in this early Carolina town, the Dixon-Powell House (right), 1895, and other Victorian structures attest to Edenton's rich architectural variety.

*I*n order to capture the cooler breezes off the water, houses in the coastal Carolinas often had double-tiered porches such as the one on the Homestead, 1810 (below).

The first known incidence of women's political power in United States history occurred in Edenton, when fifty-one determined colonial women banded together and signed a boycott of English tea. The shores of Edenton are dotted with these historic sites and public parks. Those fortunate enough to call Edenton home often canoe its waters just as did the early colonists, slipping quietly into the Albemarle Sound and paddling back two centuries in time.

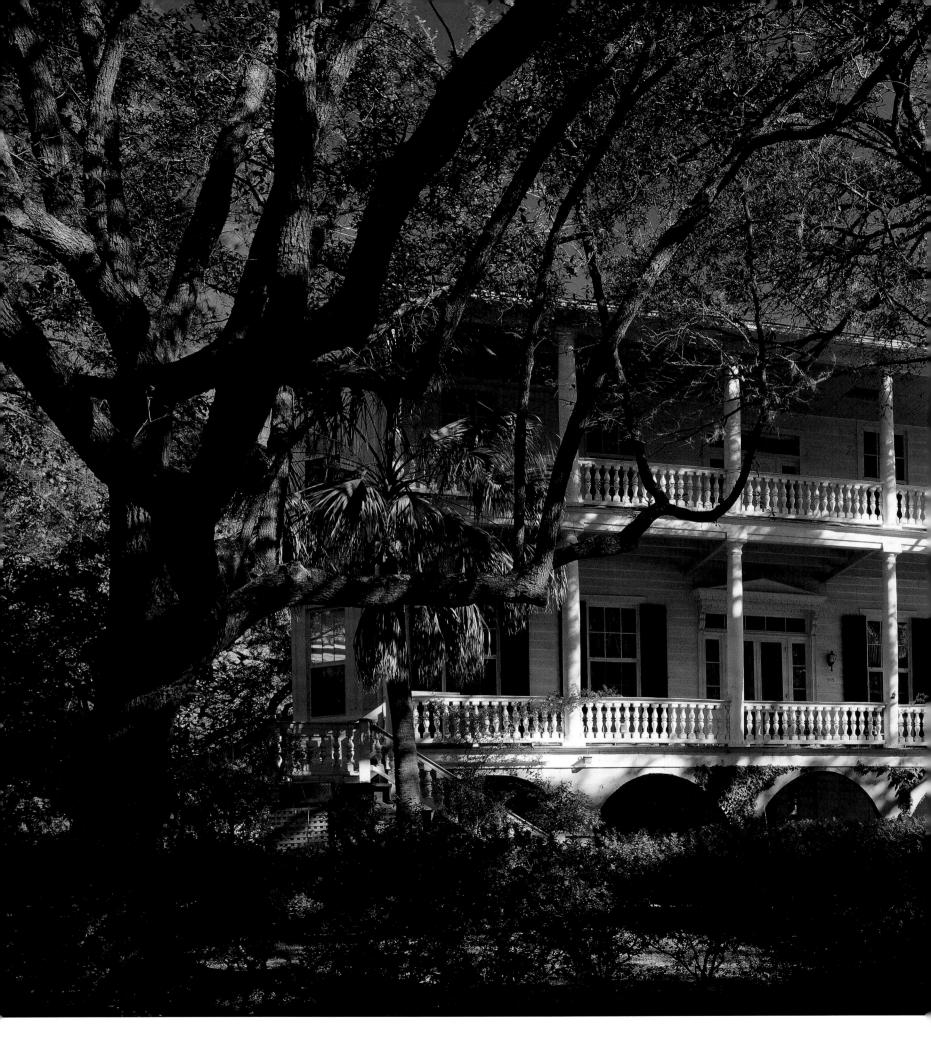

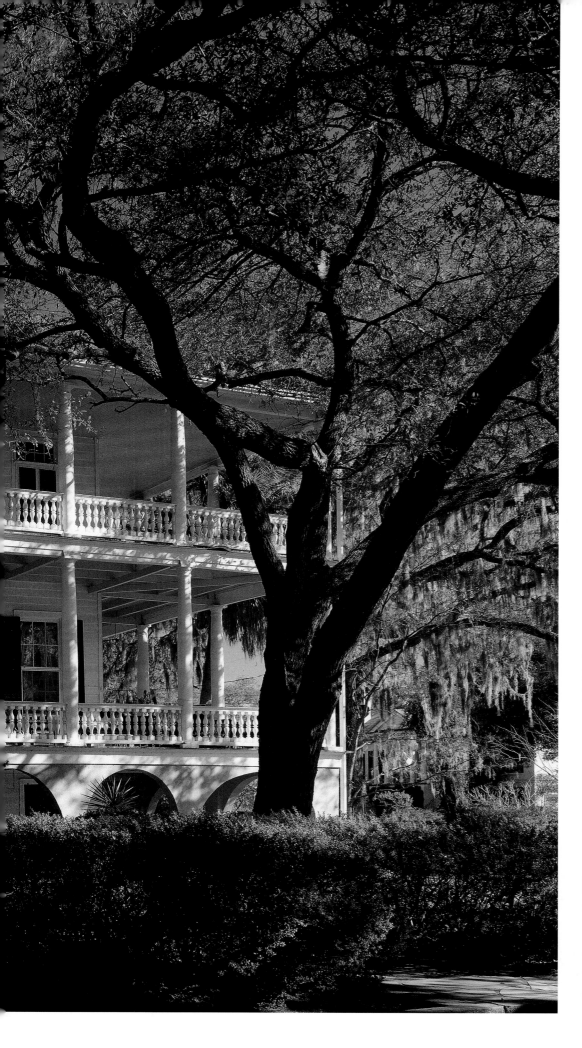

Beaufort
SOUTH CAROLINA

THE TOWN OF BEAUFORT RISES ELEGANTLY above the tides on Port Royal Island in South Carolina, mid-way between Savannah and Charleston. Named for Henry Somerset, Duke of Beaufort, the town was founded in 1710, making it South Carolina's second oldest town. Located on a low bluff, Beaufort harbors sea breezes out of the south and the highest tides south of New York. Most of the grand historic houses in Beaufort were summer residences for planters whose plantations were on the nearby islands, over sixty of which fringe the Beaufort County coastline. The quality and sophistication found in these eighteenth-century Federal-style houses is remarkable for a town this size.

*B*uilt after the Civil War, the James Rhett House (left), 1886, is quintessentially Beaufort, with double verandas and an arcaded masonry foundation. Nearby is peaceful Petit Point (below), 1855. The houses in Beaufort's historic district lie only minutes away from the 60 large islands which fringe the Beaufort County coastline.

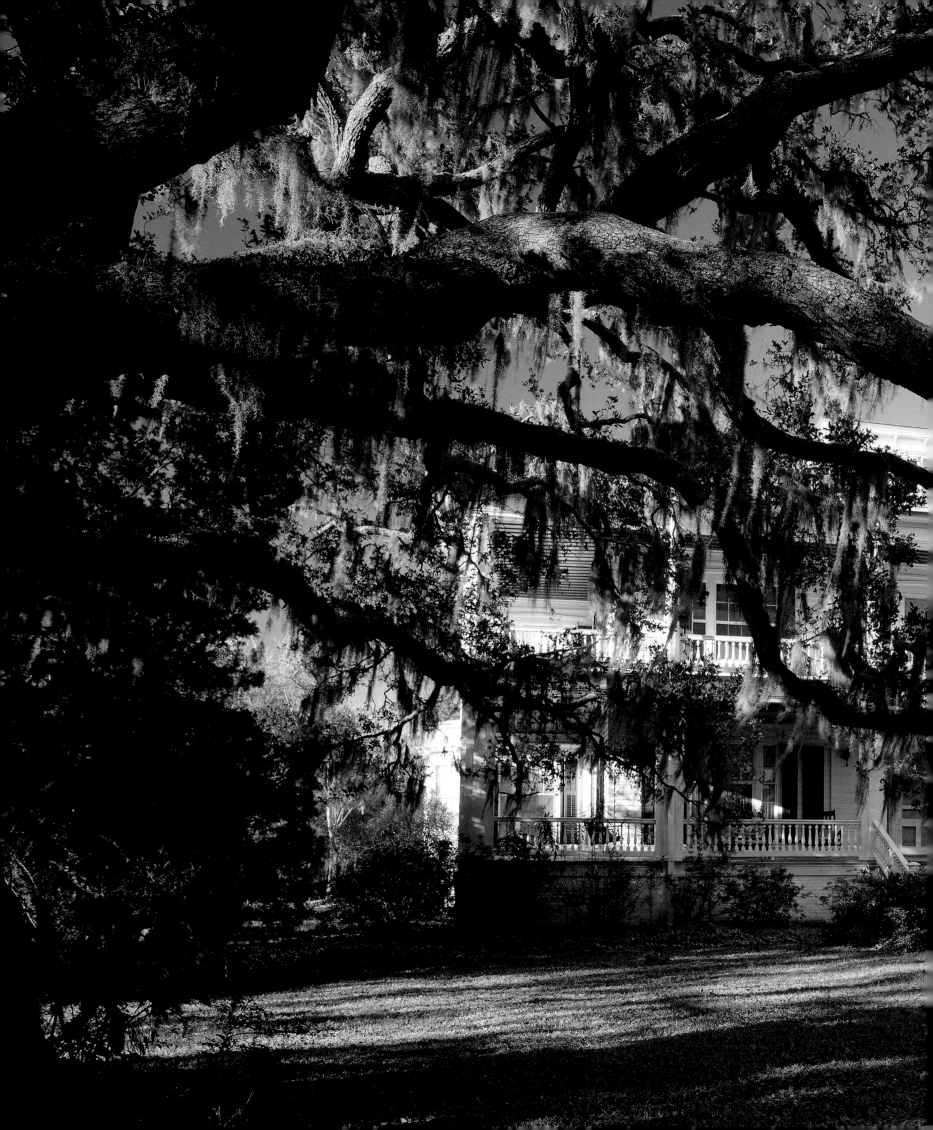

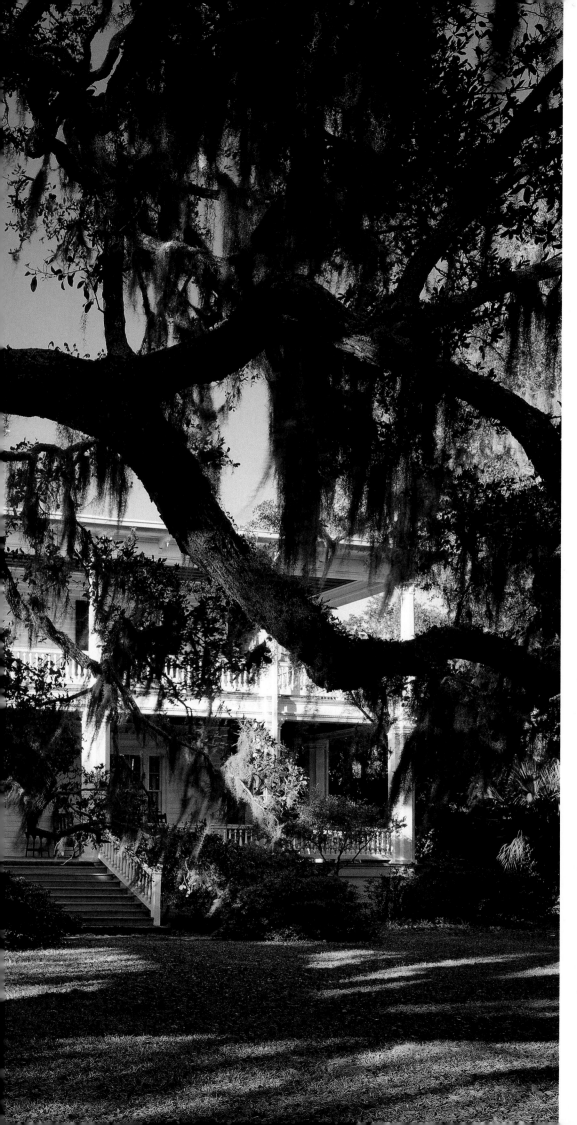

The grounds at The Oaks, 1855, are graced by oak trees which are thought to be over 450 years old (left). Not as old as its natural environment, Beaufort is nonetheless South Carolina's second oldest town. It was founded in 1710 and named for Henry Somerset, Duke of Beaufort. Streets like this (below) can be found throughout the 124-block historic district.

During the South's building boom in the mid nineteenth century, houses like The Castle, 1859, expressed the best of Beaufort. Built of brick made on nearby Lady's Island, the house is covered with stucco scored to look like stone and has seventy-two windows to embrace the water view.

In 1861, residents of Beaufort were among the principal secessionists advocating the withdrawal of the Southern states from the Union. The first secession meeting in South Carolina was held in Beaufort, and it was impossible to predict then that if war began, Beaufort would be the first town in the Confederacy to fall to Union forces.

In the last century and a half, Beaufort's 124-block historic district, covering 304 acres, has gained diversity

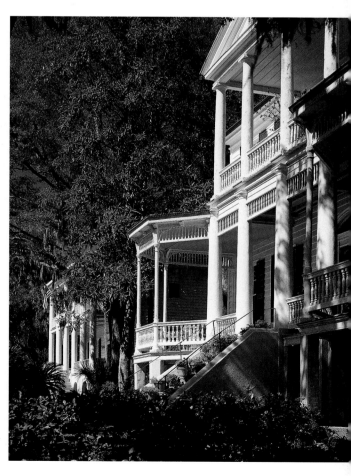

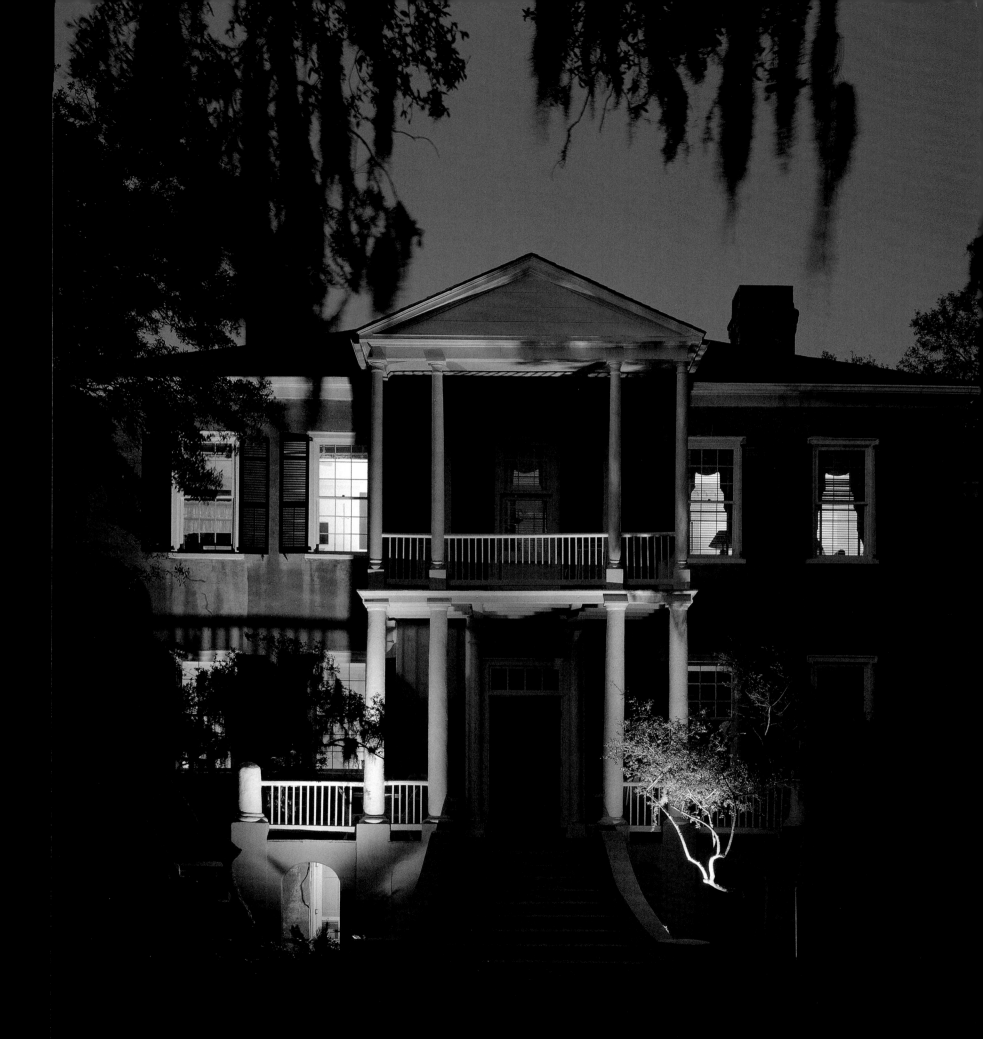

with the addition of Victorian and Italianate houses. The colorful Victorian houses added in the late nineteenth century stand out against the landscape of monumental white houses like so many azaleas in the snow. In the late twentieth century, tourists and film-makers discovered Beaufort. Part of Beaufort's charm, however, is the sense of the undisturbed and the eternal that continues to exist here. Movie stars and tour buses may come and go, just as hurricanes and armies have in the past, but Beaufort's soul remains, unruffled, on the porches of these old houses.

The Thomas Fuller House (opposite), c. 1786, also known as Tabby Manse, is of the Federal style with a tabby exterior scored with stucco to resemble stone. The Reverend Thomas E. Ledbetter House (left), built in 1840, was one of the first houses to be built in what would become the "Beaufort style," houses characterized by their sweeping double verandas. Such houses as Marshlands (below), a National Historic Landmark built in 1814, were sited to make the most of the beautiful water views surrounding Beaufort.

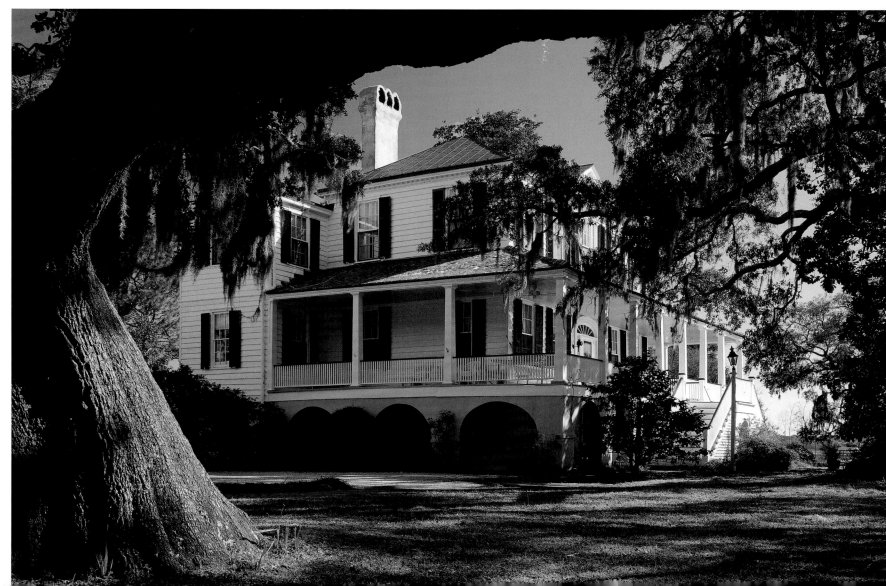

Fernandina Beach

AMELIA ISLAND, FLORIDA

FERNANDINA BEACH IS A TOWN THAT likes itself. Its residents and their houses exude an islander's air of mystical nonchalance, a tranquil independence, and a rich sense of history. The carefully restored nineteenth-century downtown commercial district, and the Victorian houses around it, terminate in a picturesque pier on the deepest natural harbor in the South. Racketeers practiced their illegal trades there in the early nineteenth century. Fort Clinch, a Confederate post during the Civil War, was not even completed when captured by Union Forces seeking a coastal foothold in 1862.

The Florida House Inn, 1858, the state's oldest surviving tourist hotel, still flies the eight flags that have flown over the island in its 400-year history. The

Villa Las Palmas, 1910, is a reminder of the Spanish origins of Amelia Island. The Spanish Colonial Revival style gained widespread favor in Florida in the early part of the twentieth century.

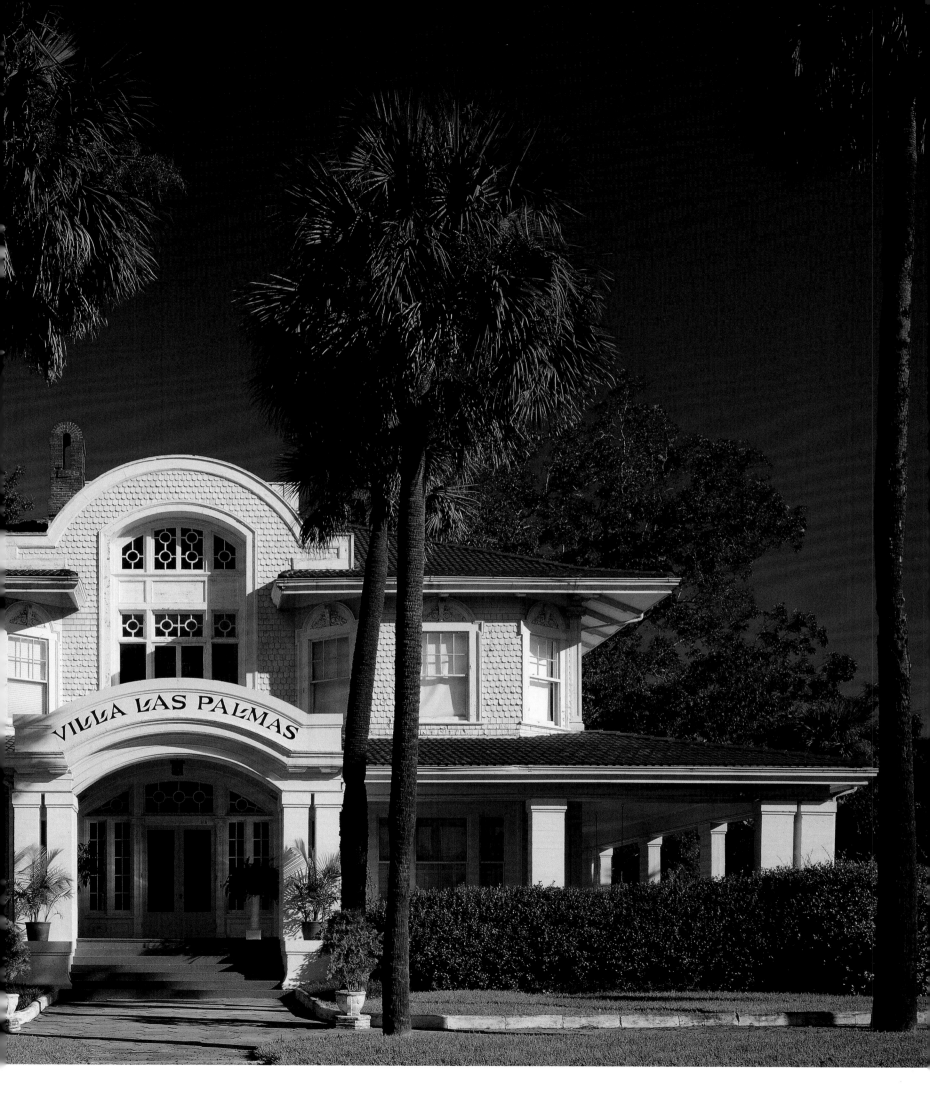

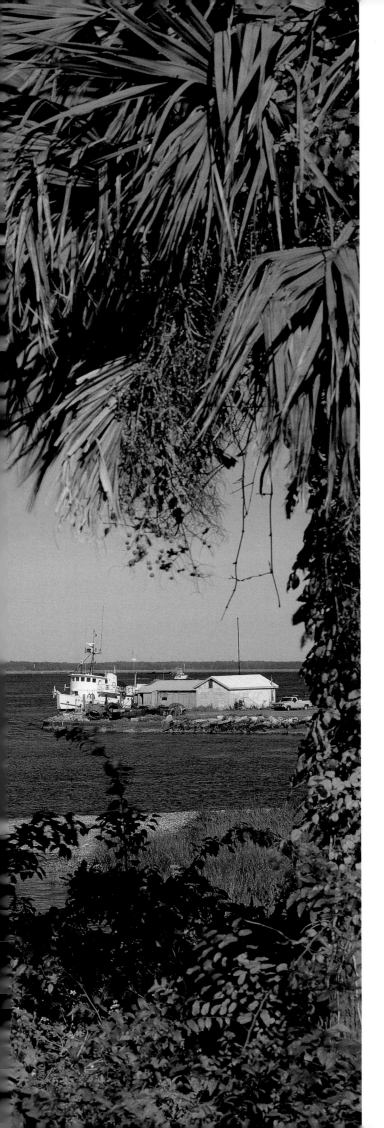

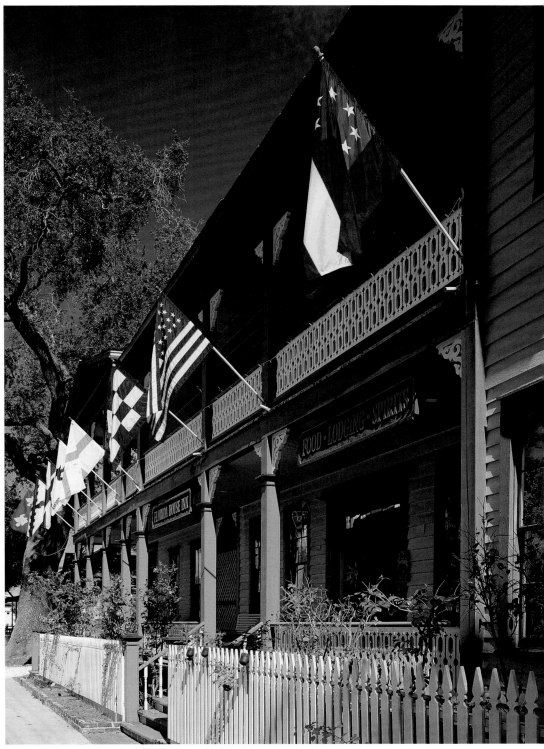

*F*ernandina Beach natives talk of pirates, buried treasure, Spanish galleons, and ghostly wanderings on Amelia Island which is home to the deepest natural harbor in the South (left). Island history records eight flags flying over Amelia Island and they all flutter in the ocean breeze outside the Florida House Inn (above), one of the state's oldest hotels and a favorite with locals for Sunday lunch.

Palace Saloon, founded in 1878, operates in its original location downtown as Florida's oldest tavern. The introduction of the railroad in the 1850s and the arrival of steamships forever changed the nature of Fernandina Beach. The town's center moved away from the area known as Old Town, and now only a few tabby ruins are reminders of the legendary smugglers and mariners.

Only blocks away is the colorful Victorian District, built during the economic boom that accompanied Florida's first wave of tourists in the late nineteenth

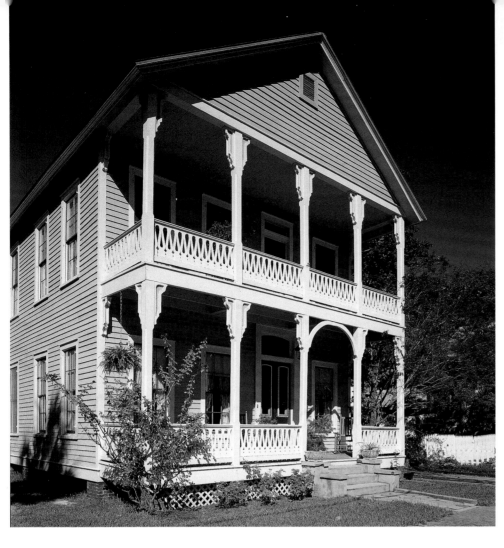

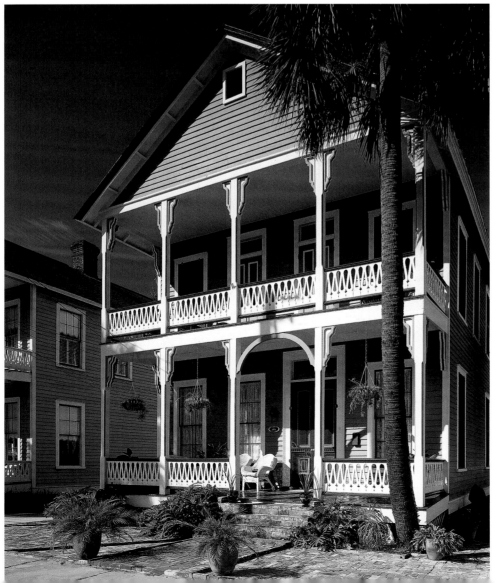

*P*reserved in colorful Victorian hues, Williams House (preceding pages), 1856, is one of the island's numerous Victorian bed-and-breakfast inns.

*T*hese twin-like Victorian houses (above left *and* left) built in 1903 are known locally as "The Four Ladies in Waiting."

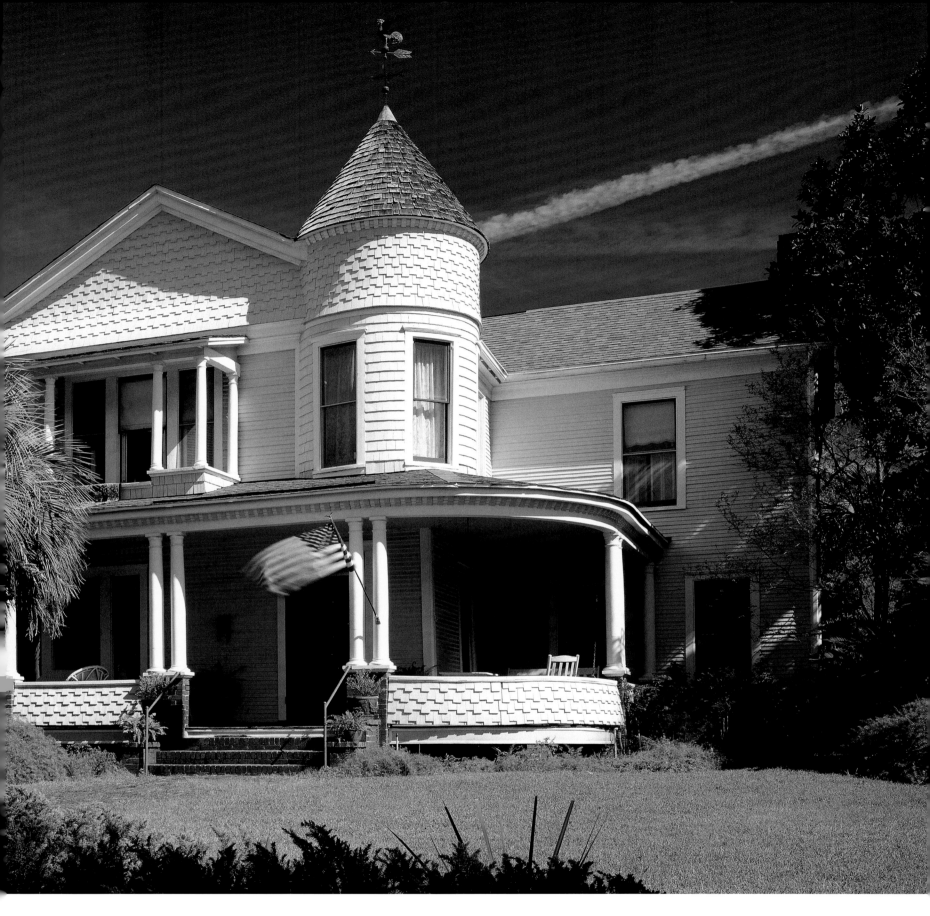

century. Neighborhoods like Fernandina's Silk Stocking District, part of the town's fifty-block historic area, represent a colorful return to the Victorian palette. One hundred years later, hotels and resorts rise once again around Fernandina. History repeats itself. Some of the area's most famous historic houses have taken on new life as bed-and-breakfast inns. Visitors know now, as they did a century ago, that within the island's thirteen-mile shoreline, a legend lurks under every palmetto bush.

The Archibald Baker House, c. 1850, is located in the Silk Stocking District.

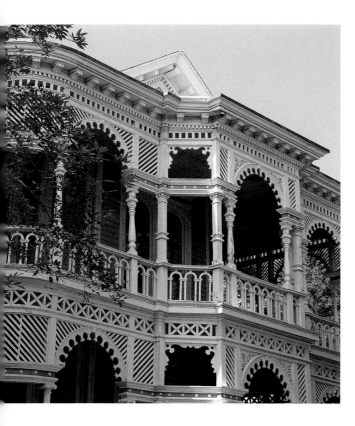

Galveston

TEXAS

Galveston Island is quintessential Texas, eager to please, ever ready to put on a good show, deeply mindful of its roots, and hospitable to a fault. But more than that, Galveston endures. After the worst natural disaster in the history of the United States, a hurricane in 1900 which devastated the island and killed six thousand people, residents rebuilt their homes and installed a ten-mile protective sea wall around their island.

Such a rich historical site deserves an impressive effort. Akokisa Indians occupied the island as early as the sixteenth century. In 1786 explorer Jose de Evia named Galveston Bay after Spanish Colonial governor Bernardo de Galvez. Pirate Jean Lafitte settled here

Galveston's fanciful approach to the late Victorian era gave birth to such treasures as the Jacob Sonnentheil House (above), 1887, and the exuberant Garten Verein Dancing Pavilion (right).

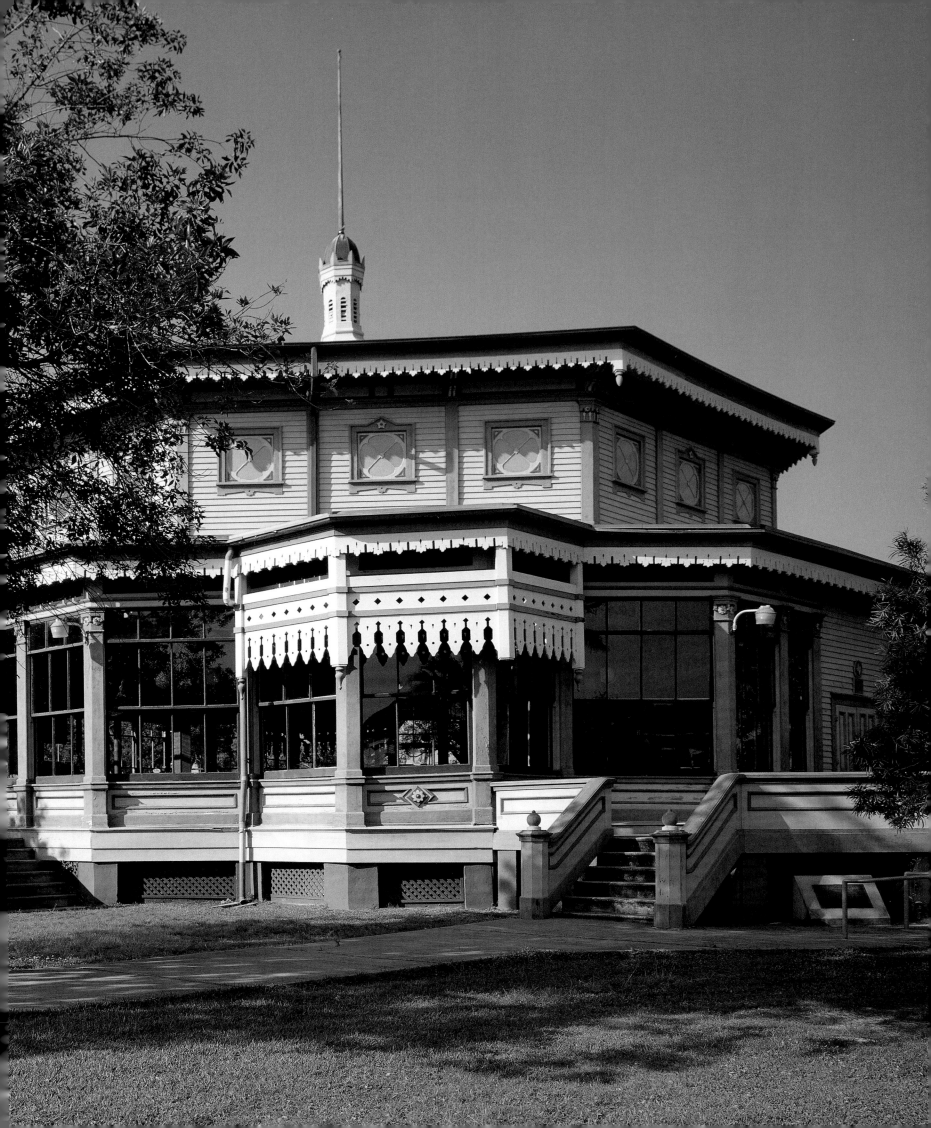

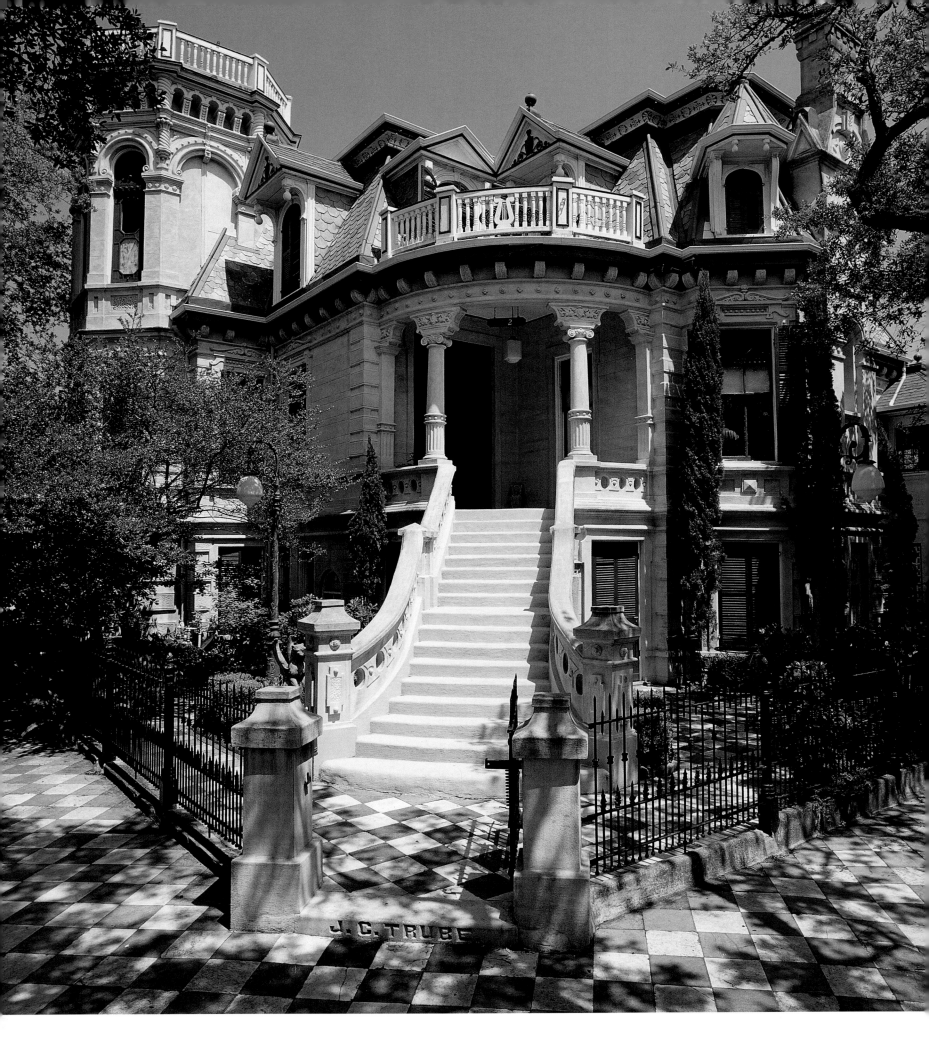

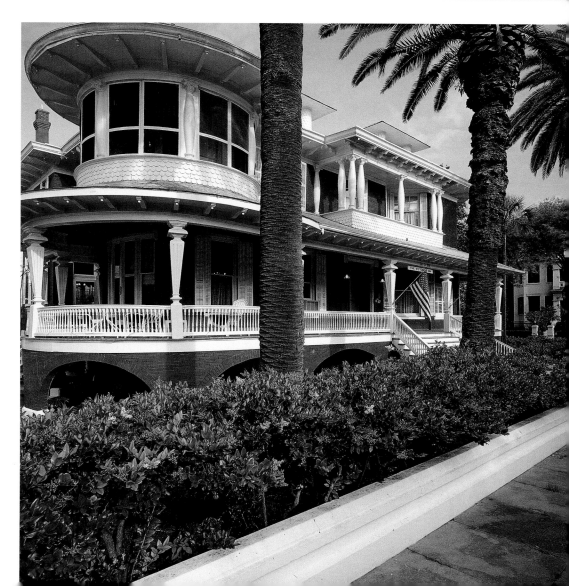

The John Trube House (opposite), *1890, is a Victorian memorial to its builder John Trube who envisioned European castles as his model.*

Palms outside the Isaac Heffron House (below right), *1900, remind travelers they are visiting a barrier reef island with 32 miles of Gulf Coast beaches. The Conness-Arnold House* (above right), *1899, survived the devastating hurricane of 1900.*

from 1817 until 1821, and the island played a pivotal role in 1839 when ships of the Texas Navy, headquartered on the island, prevented supplies from reaching the Mexican army, ensuring victory for Sam Houston's army at San Jacinto, 22 miles away.

That same year Galveston was established, and was made a port of entry a year later by the Congress of the Republic of Texas. Galveston's grand era of building began, producing a heady mix of styles including Greek Revival, Italianate and Victorian. Over 550 sites on this 32-mile barrier reef island are listed on the National Register of Historic Places. More than 1500 historic houses are located in the two historic districts, East End Historic District and the Silk Stocking District. The Strand National Historic Landmark District was considered the nineteenth-century "Wall Street of the Southwest," where wholesalers, cotton agents and shipping firms plied their trades. Today, along with the Post Office Street Arts and Entertainment Area, it is crowded with art galleries, restaurants, and antique shops.

Performing arts have also flourished here as well. The first opera house in Texas, the 1894 Grand Opera House hosted luminaries such as Lillian Russell and Sara Bernhardt who played to appreciative audiences. Later in the twentieth century, visitors to Galveston's

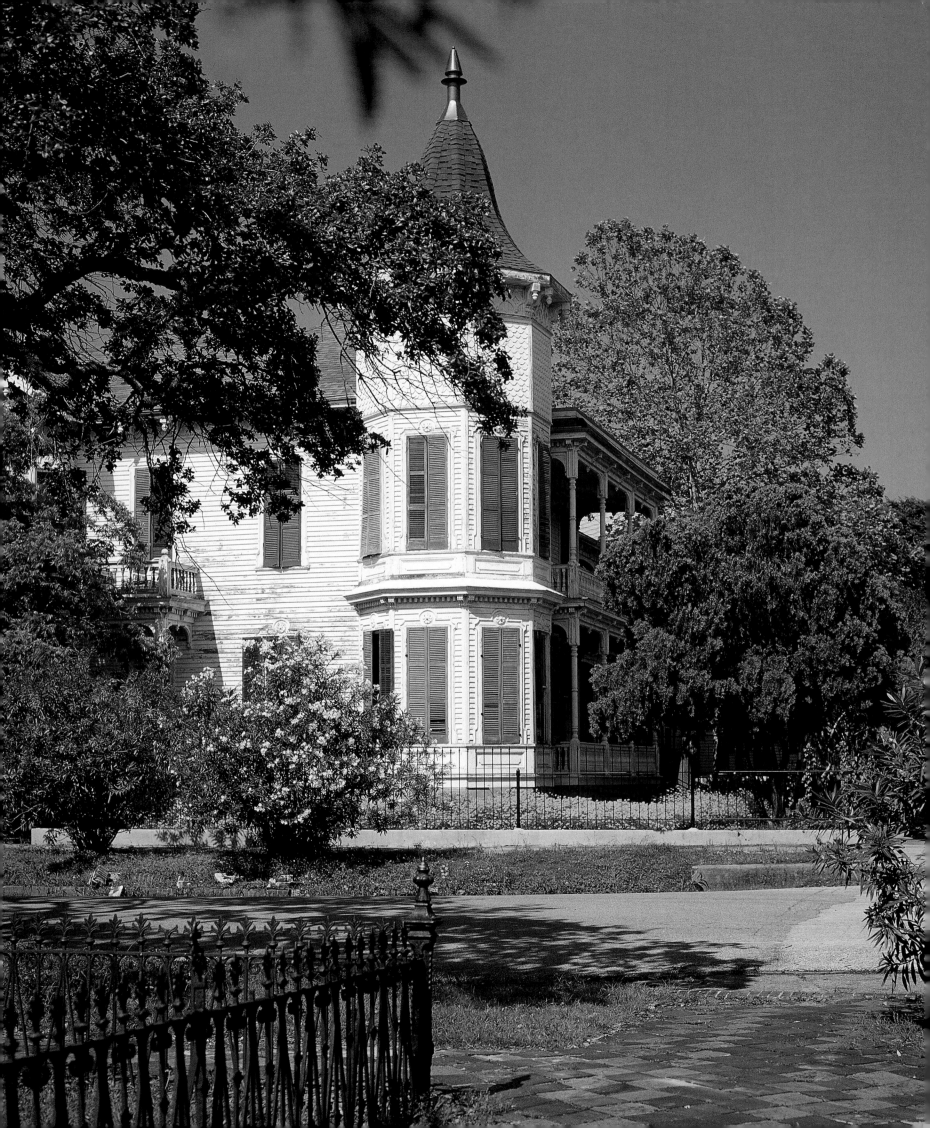

*I*ron fences surround many of the houses in Galveston's historic districts such as the Gustav Heye House (left) built in 1880.

*I*f there is a Galveston style, it is typified by the Lemuel Burr House (below), 1876, thought to have been the work of Nicholas Clayton, often termed Galveston's premier architect.

infamous night spots danced to the music of Guy Lombardo and Duke Ellington.

Today, though the jazz notes of Duke Ellington have long since faded, and Jean Lafitte's stay is only a footnote in history, Galveston remains adorned in Victorian gingerbread, blessed with constant Gulf breezes and magnificent architecture.

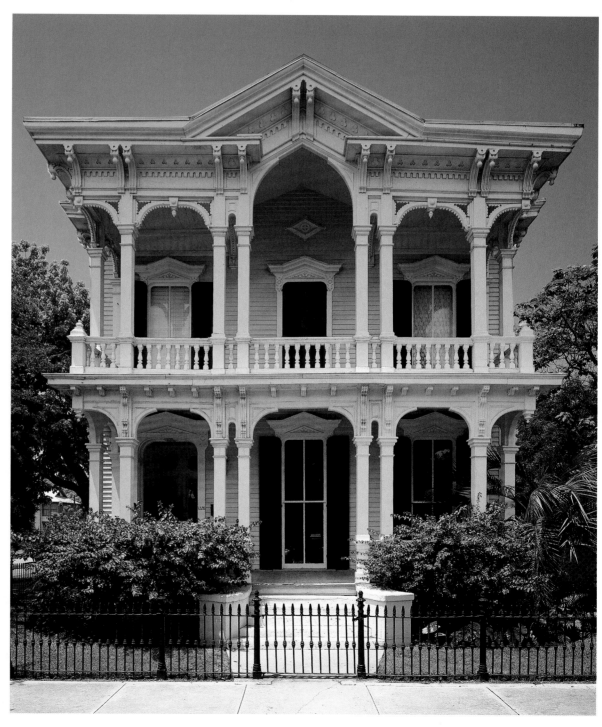

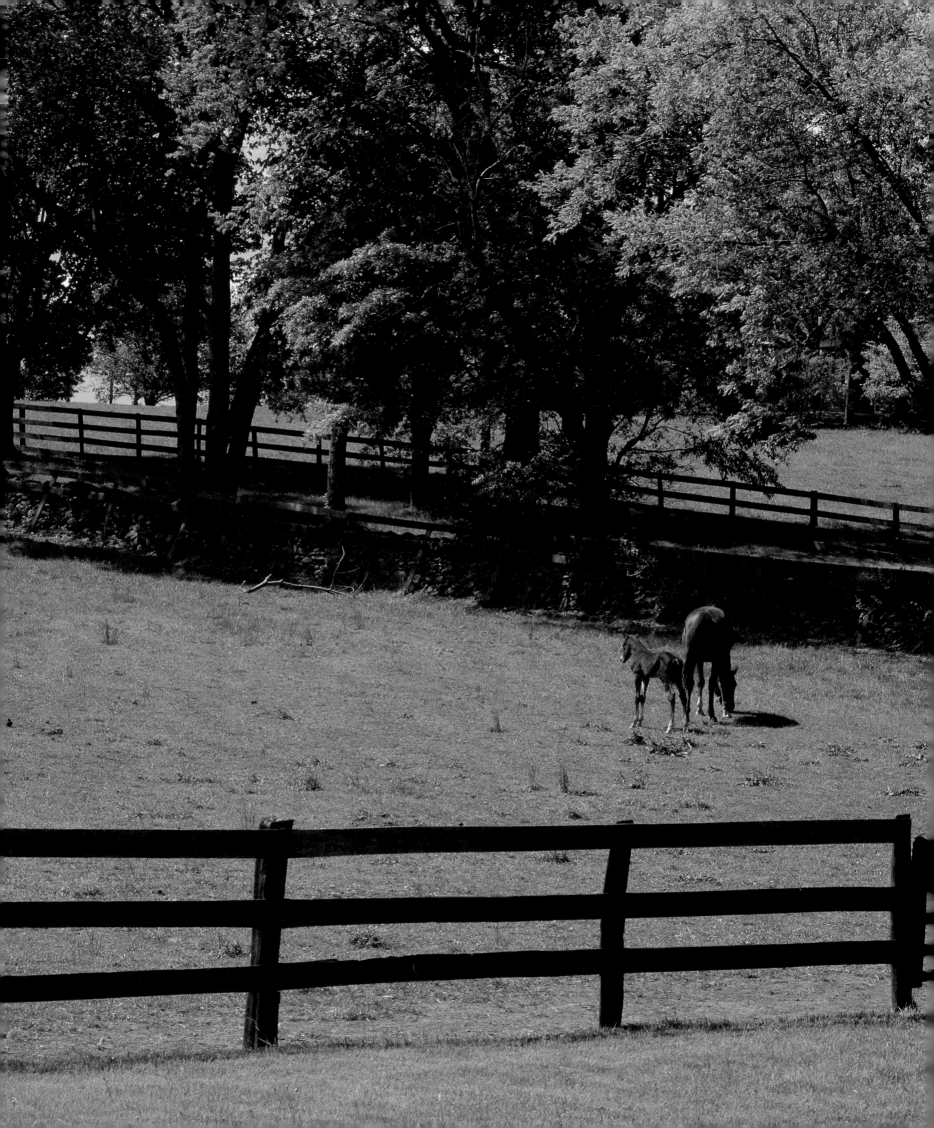

Horse Country

Horse Country

DARK OF THE MOON

Preceding pages *Rolling terrain and neat fences are typical in pastoral scenes of the horse country of Virginia near towns like Middleburg, Warrenton and Upperville.*

Horses at Rokeby and Paper Chase Farms (above and opposite below left) *rest before the arrival of visitors for the annual Hunt Country Stable Tour, held each Memorial Day Weekend to benefit Trinity Episcopal Church in Upperville, Virginia.*

Horses still traverse the highways of the South just as they did in the nineteenth century. Now, however, rather than laboring along on packed clay roads, they are transported in eighteen-wheel deluxe horse carriers pulled by diesel trucks. The warning "Caution: Show Horses" painted on the back of a horse carrier signals a van filled with American saddlebreds headed for the highly competitive horse shows in Lexington or Louisville, Kentucky. If you pass a van from Ocala, Florida, loaded with thoroughbreds, you can guess that the occupants will not be unloaded until their arrival at the race course at Saratoga Springs, New York, for the summer racing season. In South Carolina, a truck filled with thoroughbreds is undoubtedly headed to a steeplechase in Camden or up to the Virginia hunt country.

In the nineteenth century, before the Civil War, horse-racing was the only organized sport in America. A decade after the war's end, in 1875, the first Kentucky Derby was run in Louisville, and the Southerner's liking for good horseflesh has not diminished since. In many Southern villages and towns, good horses and dogs are important to the lifeblood of the community. And to some towns, such as Aiken, South Carolina, horses were, and still are, important to the town's economic success.

In Camden, the Carolina Cup and the Colonial Cup can draw as many as 68,000 fans to the race course in a weekend. There are parties such as the Colonial Cup Dinner at Camden's venerable old Spring Hall Club, where talk of the day's race goes on long after the finger bowls are cleared.

Down the road from Washington, Georgia, anticipation builds each fall before the opening of the Belle Meade Hunt Club. Whether you are watching the hounds gather on that first cool morning of the hunt season, or are one of the regulars at The Track Kitchen restaurant over in Aiken, you will most assuredly be talking horses.

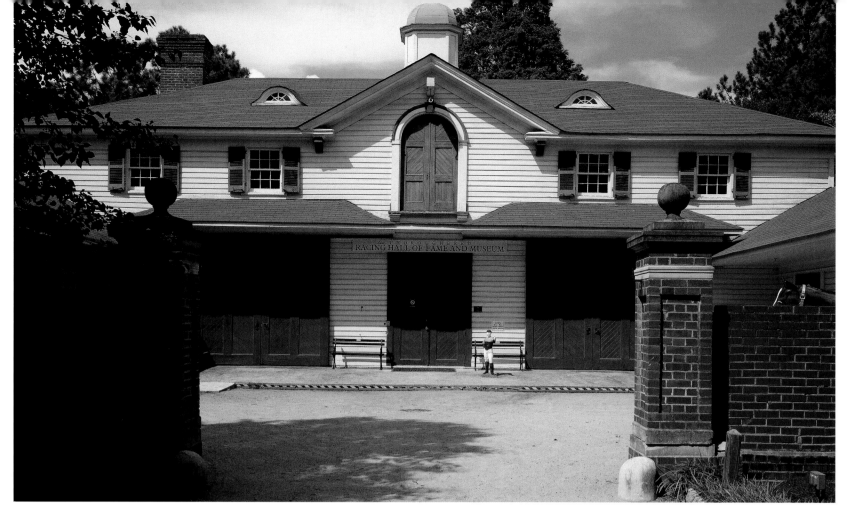

*T*he old stable at Hopeland Gardens (top) in Aiken, South Carolina, is open today as The Thoroughbred Racing Hall of Fame, featuring horses trained in Aiken which have distinguished themselves nationally. Jan Neuharth, owner of Paper Chase Farms, prepares for a ride dressed in traditional equestrian attire with silk top hat and veil (above).

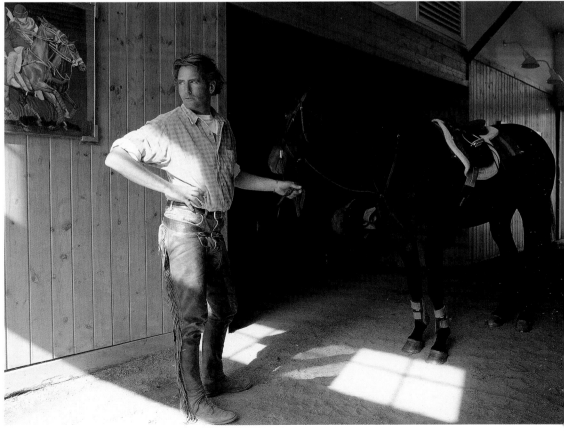

*B*arns such as these at Blue Ridge Farm (opposite above) *are famous throughout the hunt country for their architectural details like the twin cupolas. Also characteristic of the horse country are the miles of fencing that line the countryside of Virginia. It is, however, the horses and everyone associated with them which give this country its special glamour: Snowden Clarke (opposite below right)* is both owner and a trainer at Rock Ridge Farm in Virginia.

*T*he signs of horse culture are everywhere. Occasionally a visitor to a rural barn (above) *like this one in St. Francisville, Louisiana, will still find a carriage parked inside. Log jumps for a cross-country course* (right) *are set up at Paper Chase Farms near Upperville and Middleburg.*

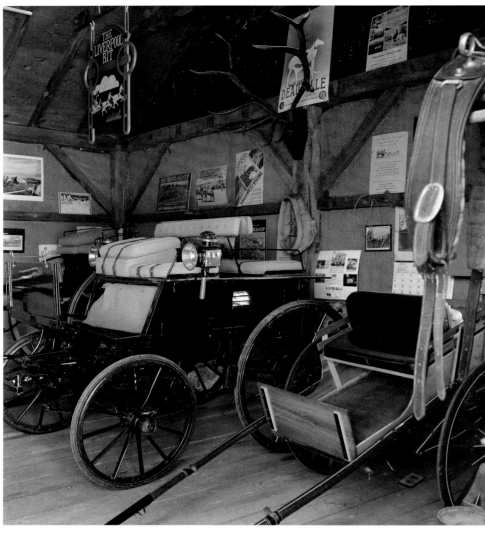

*T*he collection at Heathfield (left), *near The Plains, Virginia, includes a carriage made in England by Codington and a two-wheeled tandem gig made by Healy, both c. 1900. Charles Matheson (left below), owner of Heathfield, is ready to take over the reins for an afternoon drive in traditional coaching attire.*

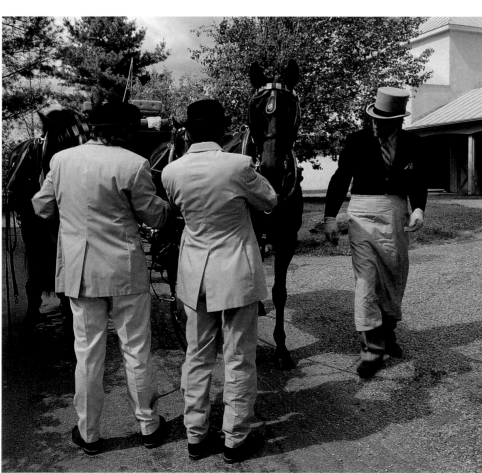

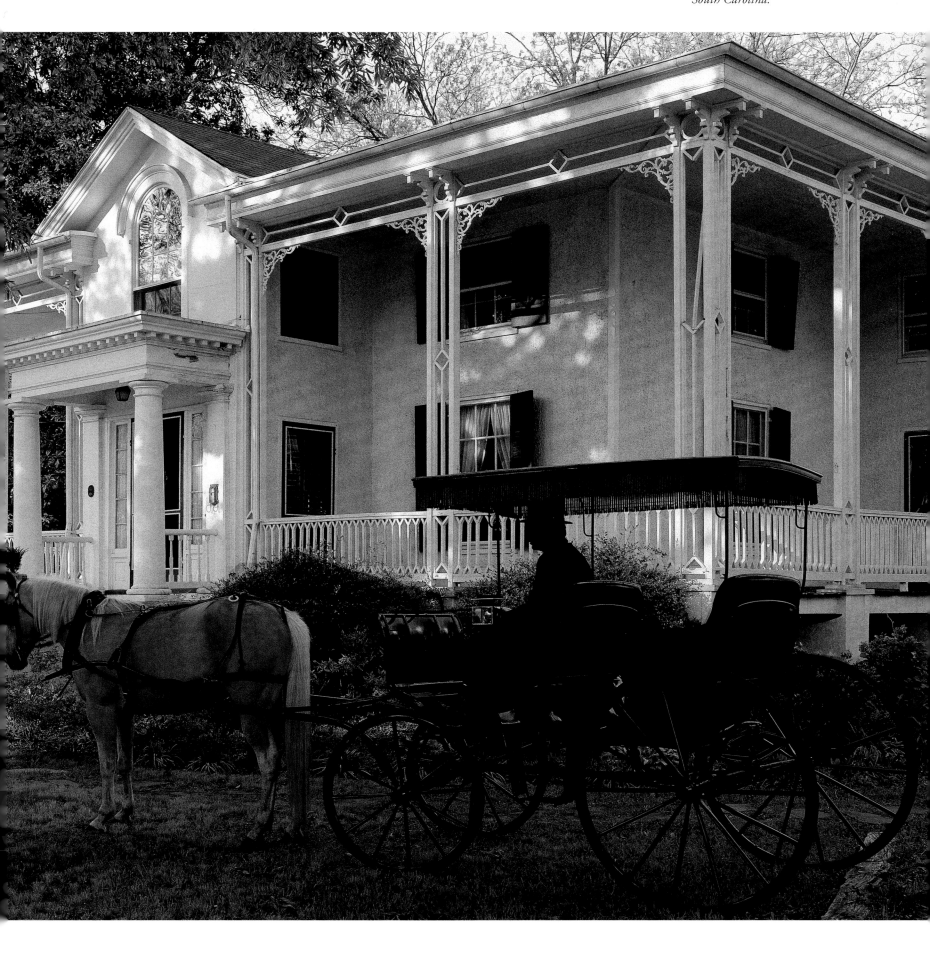

THE PIEDMONT

Thoughts of the Piedmont South, those rolling fields at the foothills of the Southern mountains, conjure up notions of planter aristocracy, Revolutionary War stories, and historic districts rich with imposing houses. These towns have traditionally been seats of education and civilization, and their residents are not likely to forget one embroidered truth of the rich fabric that sets the Piedmont aside from other regions in the South. Generally settled by the English, Scots, Irish, Germans, and French, the towns of the Piedmont continued to flourish long after the forests of hardwoods and pine had been cleared to make way for agricultural fields.

In the late 1700s and early 1800s, Federal-style architecture found favor in the Piedmont, with brick and fanlights becoming as popular in the South as they were in New England. But the Piedmont also gave birth to its own trademark style of architecture, the Plantation Plain house. The late John Linley, a Southern architectural historian, described the Plantation Plain style as a two-story, one-room deep, wooden plantation house with clay or brick chimneys. Found in both country and town, this simple style was sometimes called Carolina I.

By the mid 1800s, Greek Revival and Victorian styles were finding widespread popularity in the Piedmont. The cotton-rich residents of the Piedmont were as quick to build the great pillared white mansions as were their wealthy counterparts in the rich river bottom lands of Louisiana and Mississippi.

Piedmont towns today take pride in their architecture which is listed in countless National Register Districts, often laboriously documented and nominated to this distinguished status by well-intentioned local preservationists who realize that the preservation of these houses provides each generation a connection to its roots. Allen Kitselman, an architect in Waterford, Virginia, articulates most Southerners' strong sense of place, "These old houses are the DNA of a community's history."

The earliest section of the Hague-Hough House (opposite) was built in 1745. Now restored, the house stands in 75 acres outside of Waterford, Virginia.

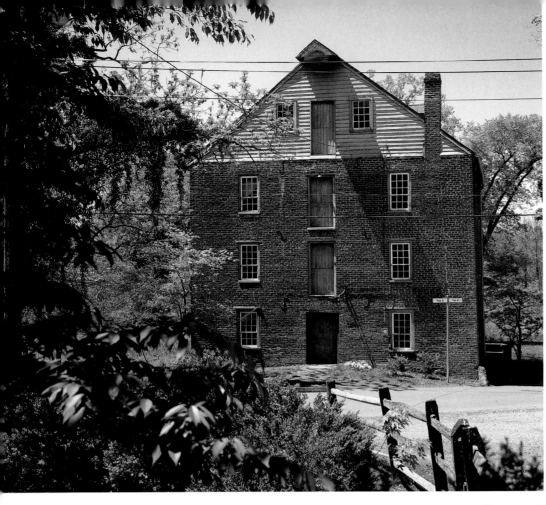

A mill, a smokehouse, and a potting area (this page) are only a few of the many historic vignettes that enhance the Annual Tour of Homes and Crafts Exhibit in Waterford each October. Heritage crafts are offered for sale and demonstrations of lost arts such as Windsor chair-making, hand-weaving, floor-cloth-stenciling, and pewter-casting are given at what is considered the finest heritage crafts fair in the nation.

Waterford
VIRGINIA

"TIS A GIFT TO BE SIMPLE," says the old hymn, and the gift endures in Waterford as it does, perhaps, nowhere else in America. Wells still provide the only source of water, and the village is comfortably enclosed by woods and fields. Founded in 1733, this tiny village in Northern Virginia was established by members of the Quaker religion who were followed by Scots-Irish settlers.

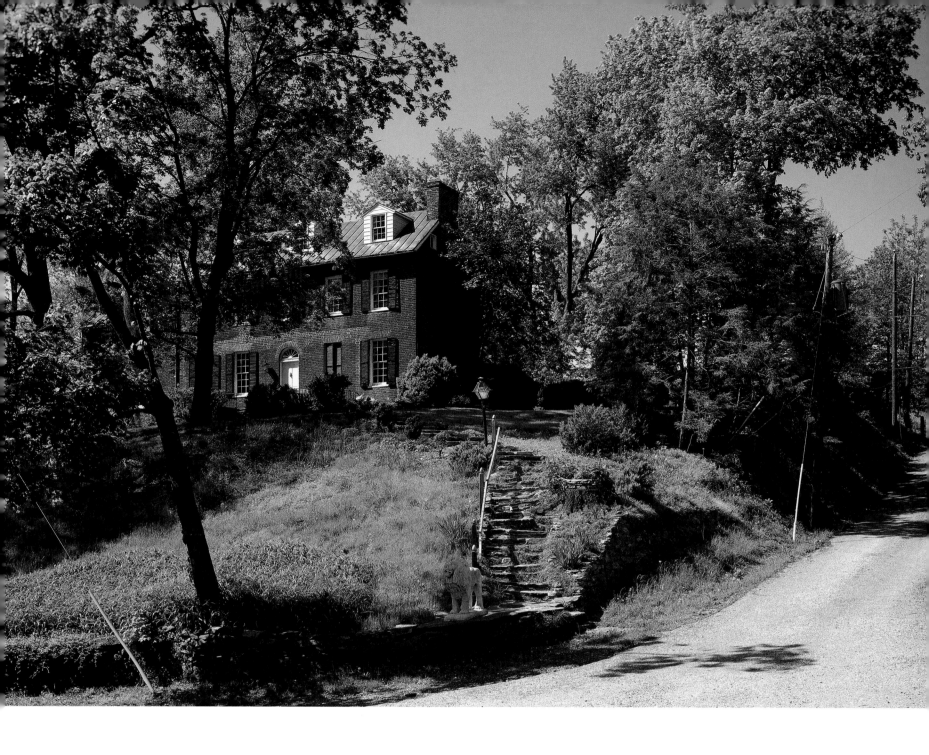

The current population of 200 basks in what could never be created or designed today. A village like this could only evolve over two centuries. In 1757, Quakers bought ten acres and built a meetinghouse, known as the Fairfax Meeting. Their austere religious beliefs affected all forms of village life. Early household inventories reveal few decorative items. Even after 1929, when the Meeting was "laid down," as the Quakers quaintly say, the simple way of life continued in Waterford.

One of the oldest community preservation groups in the country, the Waterford Foundation was founded in 1943. That same year, the group held its first fair, now acknowledged as one of the finest heritage crafts fairs in the nation. The Annual Tour of Homes and Crafts Exhibit has on view, aside from the town's architectural gems, Windsor chair-making, pewter-casting, floor-cloth-stenciling, and a myriad of other bygone crafts.

Waterford's designation as a National Historic Landmark District elevates it to national significance along with such other American architectural treasures as Thomas Jefferson's Monticello and George Washington's Mt. Vernon. Waterford also has retained one of the

A classic Federal-style house, Mill End (above) *was built in 1841 as a home for the mill's owner.*

Overleaf The village green is called the "countryside surround" in Waterford. It is one of America's best examples of nineteenth-century vernacular landscapes.

Catoctin Creek (above), built between 1810 and 1816, is one of the oldest houses in an area of Waterford dubbed "New Town." The James Moore House (left) was built in 1805 with exterior walls of rubble stone found in so many of Waterford's structures.

nation's best examples of eighteenth- and nineteenth-century vernacular landscapes. It has also maintained its green belt, or as it is called in Waterford, the community surround.

The people of Waterford today enjoy living in a village that resists the encroaching environment of fast-food marquees and strip shopping centers. As Waterford embodies it, there is a great deal to be said for the simple village life.

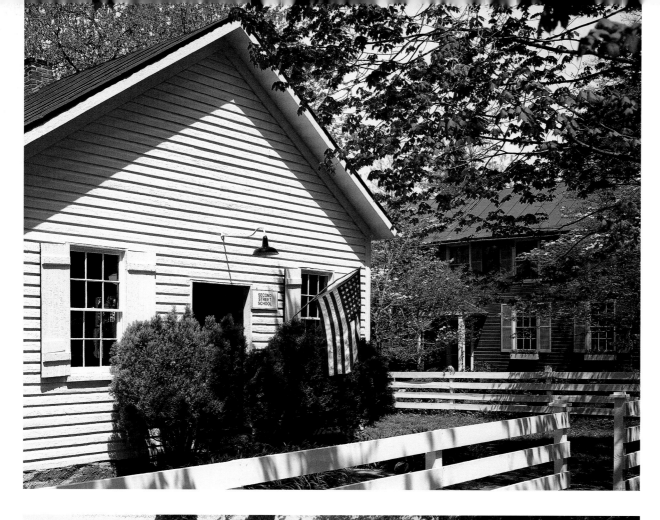

The Second Street School
(left) opened its doors in 1868
and until 1957 was a school for
African-American children.
A reenactment of an 1880s school
day is held each year during the
heritage crafts fair.

The use of Flemish bond brick
above the stone in the James
Moore House (left) is typical of
Waterford's early construction.

York

SOUTH CAROLINA

YORK, SOUTH CAROLINA, was still a stagecoach cross-roads, near Kings Mountain, when the British redcoats lost a turning-point battle to Southern frontier Revolutionaries in October of 1780. By that time, the area had been settled by Scots-Irish families from Pennsylvania for more than thirty years.

Today, York is one of the historic communities in South Carolina's Olde English District and is a show-case of Southern architecture ranging from antebellum to Victorian and twentieth-century revival styles. The nineteenth-century economic success of the South's Piedmont towns resulted in a proliferation of beautiful

residences, either town houses for wealthy planters or main residences for the captains of industry and com-merce who shaped the town's future. In the twenty-first century these towns claim some of the largest historic districts in America, but few equal the size and number of York's with 340 acres and over 180 sites listed on the National Register. York is fortunate to have an example of architect Robert Mills's work. Mills, recog-nized as one of the nineteenth century's greatest American architects, designed the Federal-style jail in York in 1823.

Like its Piedmont neighbors, York's colorful his-tory, that of its houses and of their occupants, is

The front façade (opposite) and rear view (left) of the Brandon House, built in the 1850s as a residence and later used for commercial space on the first floor with living space upstairs.

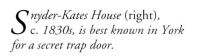 *nyder-Kates House (right), c. 1830s, is best known in York for a secret trap door.*

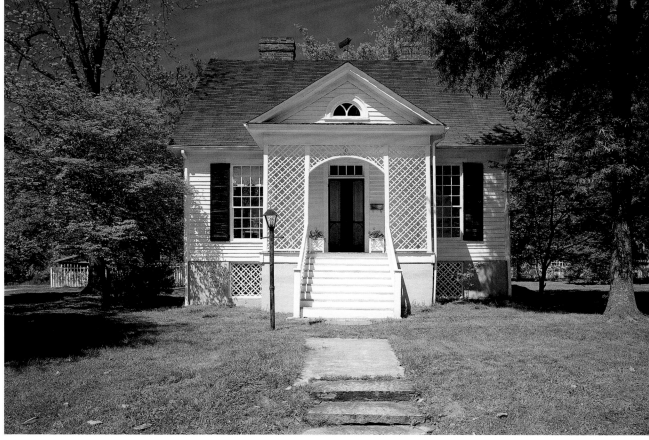

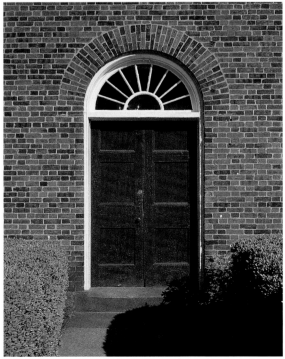

These three buildings in York exemplify the adaptive use of historic structures: the old Train Depot (above) now houses the Chamber of Commerce; this door (left) opens the Jail-Wilson House, now commercial space; and the Latta House (opposite), built in 1824 as York's finest residence, is now a place of business.

recorded in charming detail in a small booklet published by the Historical Society entitled *The Historic District Walking Tour*. Along with professionally written architectural descriptions and accounts of the area's vivid and impressive history dating back to the Revolutionary War, are the bits of ephemera that reveal Southern narrative at its finest. A visible crack in the Latta House, 1824, is a legacy of the 1886 Charleston earthquake. The existence of a "prophet's chamber" for visiting ministers to use as their quarters is decribed in the account of another nineteenth-century house. The tale of a house made of bricks once used as ballast on ships en route from England to Charleston is depicted. And would it be a Southern town without at least one house claiming to be the model for "Tara" in *Gone With the Wind?* York, entrenched in the rich history of the Piedmont, is also immersed in the eccentricities that Southerners love and appreciate.

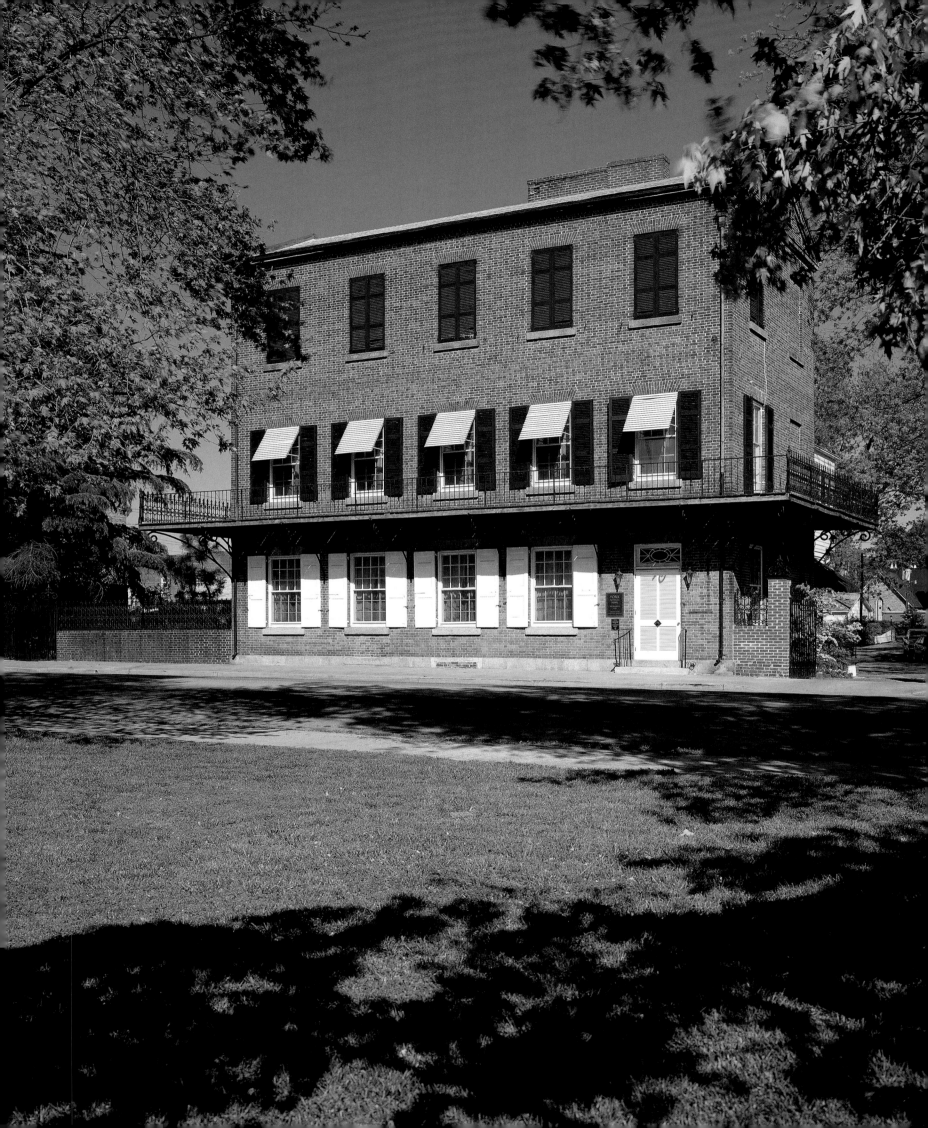

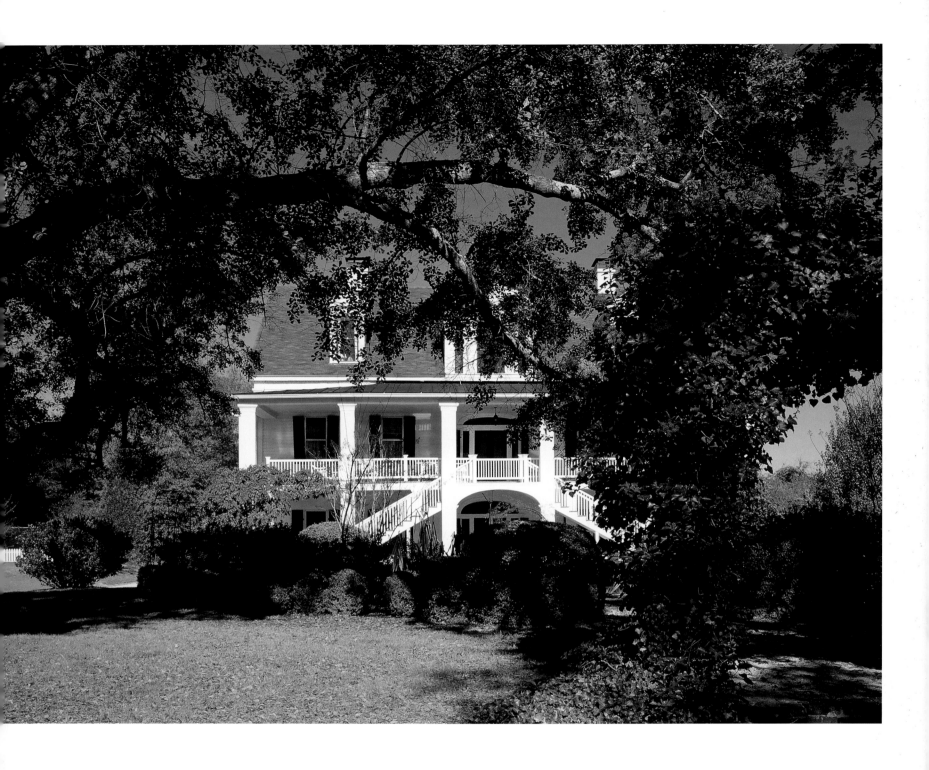

Camden
SOUTH CAROLINA

Since 1732, Camden has been the focal point of South Carolina's Olde English District. It is named after Lord Camden who had been a defender of colonial rights in the English Parliament, and in the 250 years since its beginning quite a few famous names have been dropped in the town. Illustrious Revolutionary War soldier General Nathanael Greene and his troops faced British forces outside Camden. George Washington, during his tour of the South in 1791, visited this oldest of the inland towns of South Carolina. The Marquis de Lafayette stopped by on his legendary American trip in 1825. Robert Mills designed Camden's courthouse and its Presbyterian

Horsebranch Hall (above), c. 1840s, is a large raised cottage which exhibits the coastal influence found in much Camden architecture. The wisteria garland framing Kamschatka's porch (opposite) is typical of Camden houses.

Fairhaven's gates are an ornate Charleston accent amid the simplicity of the house's Plantation Plain style exterior.

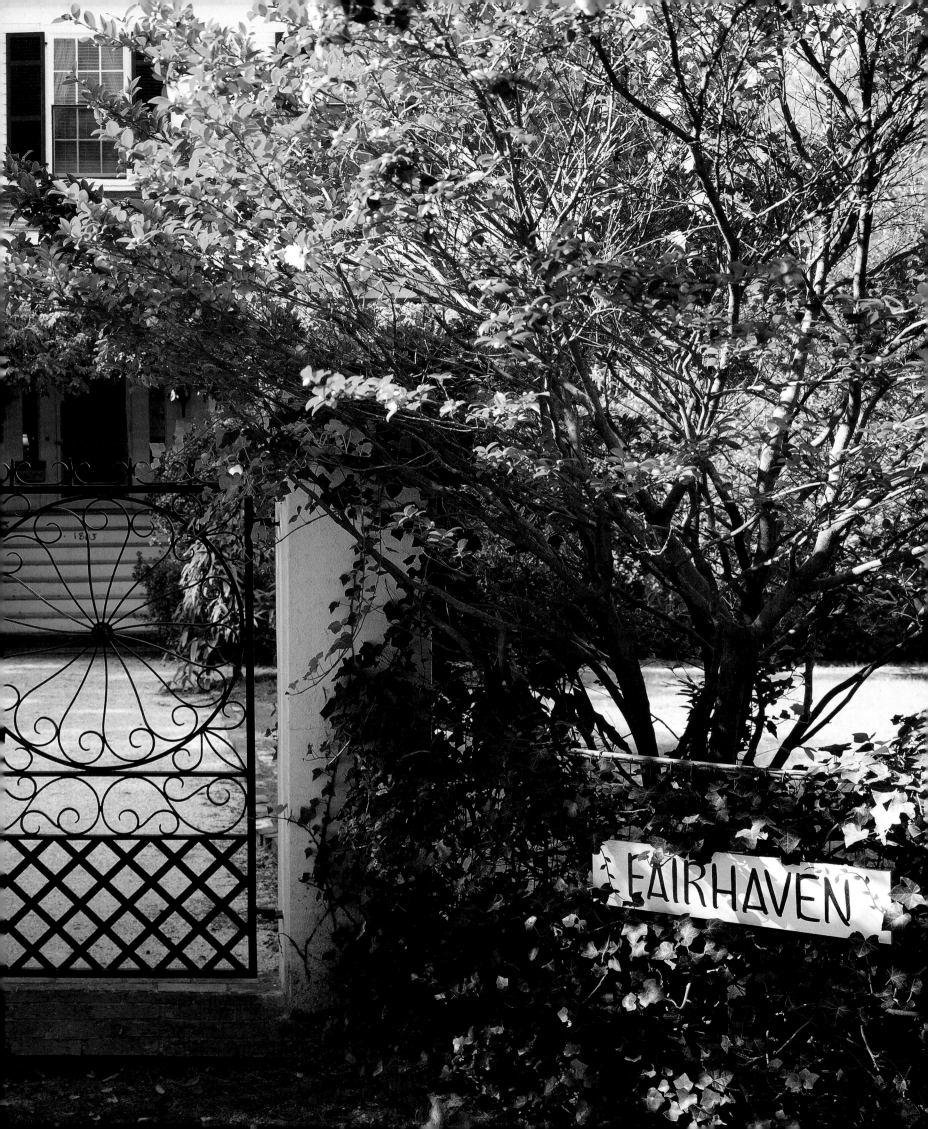

Church. Mary Boykin Chesnut wrote parts of *Diaries from Dixie*, the acclaimed Civil War chronicle, while staying at Mulberry with her in-laws during the war.

All of these noteworthy people, like the people of Camden, carried on their business among some of the South's greatest architectural achievements. Of particular interest to visitors, the South's Plantation Plain style of architecture is illustrated in Camden by two examples, Fairhaven, 1842, and Tanglewood, 1831. This style was popular in the South between the 1820s and 1840s, and is usually located in the Eastern seaboard states of the Piedmont South.

Camden, like Aiken, South Carolina, experienced an economic rebirth after the Civil War with the arrival of Northern visitors to participate in the abundant sporting life which flourished in the temperate climate. As in most Southern villages, good dogs, horses,

and an occasional round of golf are important to the lifeblood of this community. Camden's legendary Springdale Race Course hosts the Colonial Cup each November and the Carolina Cup in the spring.

Camden's inescapable sense of history frames the town and is as tightly woven around its city limits as the gnarled wisteria garlands which are entwined around so many of Camden's front porches.

*M*ills's courthouse (below), *owned by the Kershaw County Chamber of Commerce and built in 1826, was designed by Robert Mills, acknowledged as one of the most successful architects working in America from 1820 until 1850. Tanglewood (right), 1831, is an excellent in-town example of the South's popular Plantation Plain style of architecture, usually found in the rural countryside.*

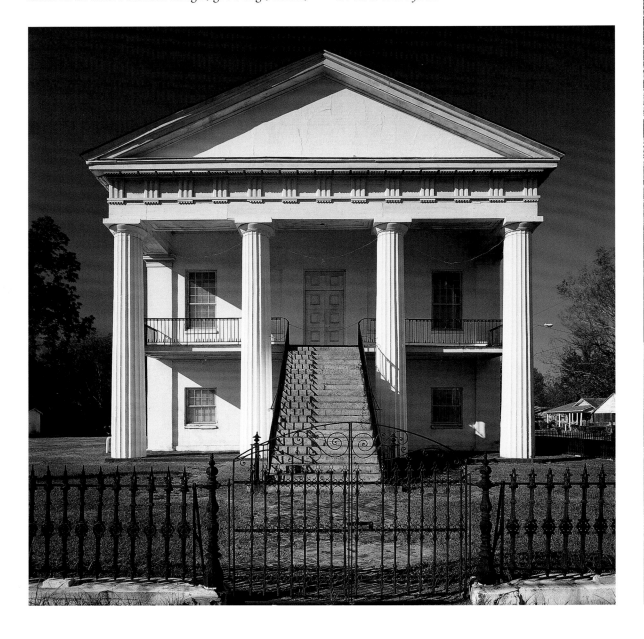

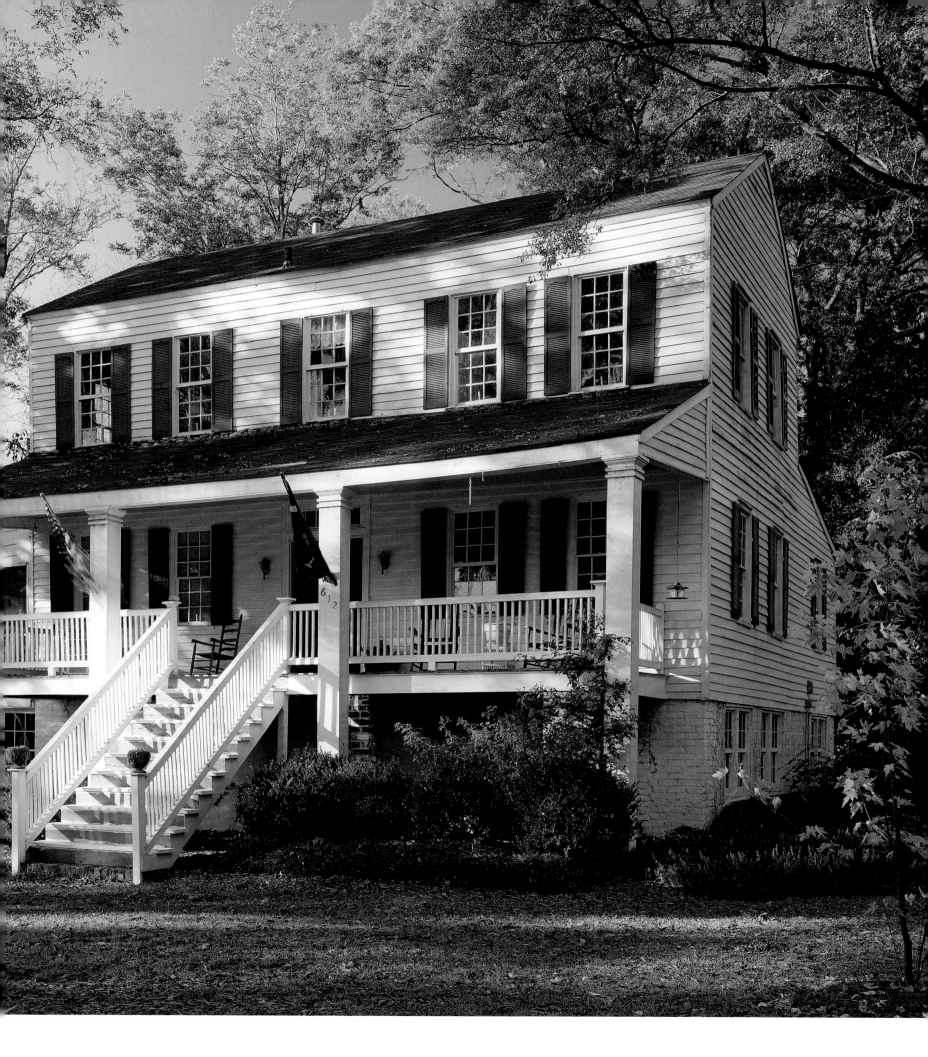

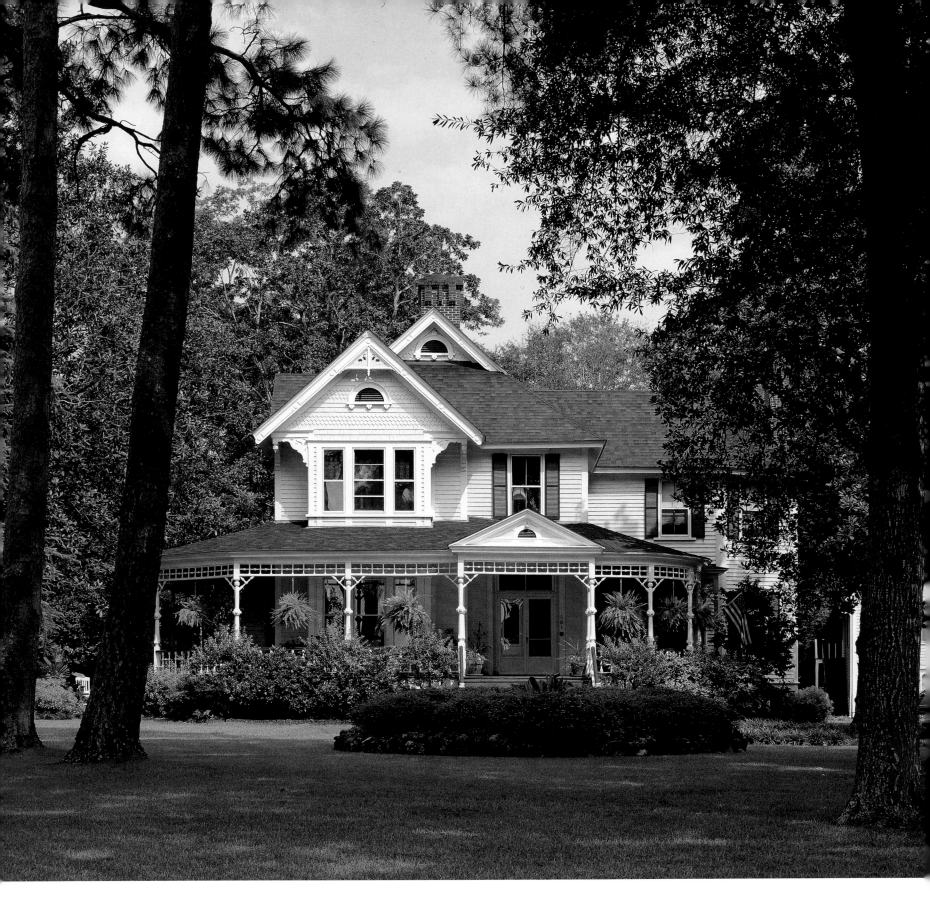

Aiken

SOUTH CAROLINA

WHILE ZELDA AND SCOTT FITZGERALD were jumping in and out of fountains in New York, the Eastern seaboard's equestrian set discovered Aiken, a small town in the gently rolling and wooded Sand Hill District of South Carolina. Founded in 1835, Aiken's rebirth began when the "winter colony" first visited it around the turn of the century. The Easterners purchased homes in Aiken and, with their horses, traveled by railroad, settling in for a five- to seven-month holiday each winter.

Aiken had long been known by South Carolina's low-country residents for its peaceful and restorative

winters. The winter colony, however, discovered a terrain that lent itself to polo matches, drag hunts, steeplechases, and leisurely afternoon rides through the town's two-thousand-acre park, Hitchcock Woods. Horse activities in Aiken took precedence over the excellent golf courses, squash and tennis courts.

Victoriana (above left), 1888, is representative of Aiken's large Victorian district. Hopeland Gardens (above), now a 14-acre public garden, was once the site of a grand house built in the heyday of winter colony migration, when wealthy Northern sportsmen flocked to Aiken to enjoy the mild winters.

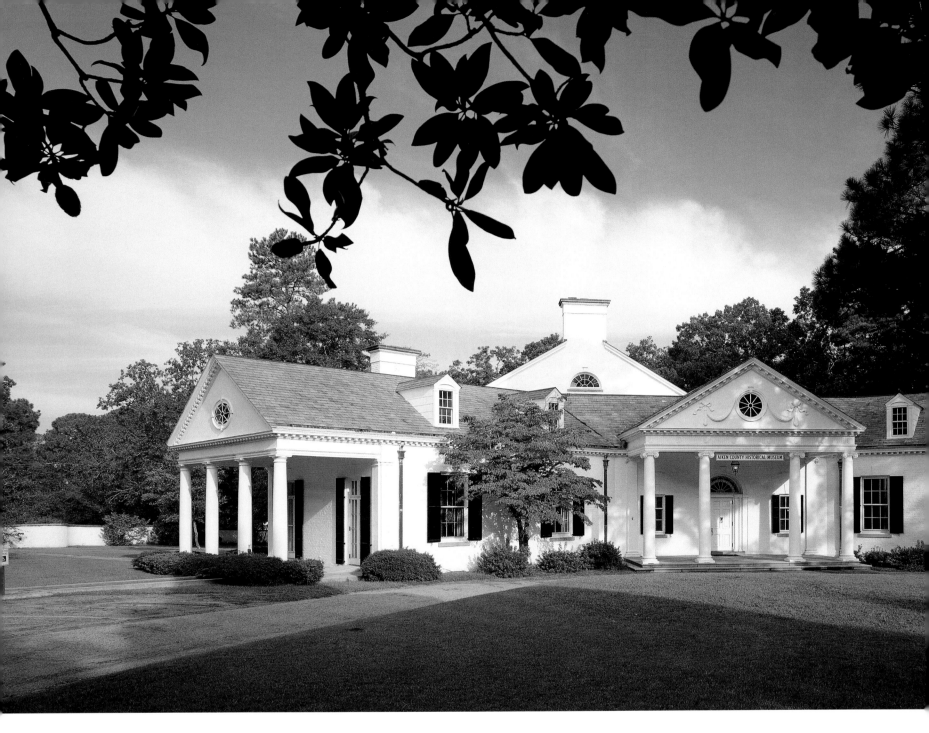

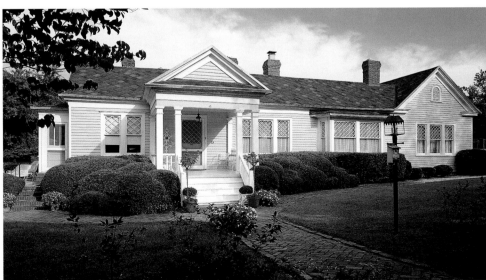

*P*art of Banksia (above) *is over 150 years old. This once small house ended up with 32 rooms and a ballroom large enough to house the Aiken County Historical Museum, open there now. Uncle John's Cabin (left), 1925, is two houses joined together. The house was built around a small house where "Uncle John," one of Aiken's greatest cooks, lived.*

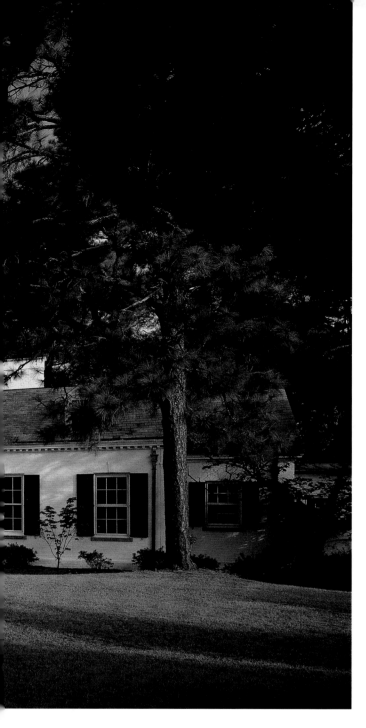

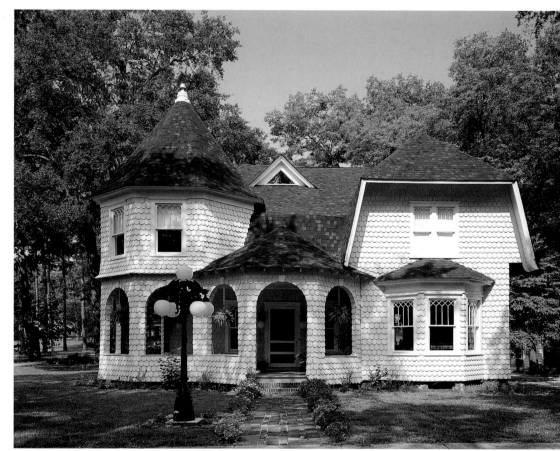

*T*he siding on Hill House (below) *is in the fish-scale pattern popular during the Victorian period.*

*T*his delicately restored one-story cottage *(foot of page), known as the Legare-Morgan House, was built in 1837. Today, it houses Number Ten Downing Street, one of Aiken's favorite restaurants.*

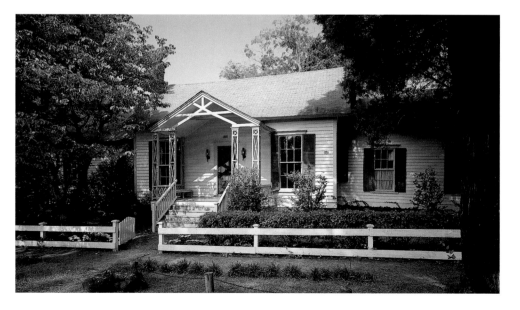

An intricate labyrinth of unpaved streets remains today in Aiken, making it one of the most horse-friendly places in America. Like a clay ribbon, these unpaved lanes tie together the polo fields, the residential areas, the training track, and Hitchcock Woods, creating a dusty equine legacy that Aiken's residents cherish.

When Aiken's grand old hotels could no longer hold all the visitors from Chicago, Long Island or Boston, a surge of home building began. Just as the winter colony brought their horses, they also introduced their housing styles. Thus, Mediterranean, Dutch Colonial and Colonial Revival houses soon dotted the local landscape.

Today, events like the Triple Crown Horse Races still draw horse-lovers to Aiken, and lovers of venerable old houses visit each March for the tour of homes hosted by St. Thaddeus Episcopal Church.

With it all, Aiken, fortunately, has never lost its sense of self. At the track, owners, grooms, and trainers still gather in the early morning mist to watch the horses during an early morning workout. And the old houses ring the fields, trails and track, standing like silent sentinels, awaiting the next arrival of yearlings from the sales at Saratoga and the people who follow the horses.

*O*nly *the iron gates and a few original outbuildings* (below) *remain at the site of the old W.R. Grace estate after fire consumed the house. Today the magnificent gates frame a new house. Palm trees growing on the lush grounds of Rose Hill* (right) *are indicative of Aiken's mild, sympathetic winters.*

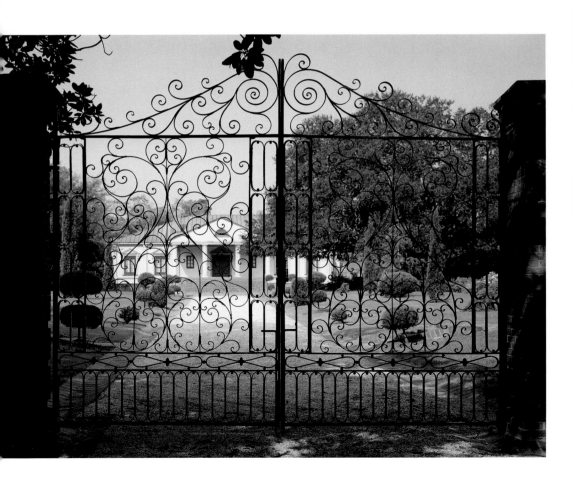

Athens

GEORGIA

RENOWNED FOR A WEALTH OF historic architecture, particularly in the Greek Revival style, Athens has been home to the University of Georgia since 1785. On a hill overlooking the Oconee River, the university's first professors lectured in the open air beneath the trees where Cherokee and Creek Indian tribes had once hunted. Not until the 1820s, when the building of the campus began in earnest, were the dignified structures that now grace the university's historic North Campus completed.

From the beginning a bond existed between town and gown. And today the town seems as comfortable with the world of academe as it is with its own aristocratic air which persists from one generation to the next. Historian Francis Butler Simkins writes in

The University of Georgia's oak trees (right) *offer shade for studying on the lawn or for tossing a frisbee.*

Athens' notorious and extremely unsuccessful double-barrel cannon (below) *sits contentedly today among the flowers on the lawn at City Hall.*

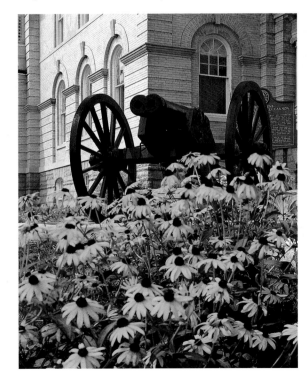

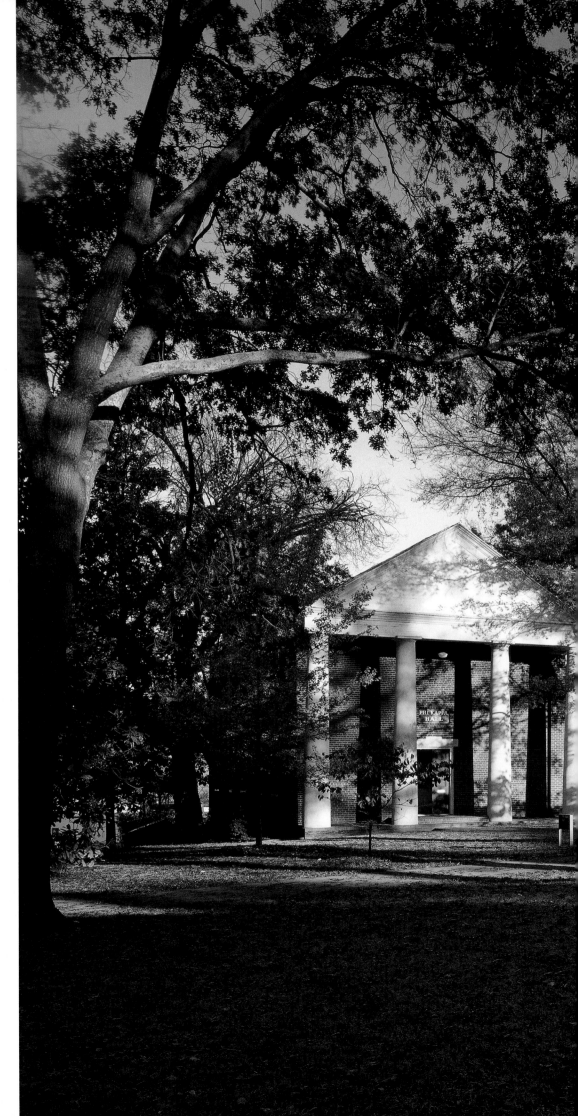

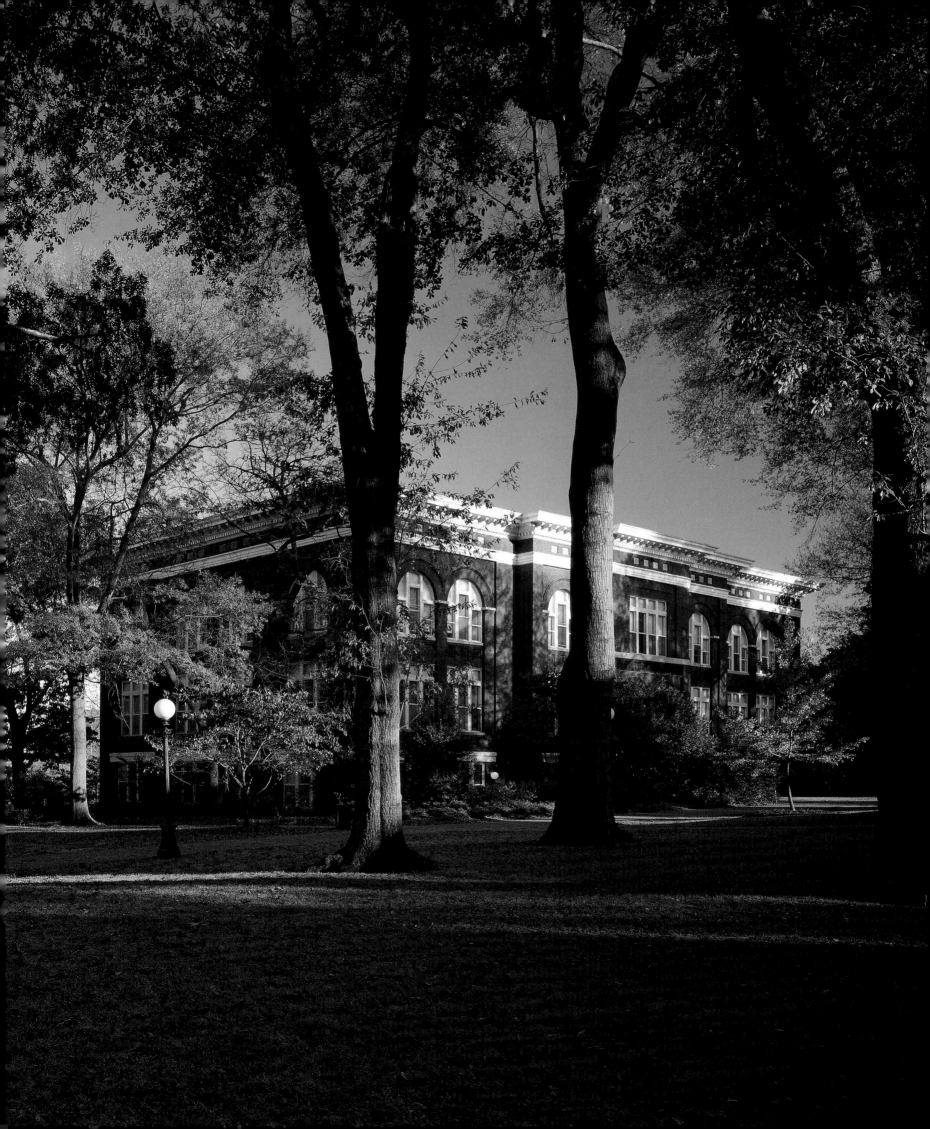

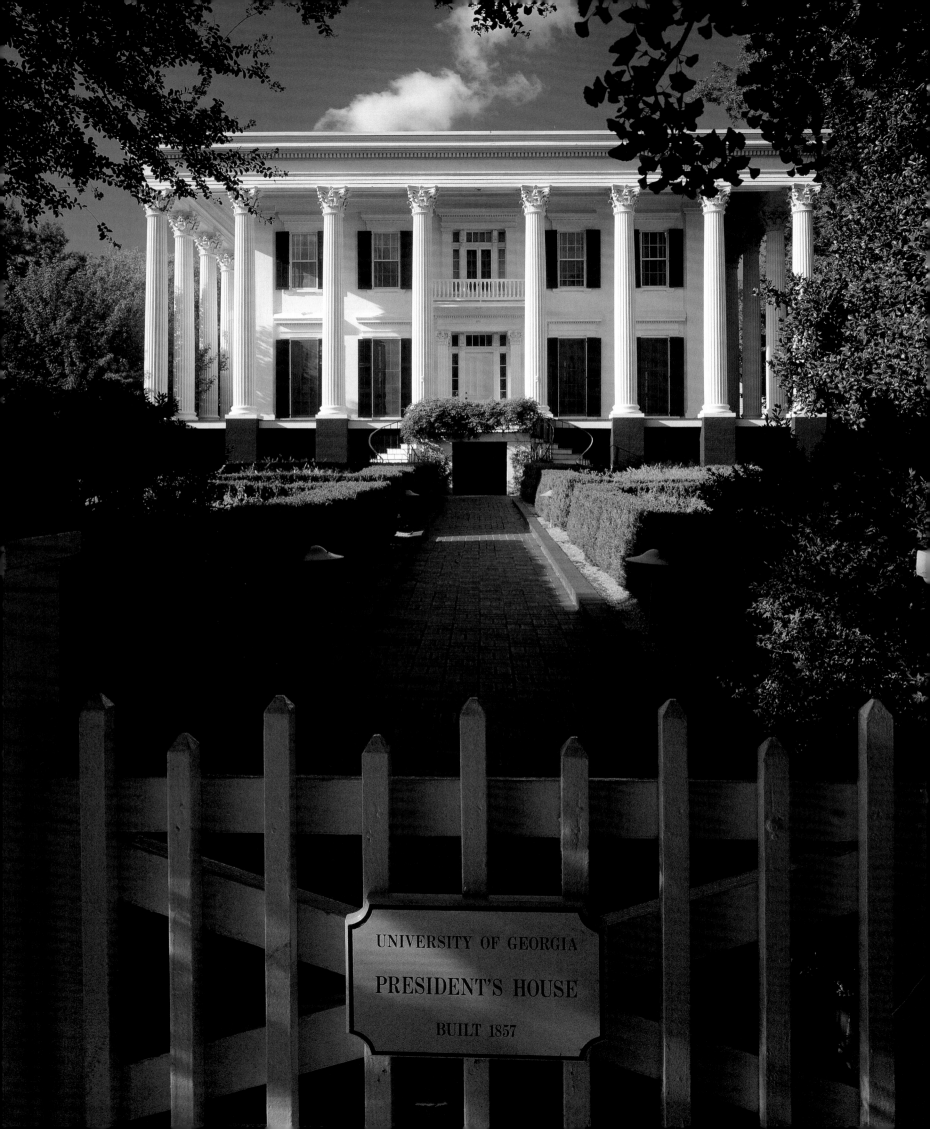

UNIVERSITY OF GEORGIA

PRESIDENT'S HOUSE

BUILT 1857

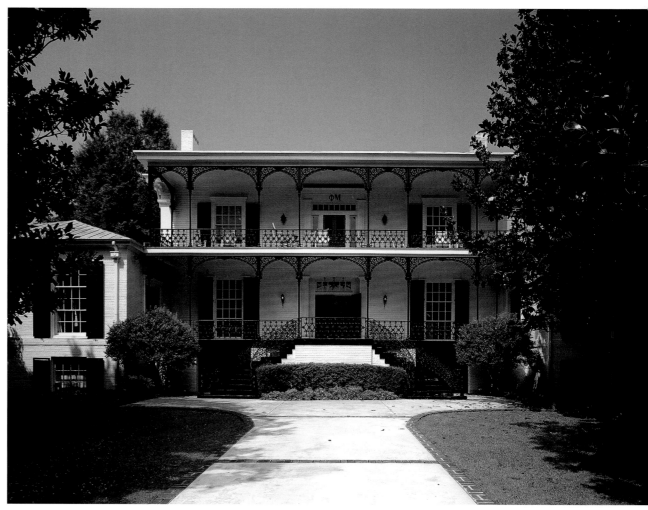

*T*he old and the new live comfortably beside one another in Athens. The University of Georgia's President's House (opposite), 1857, is considered one of the finest examples of Greek Revival architecture in America. The Hubert Owens House (above right), built in 1941, incorporates architectural details from earlier Athens' houses that were destroyed, including such elements as the sheaf and wheat porch railing across the front of the house. The venerable Phinizy-Segrest House (right) is now home to the Phi Mu sorority at the University of Georgia, one of Athens' numerous historic houses along Milledge Avenue occupied by Greek organizations on the campus.

The History of the South, "Those who set the standards of Southern society congregated in many cities other than Charleston and New Orleans." Athens, and nearby Washington, Georgia, were cited as inland examples of gracious behavior in the early nineteenth century.

Athenians, says local historian Milton Leathers, have always thought of themselves as "citified folk" in the middle of a huge agricultural section of Piedmont Georgia. Even today, Athens straddles a fine linguistic line between the small-farm hill-country accent and Southern plantation speak.

The bond between town and gown continues today. Fraternity and sorority banners flutter across the columns of Greek Revival houses on historic Milledge Avenue. Law, medical and financial firms move into houses where captains of industry once lived and preserve them for another generation to admire. Students and alumni gather to watch the Georgia Bulldogs football team play at Sanford Stadium or attend a concert by one of the many famous bands like R.E.M. or the B-52s that earned Athens its national musical reputation in the 1990s. Through it all that air of relaxed civility is as present as it was in 1785.

The Donald-Epting House (below *and* right), c. *1800, was moved to Athens from South Carolina and restored to the simple beauty of the Plantation Plain style by a sixth-generation member of the same family which first built the house in South Carolina.*

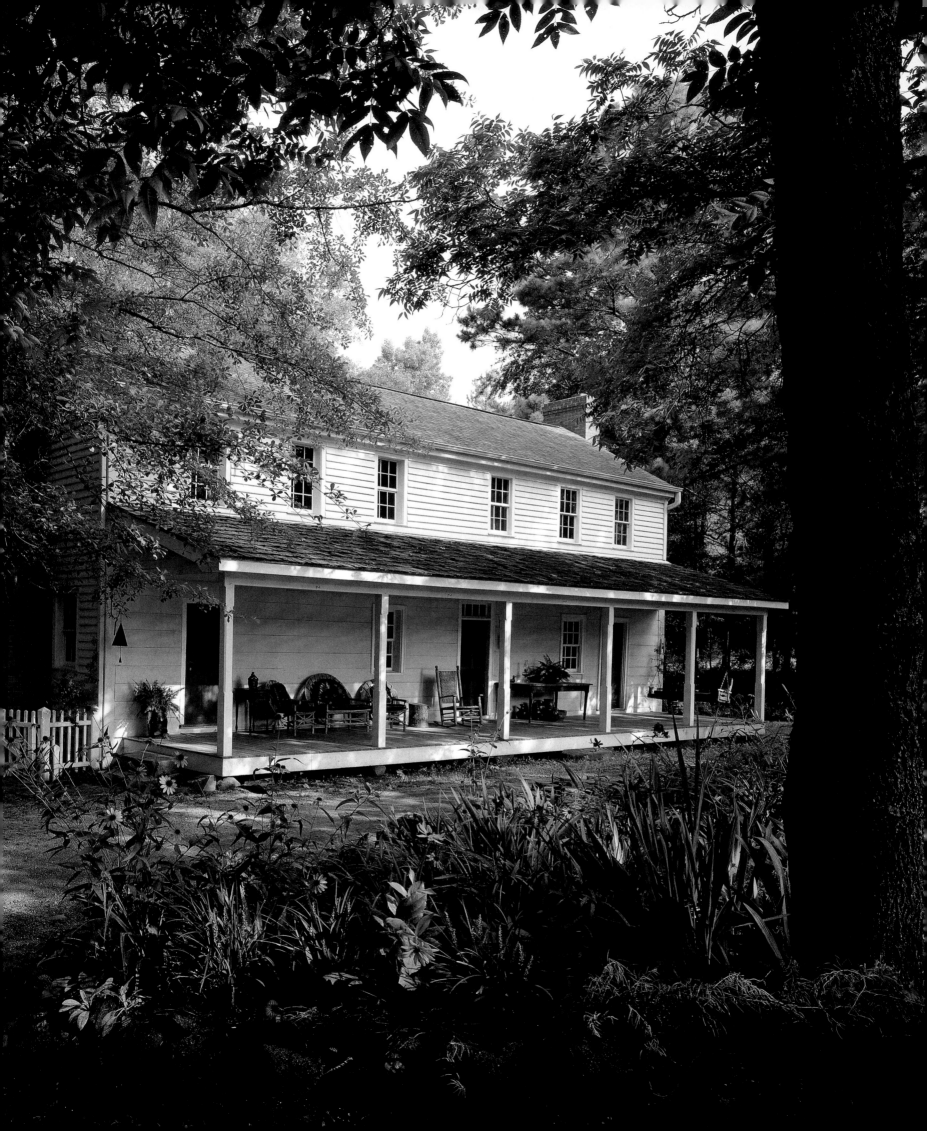

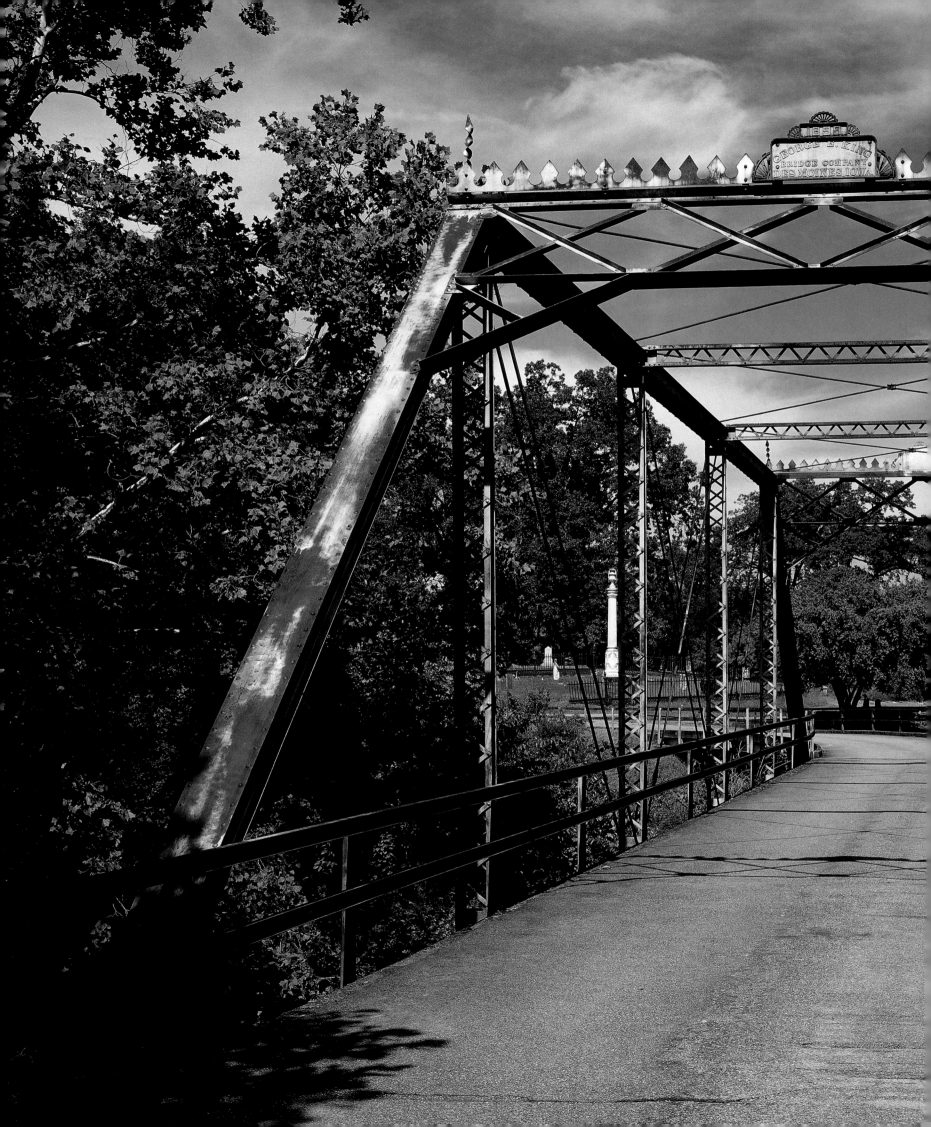

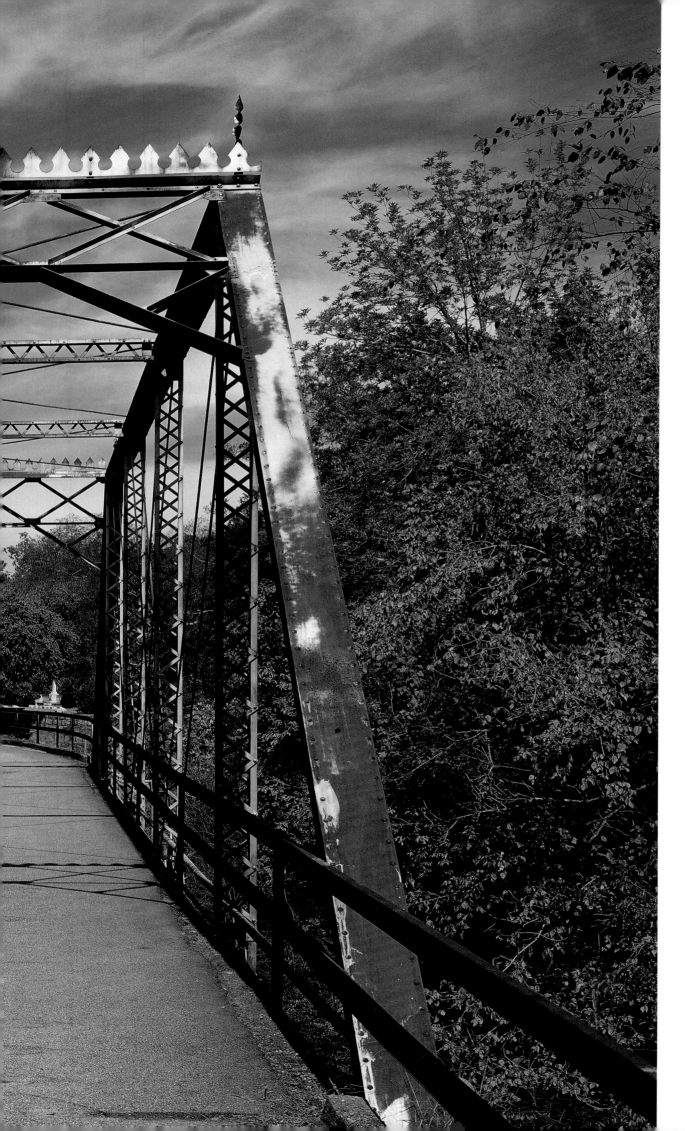

*C*onnecting the banks of the Oconee Hill Cemetery in Athens, this bridge crosses the Oconee River.

Washington

GEORGIA

THE RICH SOIL OF GEORGIA's Wilkes County attracted English, Irish, Scots, and French settlers. At its center was the town of Washington, chartered in 1780 in the name of the nation's first president, George Washington. A decade later Wilkes County boasted forty-four per cent of the population of the state of Georgia.

Early on in prosperous Piedmont towns, the architectural styles of England were emulated, for all things English were the acme of good taste in most settlers' minds. What was known as the Federal style in the colonies, after the Adam style in England, began to appear throughout the Piedmont. Washington was no exception, as planters seeking a more cultured lifestyle in town built graceful brick or white frame structures set off by curved fan lights over the door. It was the house of choice for the well-to-do.

By the 1830s, another architectural style began filtering into the South, the English version of Palladio's

Victorian details embellish the cupola of the Julian May House (left) *and add a distinct character to one of Washington's oldest houses, The Cedars* (below), *1790. New Haywood* (opposite), *1887, in its colorful Victorian red, is a startling contrast to the white Greek Revival houses nearby.*

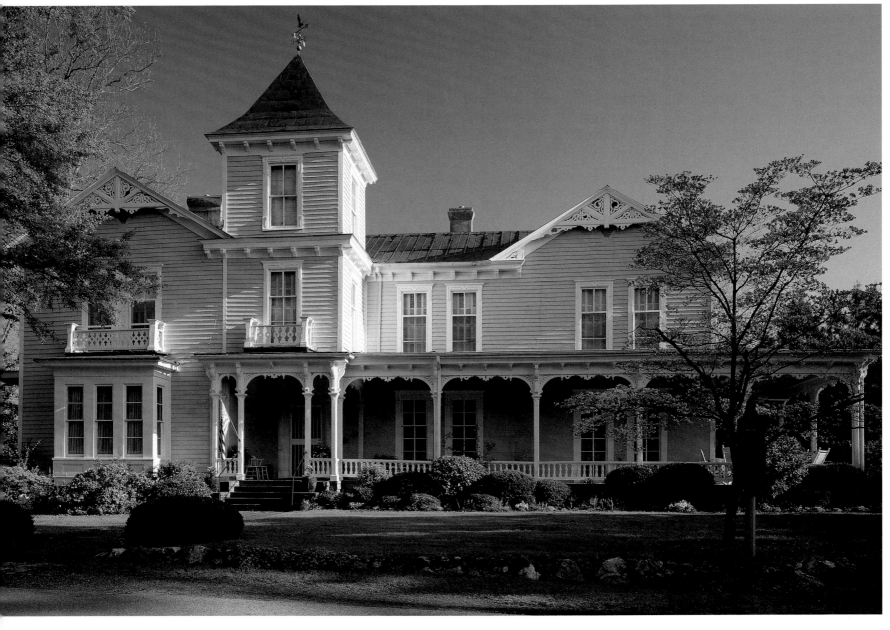

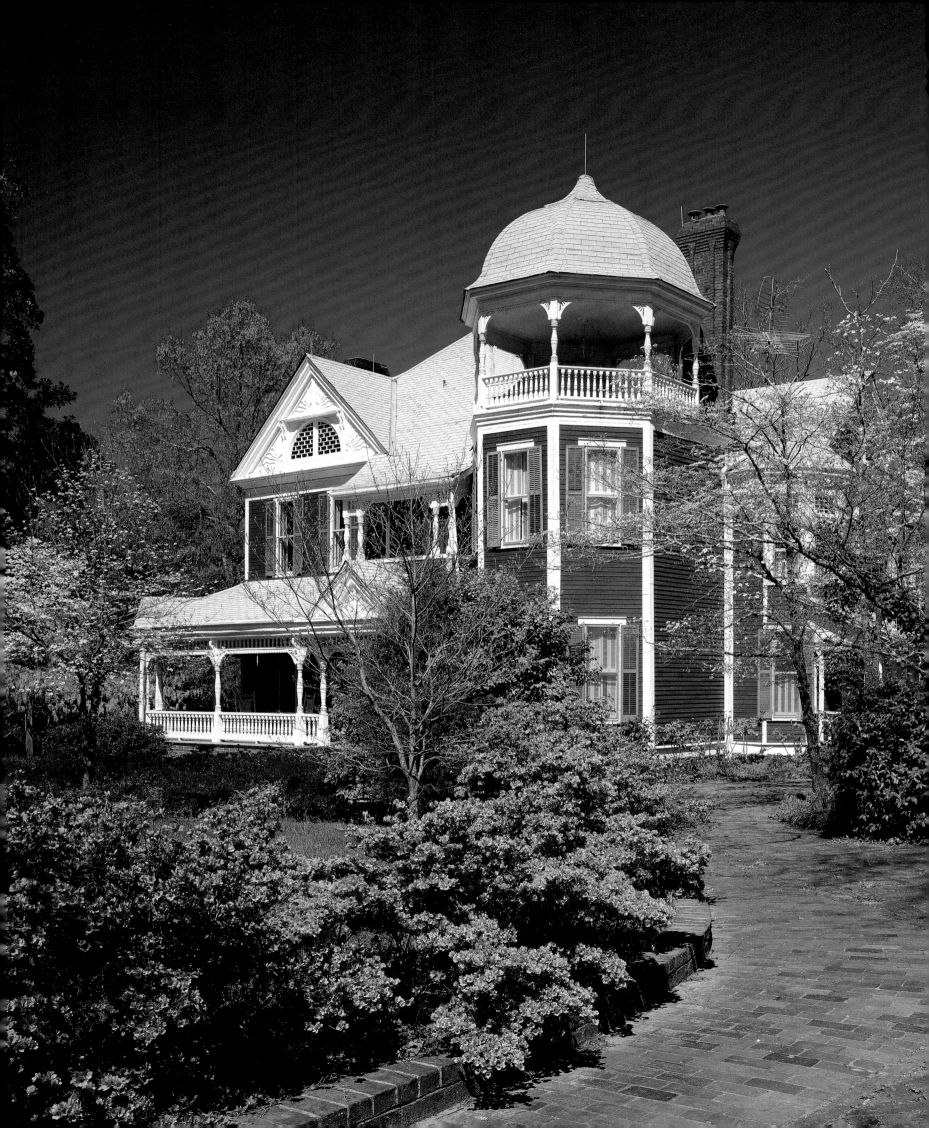

*M*any of Washington's old houses are set on immense lots, like this one at The Cedars (left), with space for outbuildings, such as the carriage-house (top), at the Washington Historical Museum, and the dovecote or bird house (above), at the Robert Toombs House State Historic Site.

classicism called Greek Revival. Later, in the mid nineteenth century Washington residents turned to the Gothic Victorian style just as did their neighbors in other Piedmont towns like nearby Madison. As the styles changed it was not practical to tear down and rebuild when one's home was out of fashion, so many early Federal-style houses were updated with a columned porch and later during the Victorian era, elements such as gingerbread trim were added.

Echoes of the planter lifestyle and the Confederacy still reverberate throughout Washington. And no wonder. Washington was the site of the final meeting of the

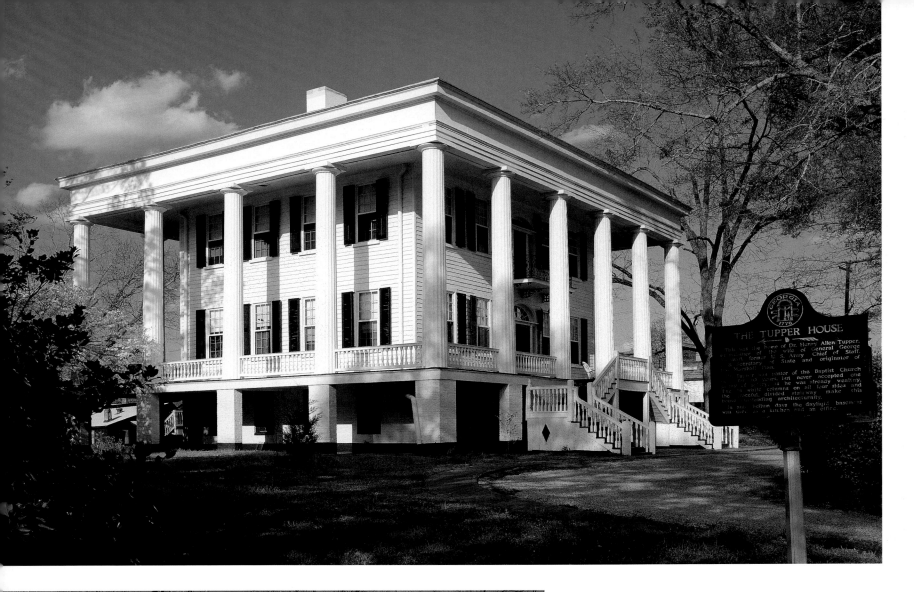

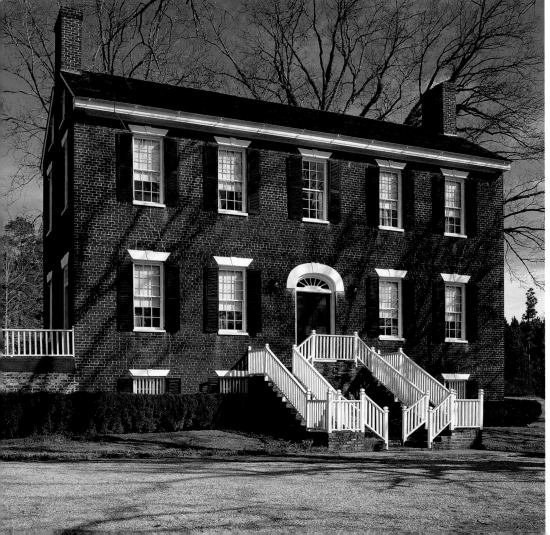

The signature "welcoming arms staircase" at the Tupper House (above) *never fails to attract a camera. Outside of coastal Georgia, Kettle Creek* (left) *is considered to be the state's finest example of brick Federal-style architecture. While cotton was king, monumental houses such as Poplar Corner* (opposite *and* overleaf) *were built in prosperous antebellum towns across the South.*

Confederate cabinet headed by Jefferson Davis. It has been said that the most outstanding men of the "New South," referring to the Reconstruction South following the Civil War, came from a geographic radius that extends sixty miles from tiny Washington, Georgia.

Washington has maintained the same population for almost two hundred years, now making up only a small percentage of Georgia's overall population. While cotton was king, so, too, was Washington. But by the 1920s, the boll weevil and Texas cotton had made irreversible inroads in the county's cotton industry. Cotton may be gone, but the town's rich heritage dating back to the American Revolution is intact.

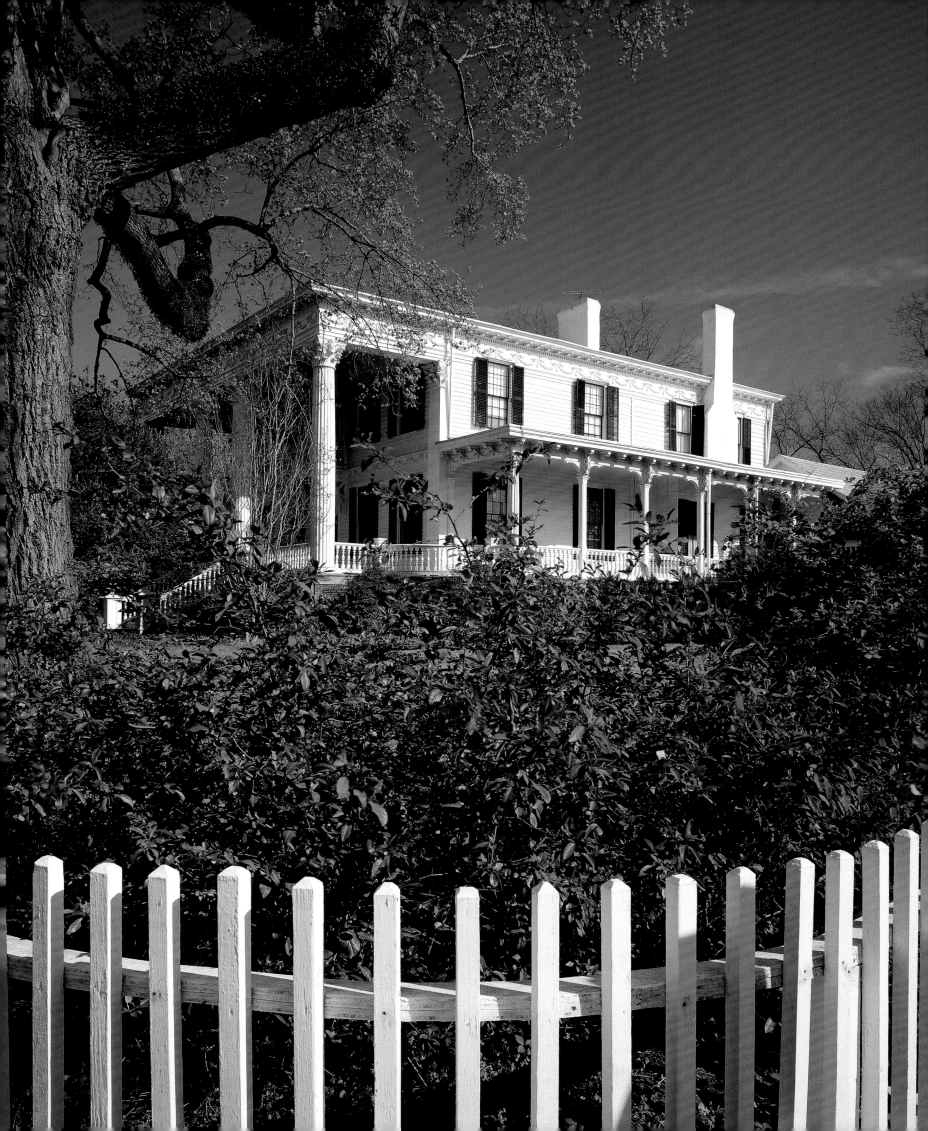

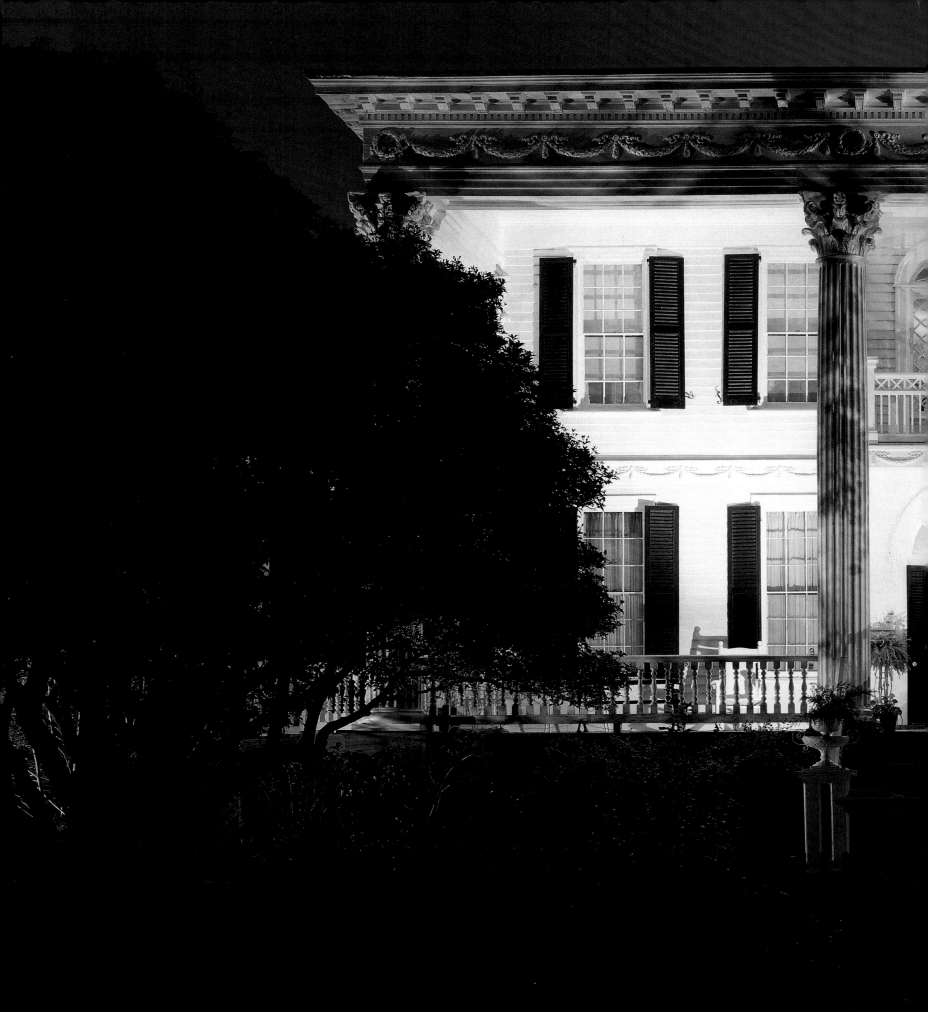

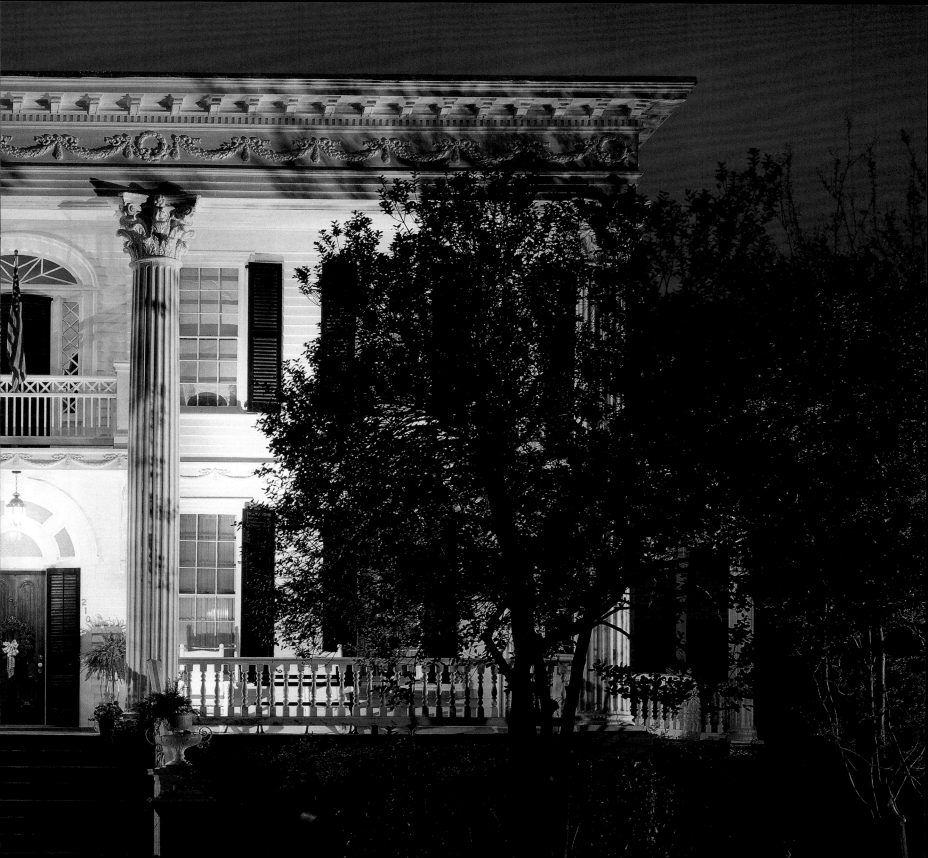

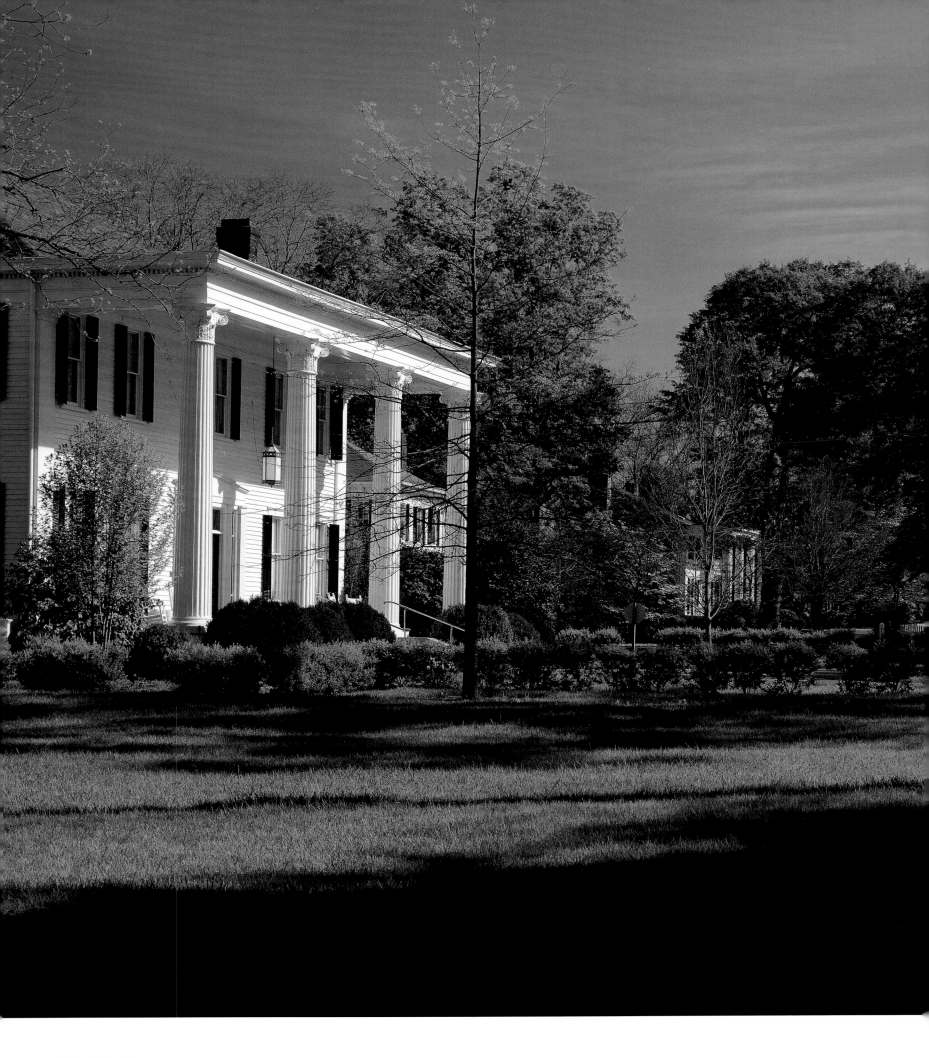

Madison

GEORGIA

LIKE ANY AGING BEAUTY, the town of Madison has undergone the occasional face-lift to keep the wrinkles from showing. Beautifully preserved, the town basks in the mirror of a steady flow of film-makers on location who create yet more allure. Somehow, Madison escapes the touristy air that befalls many popular historic towns. Rather it has successfully protected its air of authenticity with the village convenience of a pedestrian-oriented downtown where viable commerce is plied in the shadow of one of the largest historic districts in the South.

Incorporated in 1809 on land that once belonged to Creek Indians, the town took its name from President James Madison. Early on, Madison was considered a

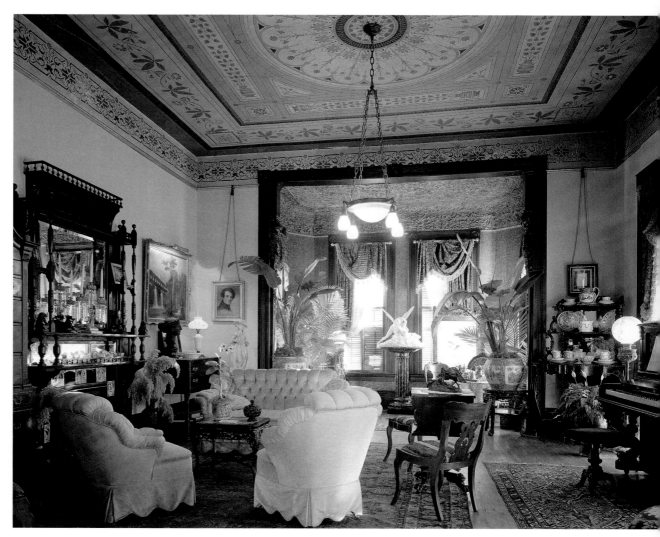

*H*ouses in historic Madison are known for both beautiful exteriors and interiors as evidenced by *Oak House* (left) *and the parlor of the Usher-Thomason House* (above).

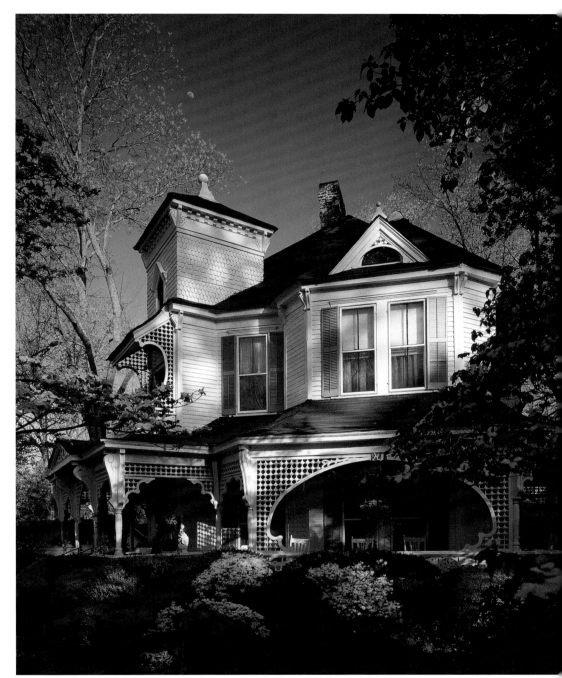

center of culture and refinement, known for its commitment to both education and architecture. Today, the carefully restored Madison-Morgan Cultural Center, 1895, reflects this town's commitment to the arts and historic preservation.

The Romanesque Revival building, one of the first graded schools in Georgia, was reopened to the public in 1976 as the Cultural Center. The old apse-shaped school auditorium now hosts dance performances, plays and concerts. The galleries, all former schoolrooms, include three permanent displays, one of which is devoted to the history of Madison and Morgan County. Another gallery is the setting for a period room exhibition of the decorative arts in the Rococo

The steps leading to Thurleston (left) give credence to the beautiful gardens and plantings which grace Madison's large historic district. Hunter House (above) is often called the most photographed house in Georgia; neighbors anticipate warm weather when the ferns take their customary places on the front porch.

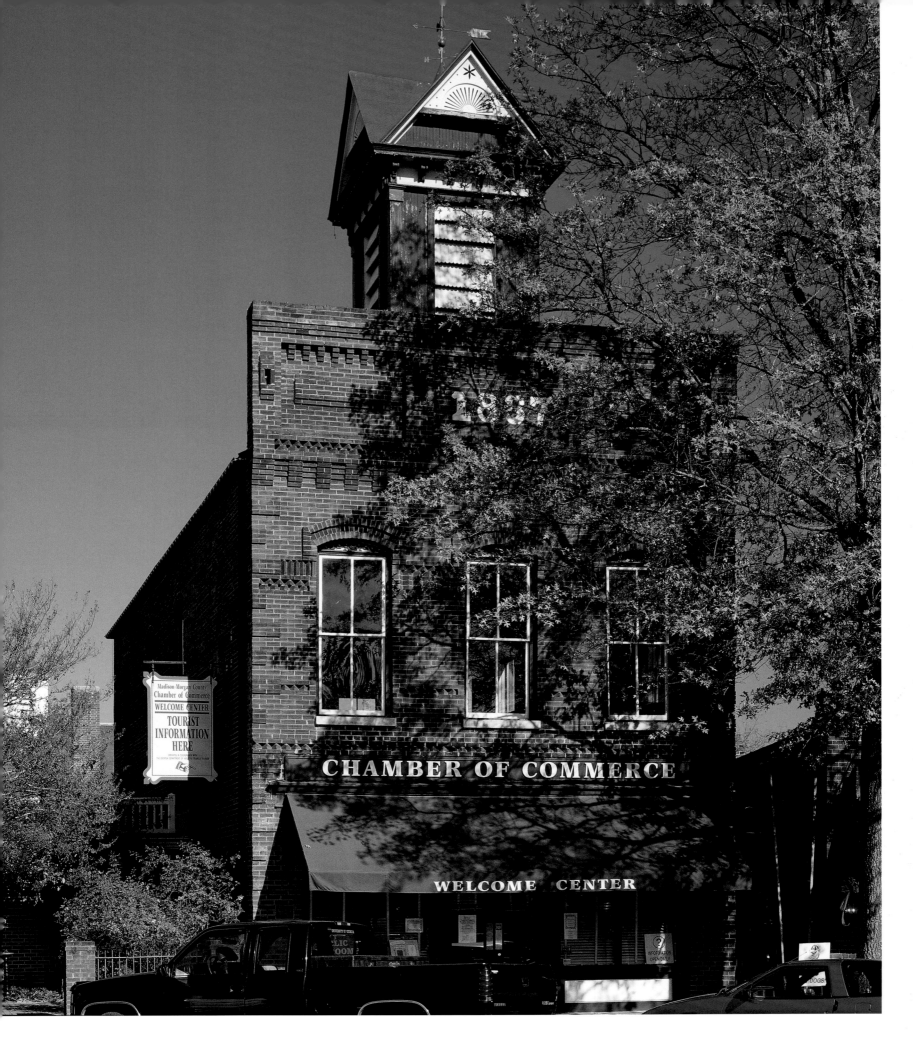

Downtown Madison is known for its pedestrian-friendly atmosphere. Historic structures are within walking distance of each other and are in use as vital parts of present-day Madison. The Chamber of Commerce (opposite) *is located on the town square, as is the Morgan County Courthouse* (below), *and only blocks away the Madison-Morgan Cultural Center* (right) *is open year-round.*

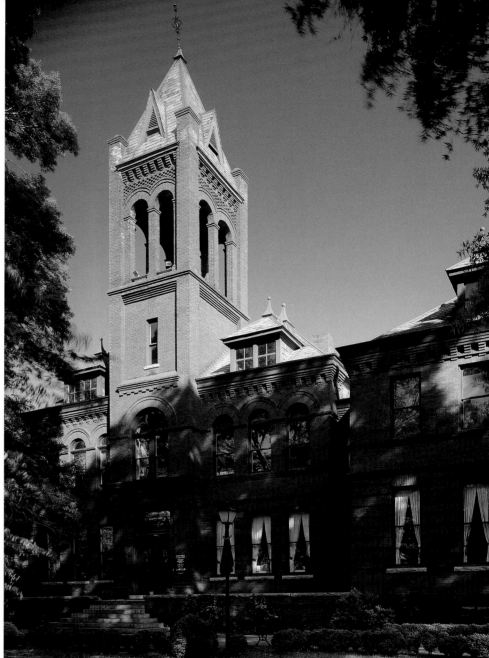

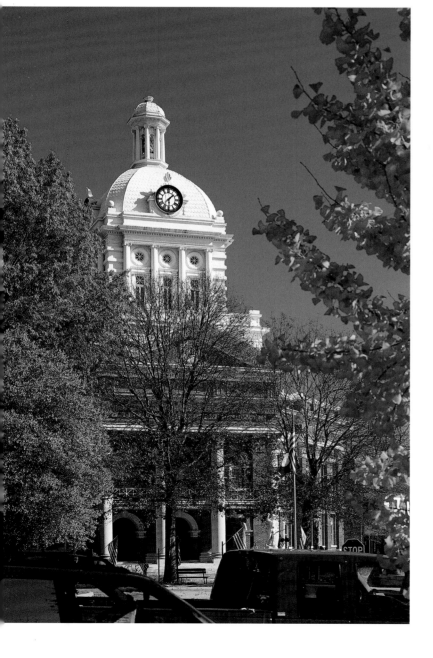

Revival style. The parlor furniture, intricately carved with shells, fruits and nuts, defined the epitome of good taste in the heyday of Madison's white-columned mansions. The collection on view actually graced one of the double parlors in one of Madison's most notable houses, Boxwood. Another gallery replicates a turn-of-the-century school-room. It only takes one visit to the Cultural Center to see life in nineteenth-century Piedmont Georgia revealed in a delightful afternoon.

Overleaf Boxwood is Madison's iconographic house, a three-story blend of Greek Revival and Italianate styles. Named for its boxwood garden, it stands across the street from the Episcopal Church of the Advent.

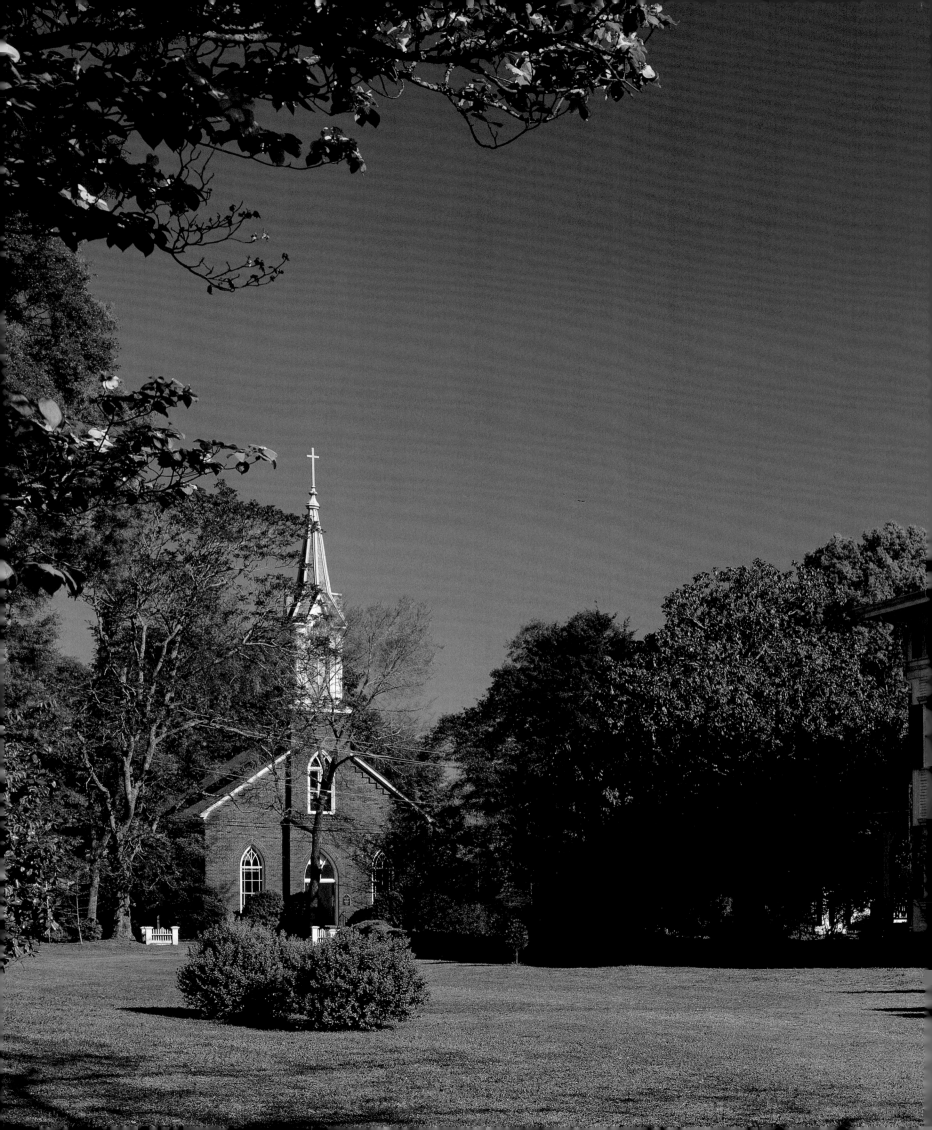

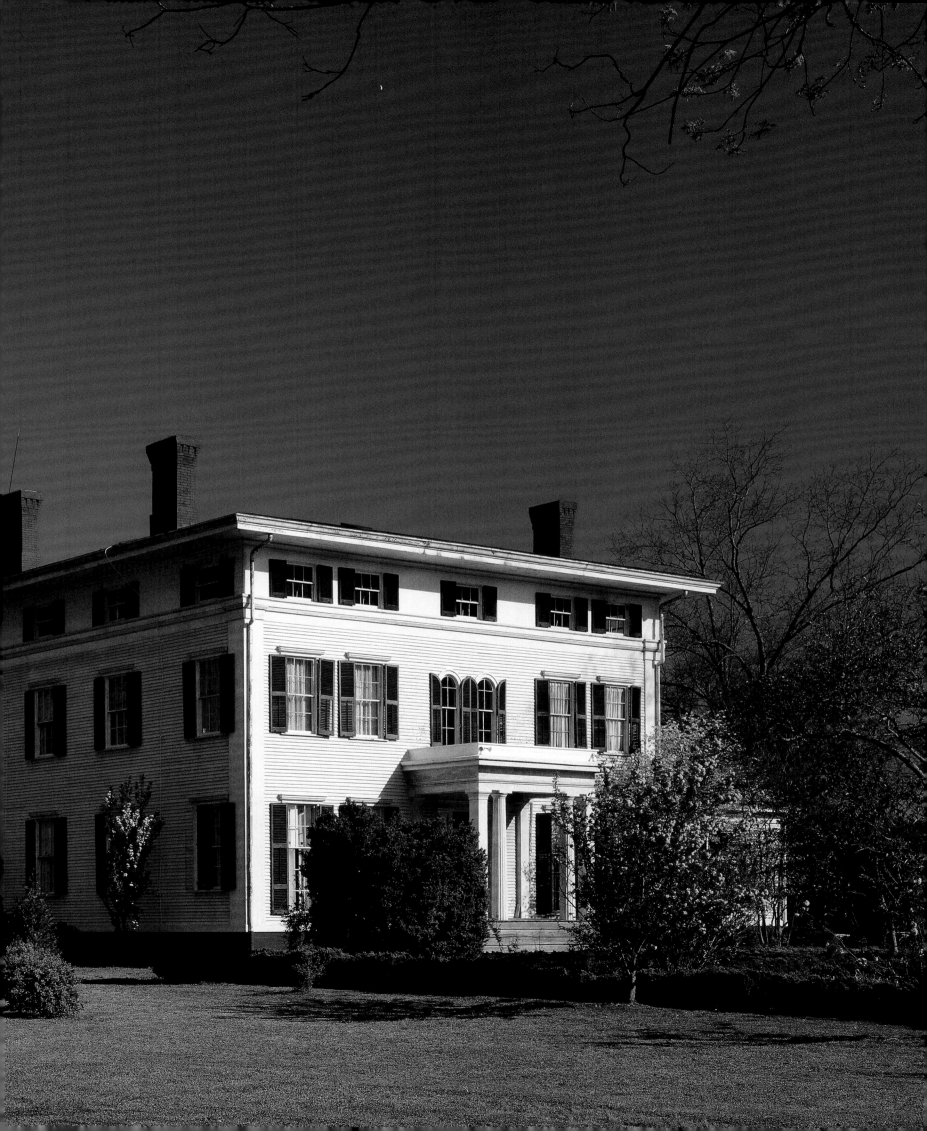

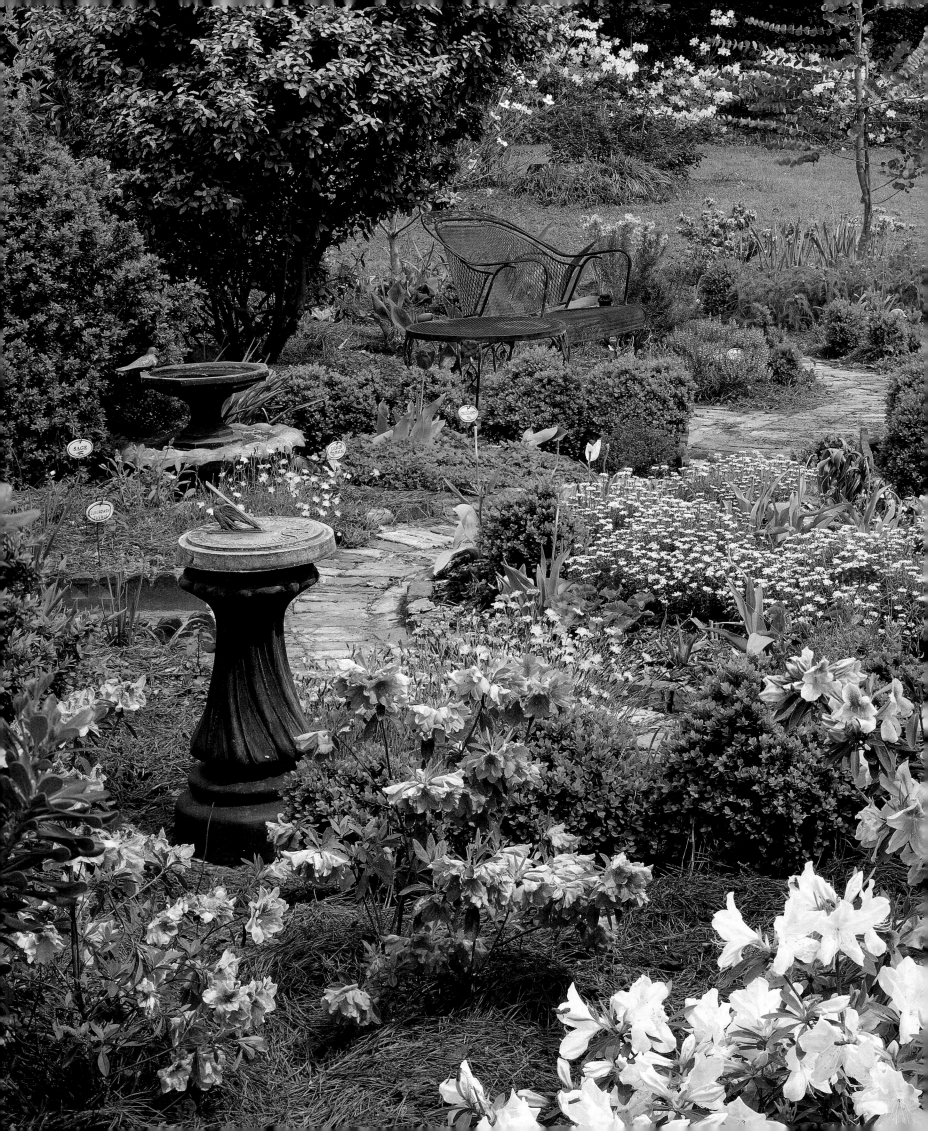

Gardens

Gardens

Gardens like the one at Poplar Corner (preceding pages) and the one at Afton Villa (below), St. Francisville, Louisiana, are open each spring, when almost every small town in the South hosts its annual home and garden tour.

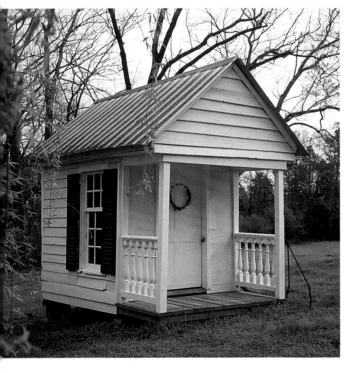

In Washington, Georgia, the doll house in the garden at Poplar Corner (above) awaits the arrival of young visitors.

Southerners are serious about gardens. They love to dig in the dirt, pore over gardening calendars, and listen to speakers who lecture on heirloom watermelon seeds and heritage camellias. The founding of America's first garden club, the Ladies' Garden Club, in Athens, Georgia, in 1891, gave rise to garden clubs large and small across the South, and eventually across the nation. Garden clubs such as the two formidable ones in Natchez, the Pilgrimage Garden Club and the Natchez Garden Club, support tours that benefit their community, and in Natchez have made a major difference to historic preservation efforts. The words "house and garden tour" appear on most tours of homes in the South. People who open their gardens for these spring tours are often scheduled years in advance so they will have plenty of time "to get the garden ready."

Flower shows are another Southern springtime ritual, and on the grand level in large cities often draw thousands of visitors. One Southern matron remembers her family drinking gallons of soda in green bottles so that her mother's garden club would have its requisite green "vases" for the spring flower show entries. In the mountains and hill country, fairs have competitions for dahlias and other flowers that bloom well in high places.

City preservation manuals outlining strict architectural guidelines for each period are careful to include in each section instructions on gardens and "appropriate" fences. *The Beaufort Preservation Manual* starts its gardening section with "suitable plants before 1840." And in its list of "do's and don'ts" the manual includes these wise words: "Always consult your local garden club for advice."

When friends "do" other friends' weddings, they pride themselves on raiding neighbors' yards for blossoms in season. These women know exactly how long a hydrangea bloom will "hold up" at an outdoor wedding in early July. Before the bloom is off the rose, they will caution you about using red maple leaves in a fall arrangement because "they will curl up in a minute." They know which hillside outside town has enough smilax to wrap around a front porch door at Christmas, or to frame an

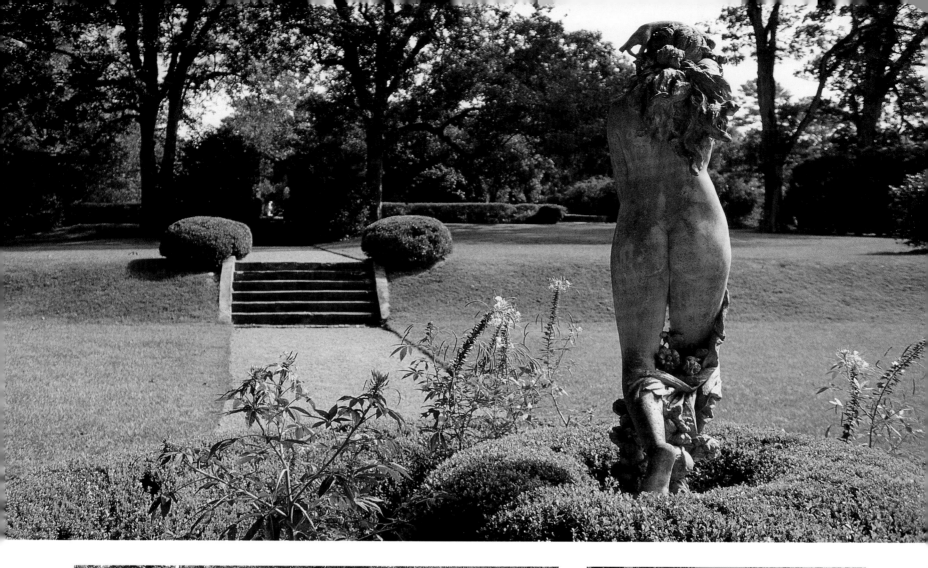

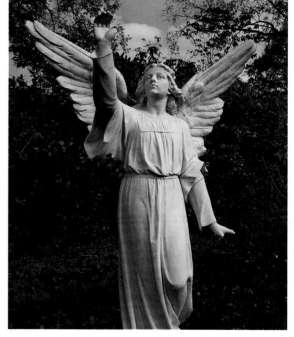

Italianate mantel for a wedding or any other family celebration.

Visitors to Southern gardens, especially the public ones such as the Founders Memorial Garden in Athens, Afton Villa Gardens in St. Francisville, and Hopeland Gardens in Aiken, quickly realize that these living tapestries have as much personality as the people who planted them.

It is not unusual for gardens in the South to be filled with statuary and garden accent pieces like the ones at Afton Villa (top) and Monmouth in Natchez, Mississippi (above). While not as durable as stone angels, this aging picket fence in St. Francisville (above left) still serves as a veteran garden guardian.

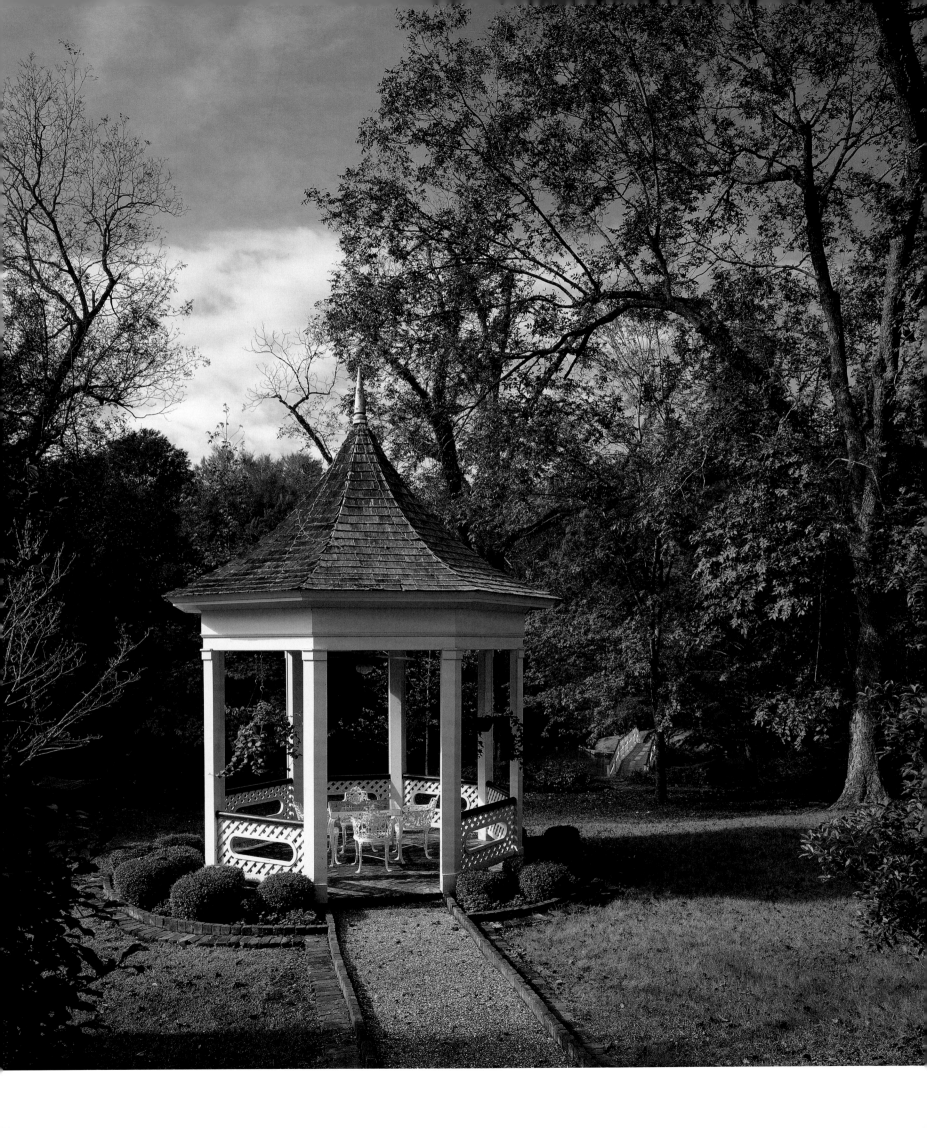

*O*ver 26 acres surround beautiful Monmouth in Natchez (opposite). Monmouth is one of the town's marvelous "suburban estates," and is open as a highly-rated bed-and-breakfast inn. The gardens are beautifully restored and offer quiet surprises like this gazebo.

*F*ounders Memorial Garden (this page) occupies two acres of gardens on the campus of the University of Georgia. Open to the public, the gardens were started in 1936 as a tribute to the 12 founding members of the Ladies' Garden Club of Athens, organized in 1891 and recognized as the first garden club in the United States.

*S*eductive folds of Spanish moss dance gently in front
of a statue at Afton Villa (above) while nearby water
spills out of a Victorian fountain placed in the middle of
a small pond (opposite). The nineteenth-century house
at Afton Villa burned in the 1960s, but its gracious
gardens are open to the public.

THE RIVERS

A river defines a town's existence. It determines not just its boundaries, but also its destiny. Before roads, before rail lines, the rivers of the South were the arteries inland. Shakers traveled down the Kentucky River in 1801 from Pennsylvania to settle in Pleasant Hill. Fertile land near the Mississippi and Black Warrior Rivers made wealthy men of the cotton planters who settled there in the early nineteenth century. The Chattahoochee River, drifting from the mountains of Georgia, then dividing that state from Alabama on its way to the Gulf of Mexico, brought commerce and industry to towns like Eufaula.

One has only to drive from the center of the town of Natchez, down the road that hugs the Natchez bluff all the way to the Mississippi River, to understand the delicate balance between river and town. Halting the erosion of the 200-foot-high Natchez bluffs is a construction project that defies imagination, a concrete wall held by sixty-foot nails driven into the earth. The river gives and it takes away.

Commerce still flows along these rivers as it did 200 years ago. Today, however, instead of the agricultural seeds that the Shakers once shipped on the Kentucky River, the cargo is more likely to be tourists. In towns like Natchez, with neither an airport nor a nearby interstate, the river continues to be a main link to the rest of the world. Old-style passenger steamers operated by the Delta Queen Steamboat Company look as appropriate in Natchez today as they did originally. From May through October, the stern-wheeler Dixie Belle *leaves from Shaker's Landing for short trips along the Kentucky River.*

The residents of these river towns, particularly those in the fertile Louisiana and Mississippi bottom lands, are also residents of a state of mind with cultural borders as indefinite as the ever-changing river. It's a land where they speak of "pilgrimages" rather than house tours, where you have a "camp" on the river rather than a second home. "River town" may be a literal term, but it is a philosophical one as well.

A view of Alabama's Black Warrior River (opposite), *one of the many rivers which flow through the South.*

Shaker Village of Pleasant Hill

KENTUCKY

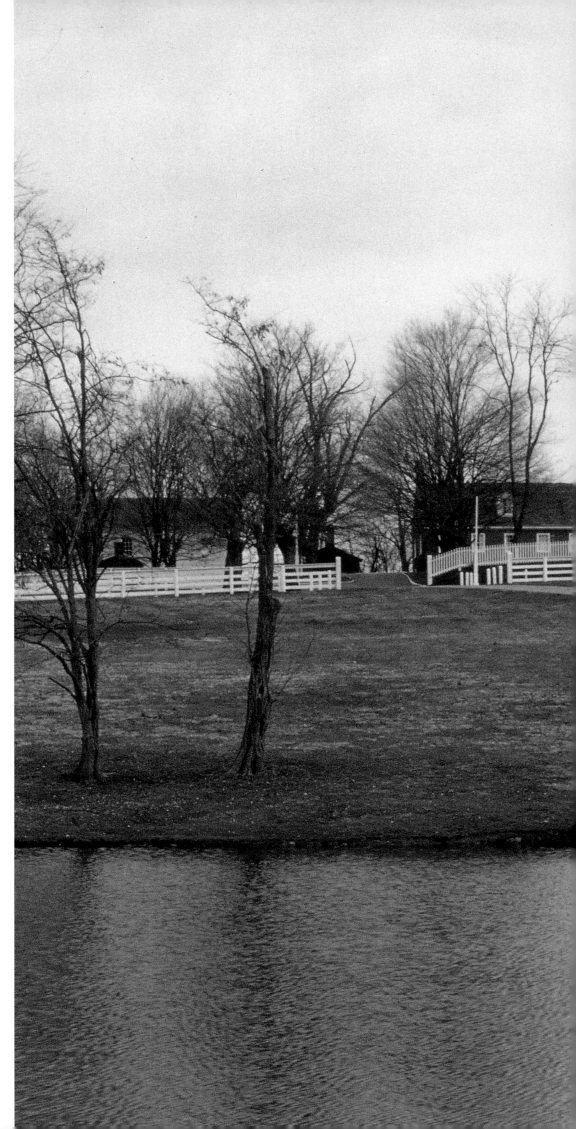

Few, if any, places in the South evoke the village spirit as powerfully as does the Shaker Village of Pleasant Hill, Kentucky. In the middle of the state's legendary Bluegrass Country, this quaint community still mirrors a simple religious life. The nineteenth-century residents of Pleasant Hill were connected to the world by what they produced, ranging from garden seeds to simple, beautiful furniture and herbal medicines. Shakers lived a well-regulated life under the guidance of their faith, which they believed shone in each of them, rising in the morning at a common hour and taking their meals together. They dressed uni-

A door opens to the simple pleasures of the Shaker Village of Pleasant Hill, Kentucky (below). The unadorned beauty of the West Family Dwelling, 1821, indicates the Shakers' respect for practicality (right).

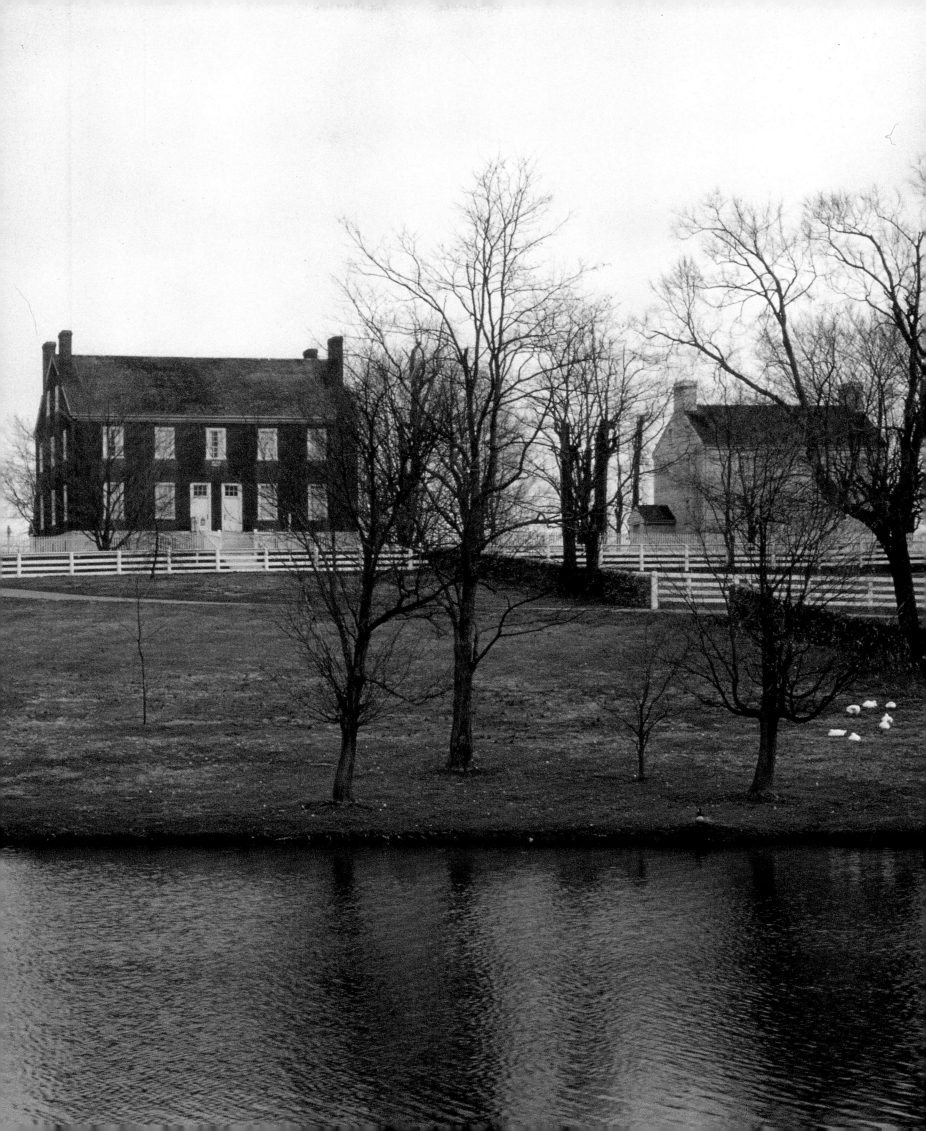

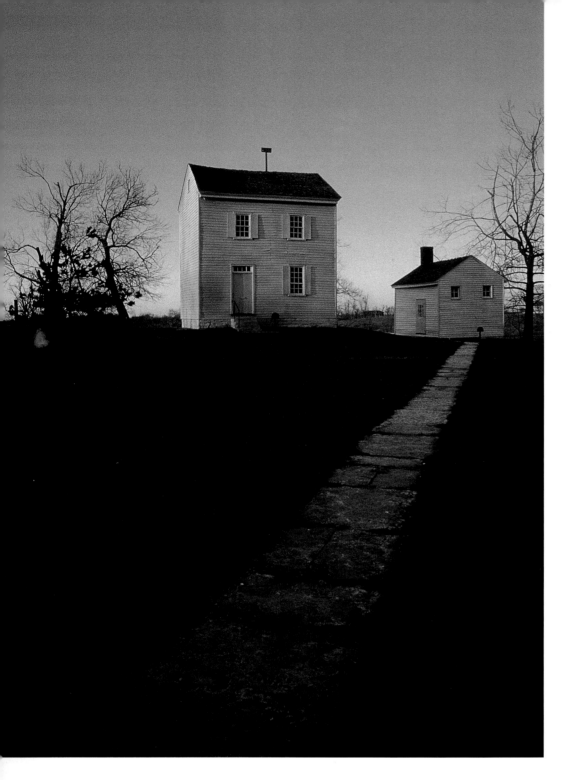

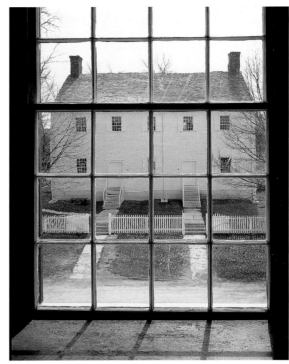

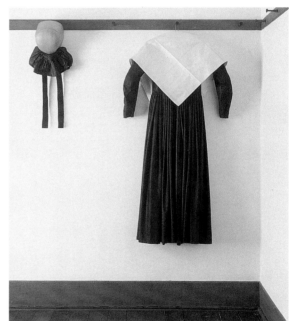

*W*ater House, 1833, is an *integral part of the Shaker Village of Pleasant Hill* (above), *the first historic site in the country to earn National Historic Landmark designation from boundary to boundary. The simple yet elegant design of Shaker architecture is echoed in this neat arrangement of clothes on wooden pegs* (above right). *The Shaker commitment to refined design is illustrated in this sweeping banister rail* (opposite).

formly and generally owned property in common. Their simple spiritual life inspired their unadorned furniture and crafts.

The integrity of the Shaker building style is reflected today in the preservation of century-old stone fences where peaceful cattle and sheep graze in what could be a nineteenth-century pastoral landscape. It is seen in the simple, yet powerful, limestone, brick and clapboard buildings that have long outlasted the last Shaker resident. Today, this village is a living history museum, a testimony to the peaceful and productive way of life these simple religious people established on a fruitful plateau near the Kentucky River in the early

1800s. In the early 1960s, almost forty years after the last Shaker died, a nonprofit, educational group began the task of saving the Shaker Village of Pleasant Hill. This site was deemed so important to American history that it became the first historic site in the country to be designated a National Historic Landmark .

Overnight stays at the village can be arranged in one of the fifteen restored buildings appropriately furnished with Shaker-style furniture and handwoven rugs. Shakers were one of the first groups to write recipe books and use spices in exact amounts, and early recipes from the 1800s are faithfully reproduced today in the village kitchen. Crafts which the Shakers prac-

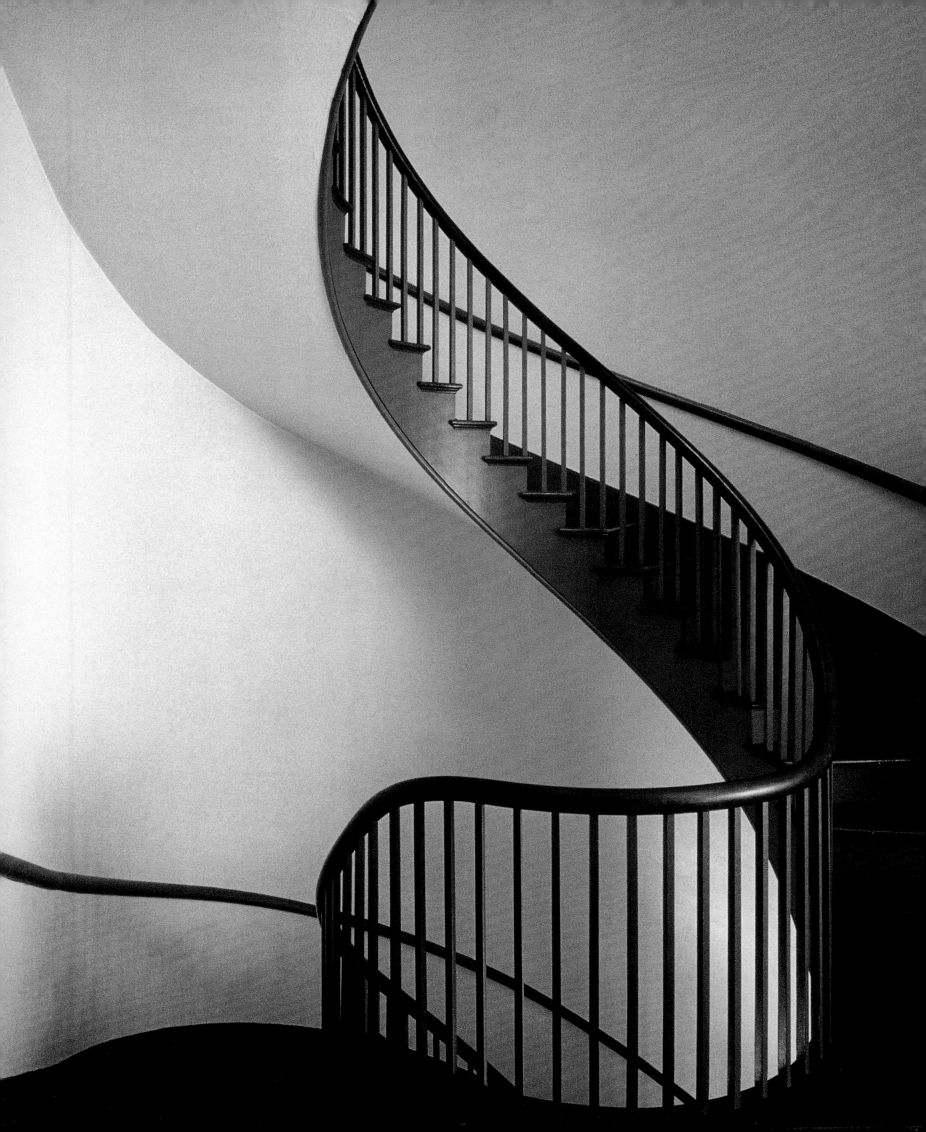

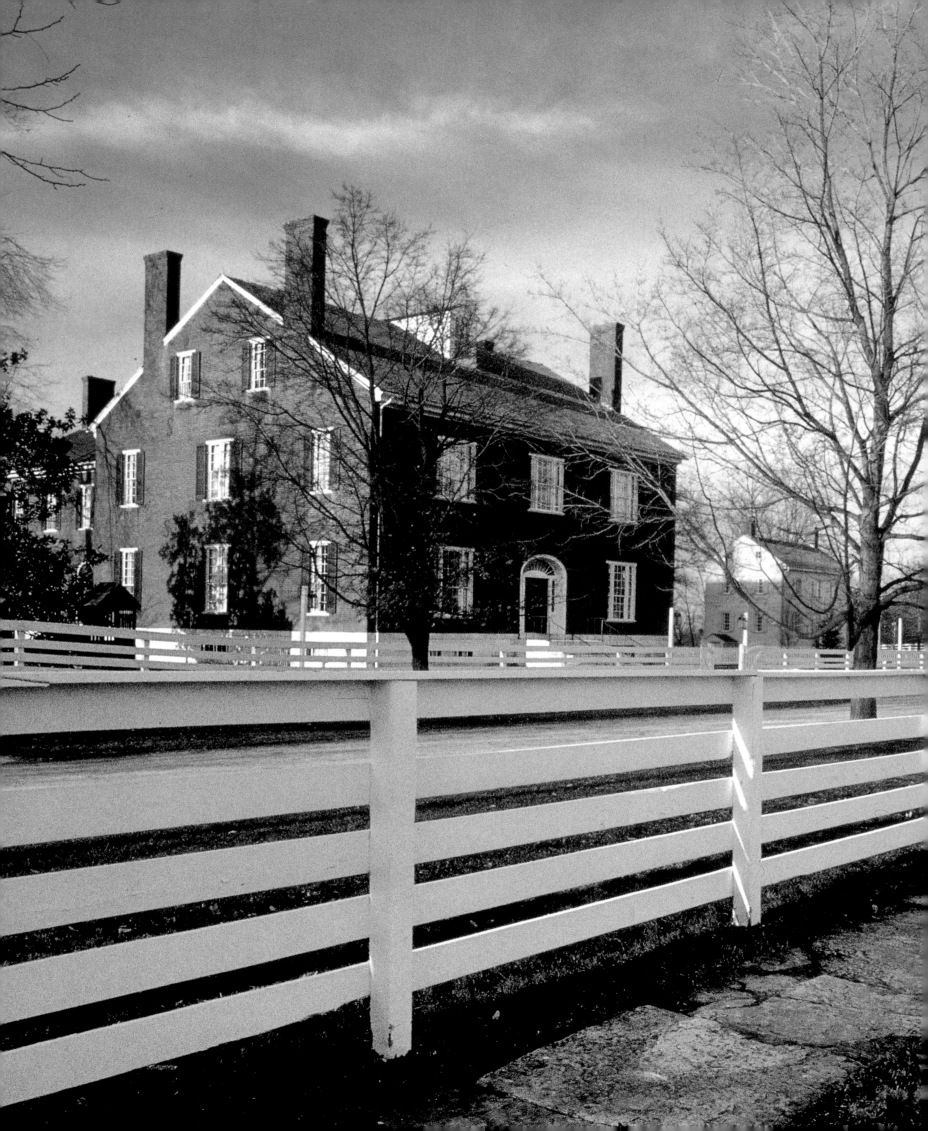

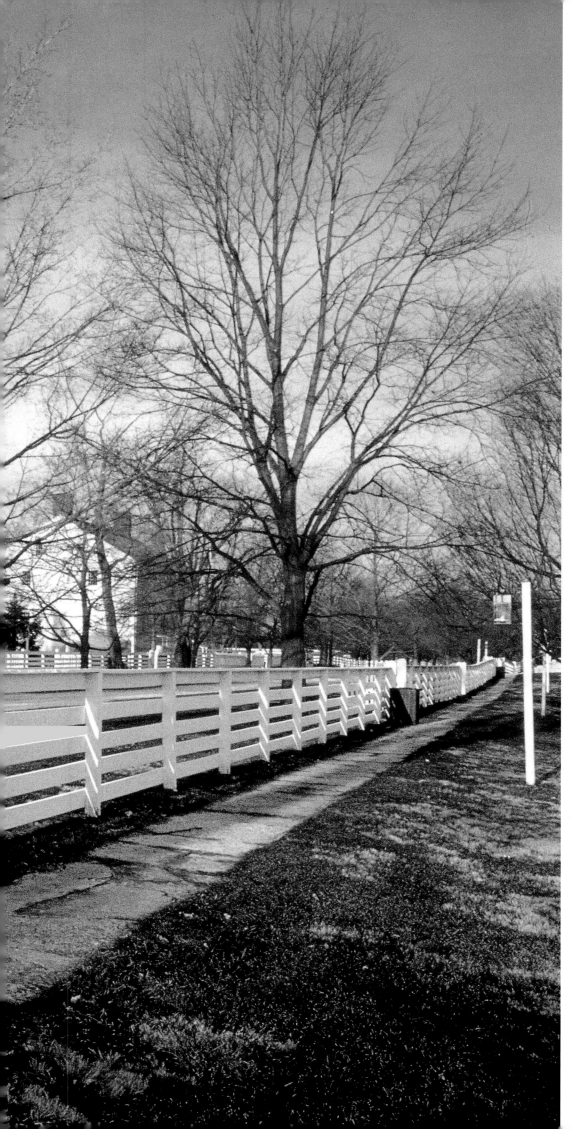

ticed in the nineteenth century are still a part of daily village life, including woodworking, spinning and weaving. From April to October, bygone techniques for gardening and farming are taught, and nature hikes are offered.

Little did people realize in 1830 that almost 200 years later, others would so admire the Shakers' workmanship that their furniture would command exceptional prices in New York's auction houses. And they could not have anticipated that the combination of an early mist from the Kentucky River, the beautiful rolling countryside, and the very spirit of its former inhabitants, which can almost be touched, would make a visit to this village an unforgettable experience. Shakers were to make the most of each day, and in the brief 100 years the Shakers inhabited this plateau they created a truly inspiring legacy.

*T*he Trustees' Office, 1839, *prepares Southern style food with breakfast, lunch, and dinner served daily* (left). *Dual doors* (above) *separated dormitory rooms, one entrance for brothers and one for sisters.*

Eutaw

ALABAMA

Located in the heart of Alabama's cotton-producing Black Belt, Eutaw's early success depended on the navigable waters of the Black Warrior River which afforded plantation owners access to the busy port of Mobile. Eutaw was established in 1835 in Alabama's Greene County, named for Revolutionary War hero Nathanael Greene. The town itself is the namesake of one of Greene's victory sites, Eutaw Springs, South Carolina.

The Gustave Braun House (below), c. 1854, was originally a one-room law office until Braun added rooms to make his family's home. In contrast, Kirkwood (opposite), begun in 1857 and completed just before the Civil War, represents a last hurrah for the cotton culture's boom times.

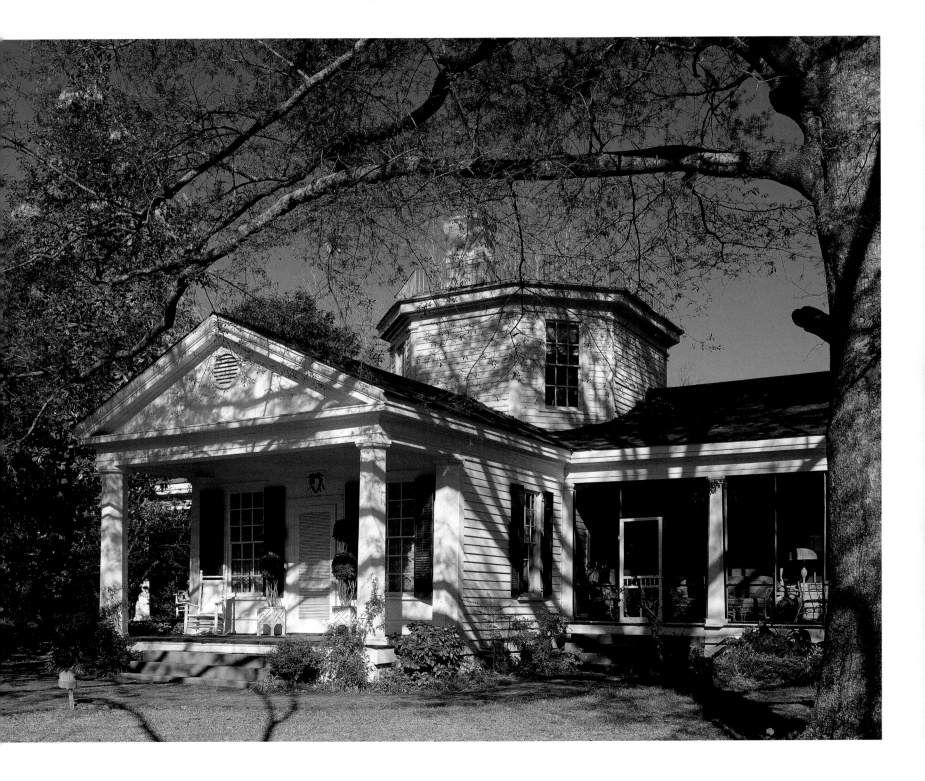

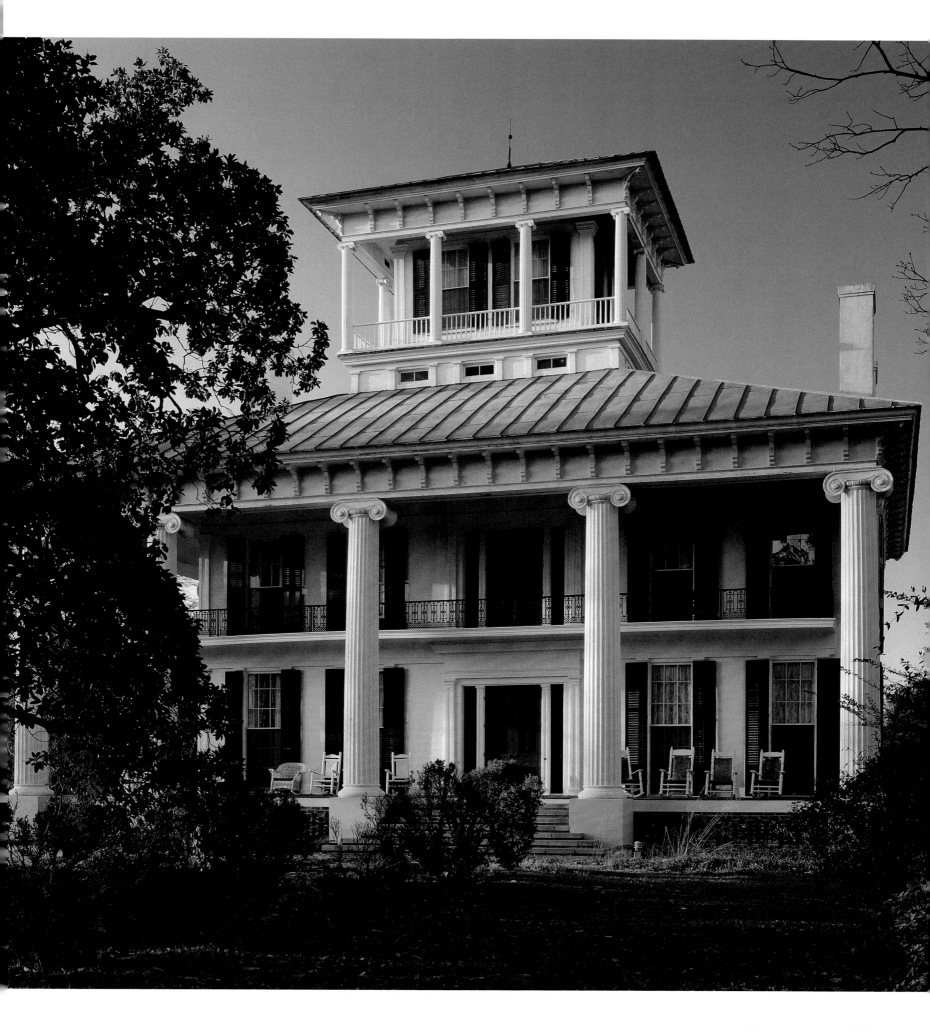

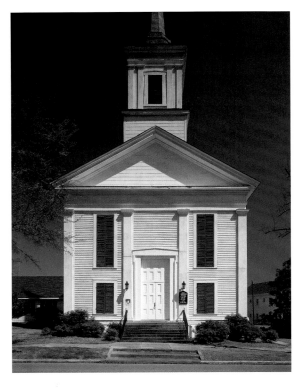

As the cotton culture matured, the town grew rich in architectural diversity. Wealthy planters built fine Greek Revival homes and raised cottages for their families in town. Not to be outdone by other antebellum towns, Eutaw has its fair share of what residents call the "pillared mansions," and though not as commonplace as Greek Revival houses, Victorian architecture is also represented.

And, even later treasures from the twentieth century, such as the W.P.A. commission, *Countryside*, a large mural painted on the wall of Eutaw's post office in 1939 by Robert Gwathmey, one of America's leading Social Realist artists, are a beautiful surprise in this tiny town.

As with many small towns in the South at the

The First Presbyterian Church (left) is crowned by a louvered bell-tower. The Meriwether-Richardson House (below) was built from materials floated across the Black Warrior River by barge in 1840. Raised cottages, typified by Eutaw's Merifield, 1839, are popular in the deep South (opposite). Its builder had the good sense to use 12-inch-thick walls to ward off the heat of Alabama's summers.

Overleaf An elaborate picket fence in Eutaw, Alabama, suggests the antebellum house which is shielded from view by the hedge.

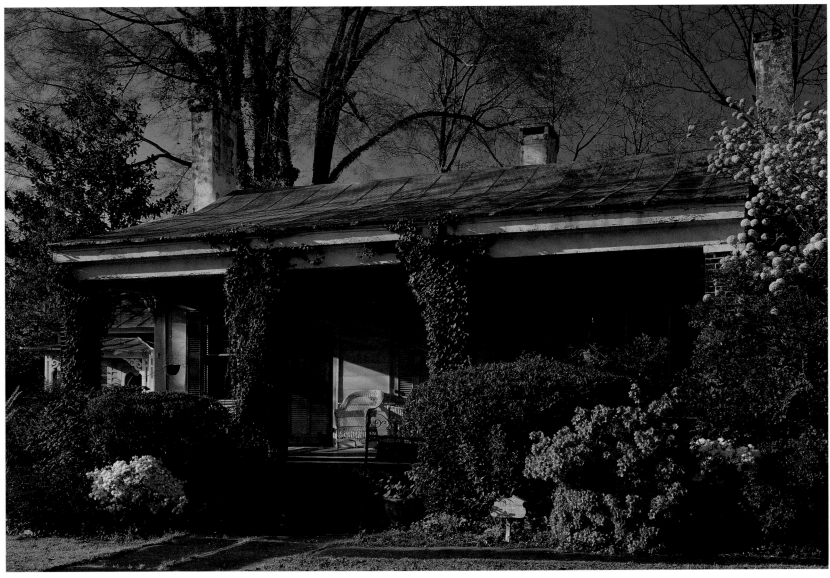

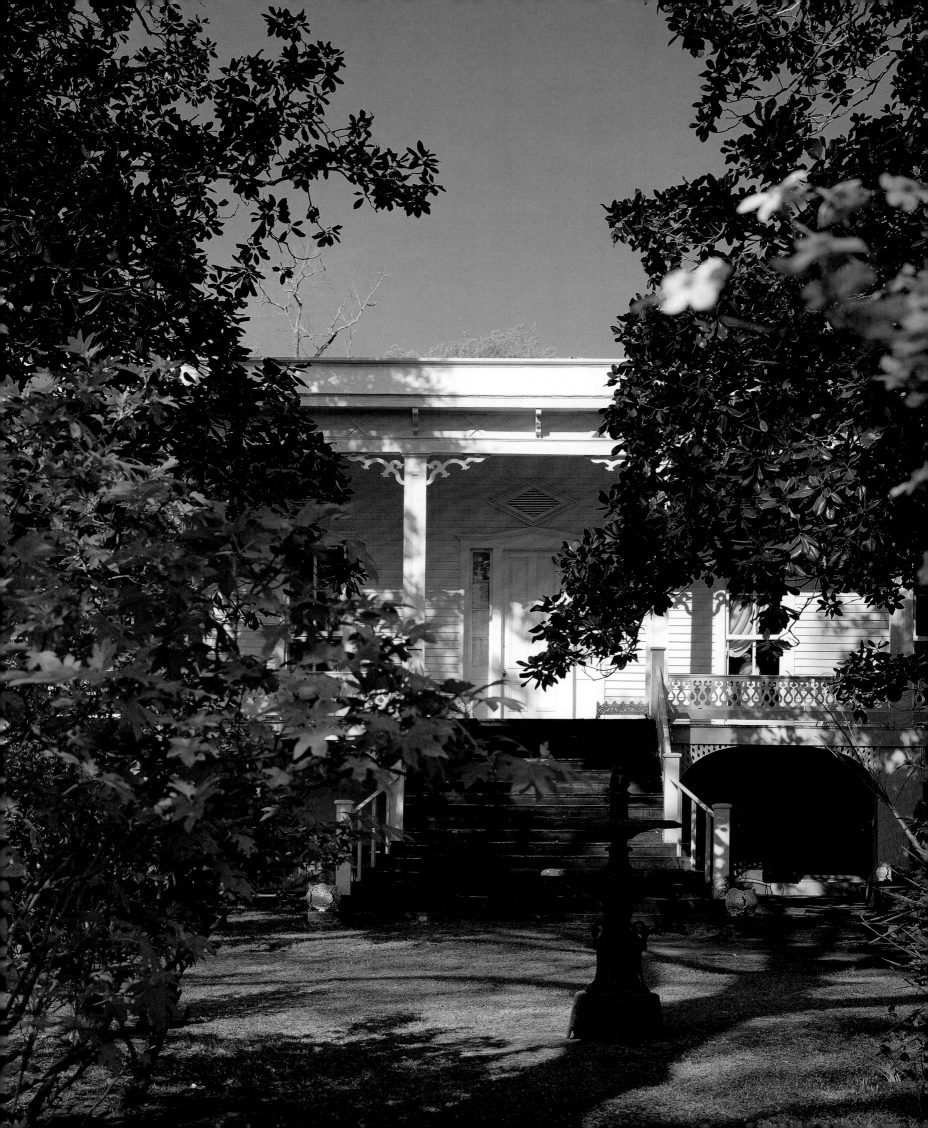

*T*he small school house (opposite) was on the west lawn of Thornhill and built for the children of the owners. During the Civil War it was used as a "sewing house" where the women of Eutaw gathered to sew Confederate uniforms. Tiny "Sipinn on Ashby" (below) is a bed-and-breakfast inn in a Federal-style dependency located in the grounds of Sipsey, one of Eutaw's Greek Revival houses.

present day, new people have arrived and restored the old houses, living alongside families who have been there for generations. Such nineteenth-century landmarks as Kirkwood, built in 1857, are now restored. The cupola atop Kirkwood, an architectural symbol in many river towns of the South, provides a lofty perch for a homebody to scan the river and monitor the river's constant activity. Stand on the porch at Kirkwood and you can almost hear the owners telling school children on a field trip, "This is the South. You are standing in it."

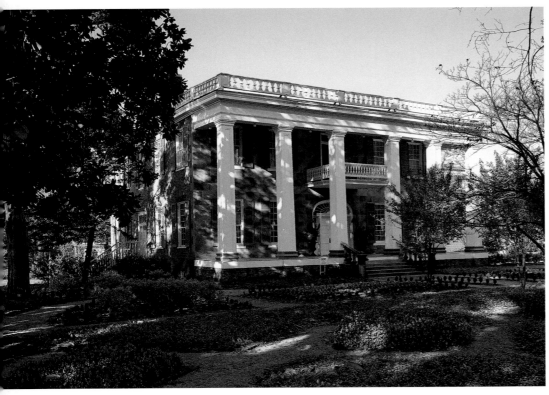

The Mildred Warner House (left) *is an exquisitely furnished house museum with rotating art exhibitions. The Battle-Friedman House* (below left), *1835, houses Tuscaloosa's cultural center and museum. The President's House at the University of Alabama* (opposite) *is one of four buildings on campus which survived the Civil War.*

Tuscaloosa

ALABAMA

TUSCALOOSA WAS SETTLED IN 1816 and was one of the first cities chartered when Alabama became a state in 1819. For twenty years, from 1826 until 1847, Tuscaloosa served as the Alabama state capital. Though the old capitol building burned in 1923, its site is now a park and remains as a legacy to that era.

Tuscaloosa is an educational town, and has been since 1831 when construction began on the University of Alabama. The campus was modeled after Thomas Jefferson's plans for the University of Virginia. Four buildings from the old campus remain today, the University President's Mansion, the Gorgas House, the Observatory, and the Round House. Other university buildings were burned in the late days of the Civil War, but the beauty of these remaining buildings is indicative of the fine architecture of that early campus.

The Gorgas House is one of the South's most copied houses, with its curving staircase and raised cottage style expressing classic low-country design. It was the home of the family of General Josiah Gorgas, an early president of the University of Alabama, and remained so until the death of the last family member

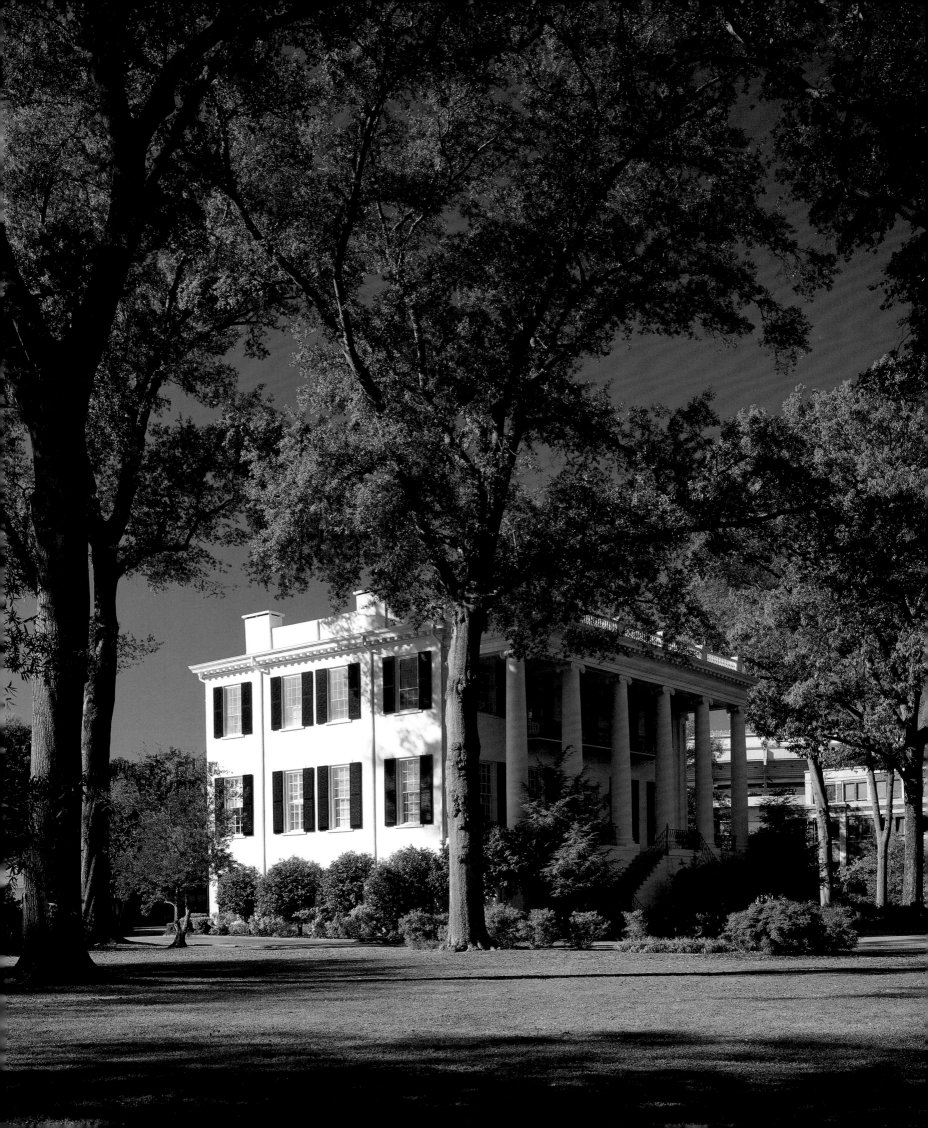

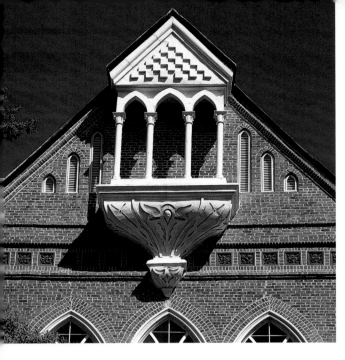

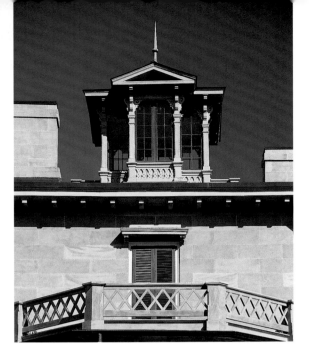

in 1953. Family heirlooms, including the silver collected by Mrs. Gorgas, are on view at the house which is used today as a museum and meeting-place. The Paul W. Bryant Museum, named for Alabama's legendary football coach Bear Bryant, celebrates 100 years of Alabama football which produced twelve national championships. The Battle-Friedman House, 1835, now serves as the city's cultural center and museum in its Greek Revival setting. Despite fires, war and the inevitable roll of Crimson Tide football each fall, Tuscaloosa remains peacefully undisturbed beside the Black Warrior River, much like the area must have seemed to Spanish explorer Hernando DeSoto when he first saw it over four hundred years ago.

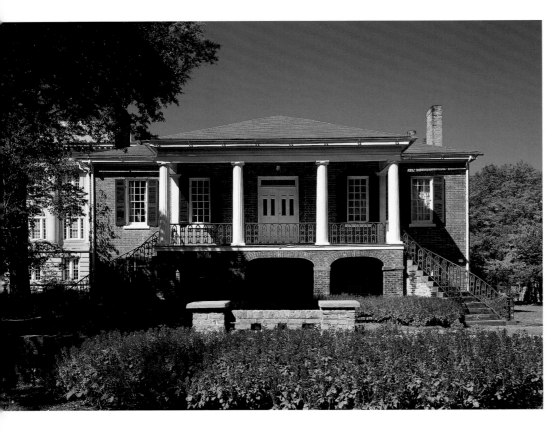

Considered one of the most copied houses in the South, Gorgas House (above) was built in 1829 and is the oldest building on the campus of the University of Alabama. Today it is open as a house museum. The Old Tavern Museum (below), 1827, was formerly an inn and stagecoach stop. Capitol Park (right) is where Alabama's old capitol building stood. Destroyed by fire in 1923, the site has been open to the public as a park where visitors can view the archaeological site and enjoy the outdoors.

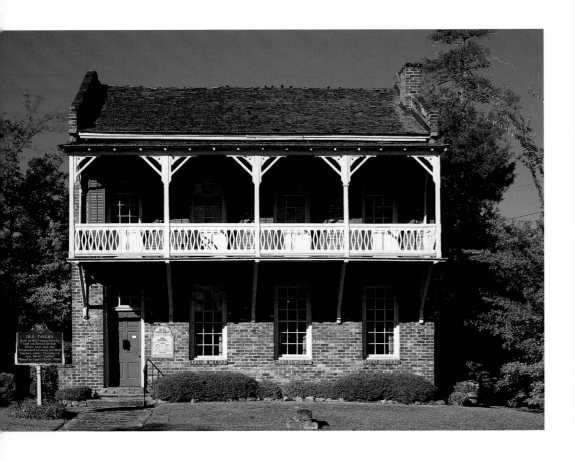

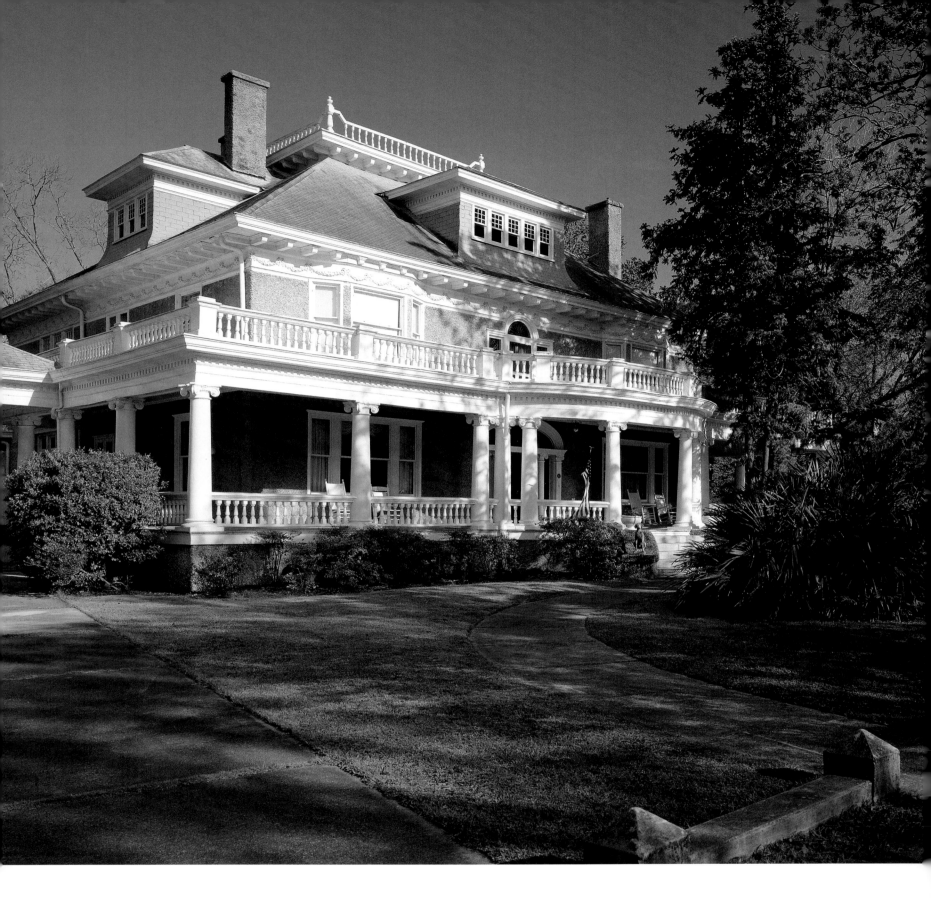

Eufaula
ALABAMA

Just north of Alabama's Wiregrass Region, and east of the state's fertile Black Belt, is the charming town of Eufaula which contains the state's second largest historic district of over 600 acres.

Like so many other Southern towns that grew up beside a river, Eufaula's life system began with, and is still nourished by, the waters of the Chattahoochee.

Prior to the arrival of the first white settlers from Georgia, the Carolinas and Virginia in 1820, Creek Indians had called the area home for thousands of years. Eufaula's first buildings were erected near the river and the business of shipping cotton provided a booming antebellum economy.

Most of Eufaula's beautiful old houses are located in

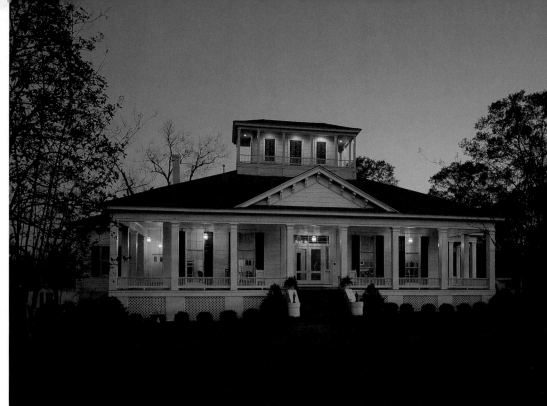

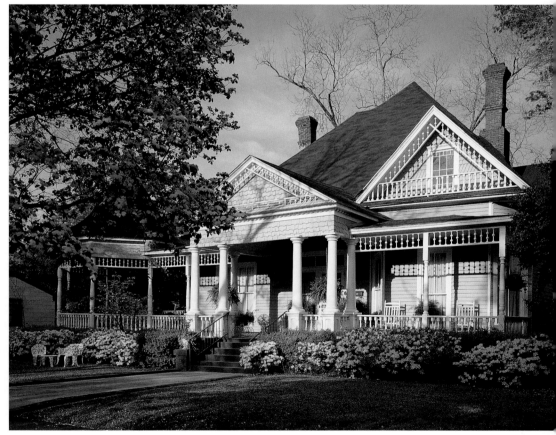

its historic district where the first letters of the early streets spell the last name of Seth Lore, a pioneering settler. Today that incredibly well-preserved area is known throughout the world for its historic houses and the annual spring pilgrimage. Many of these mansions are crowned by a belvedere which has become something of a town icon. A servant at Dean-Page Hall

*E*arly twentieth-century houses like the Russell-Jarrett House (above left), *a Neoclassical design completed in 1905, help to round out the representation of American architecture in Eufaula. That Eufaula icon, the cupola or belvedere, adds a whimsical touch to the Cato-Smith House (top), 1858, being a replica of the house. The simple beauty of the Victorian era's Queen Anne style (1880-1900) is shown in the Skillman-Simms House (above), 1891.*

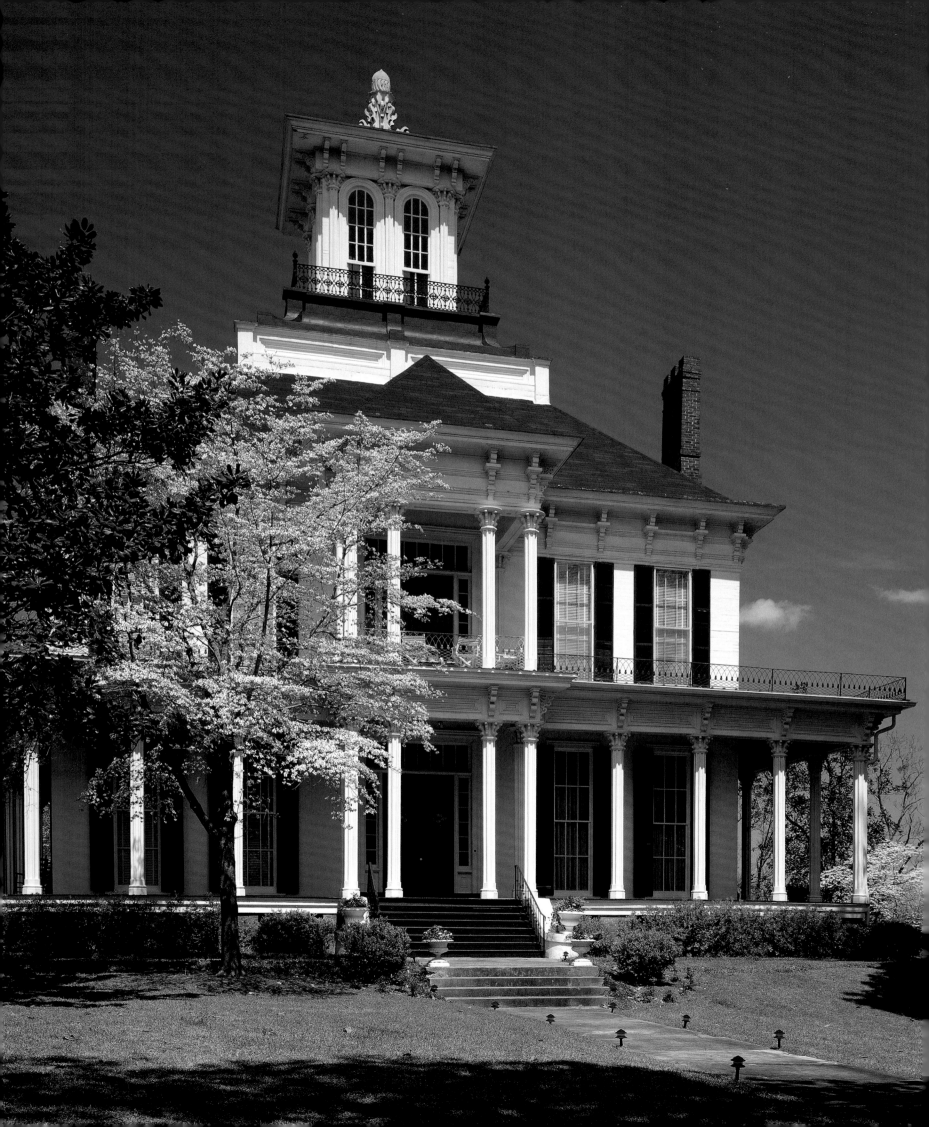

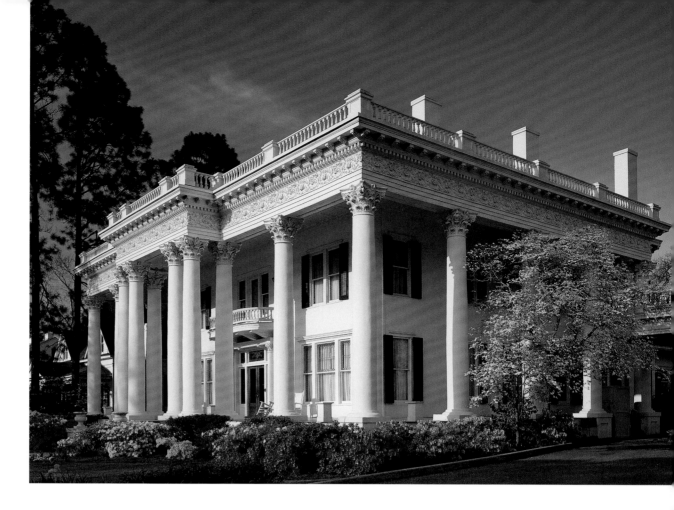

*K*endall Manor (opposite), *1872, is a fine example of Eufaula's Italianate mansions crowned by belvederes. Shorter Mansion (above right), 1906, is owned by the Eufaula Heritage Association and is open for visitors, as well as being a regular on the Eufaula Pilgrimage held each spring. Azaleas surround the Holleman-Foy House (below right), 1907, located in the Seth Lore Historic District.*

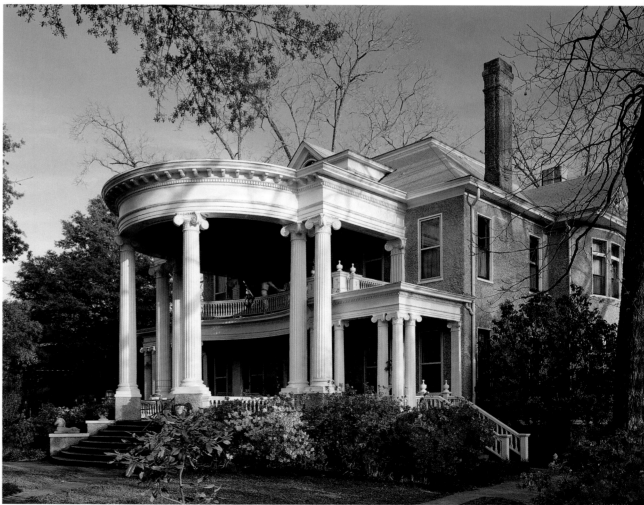

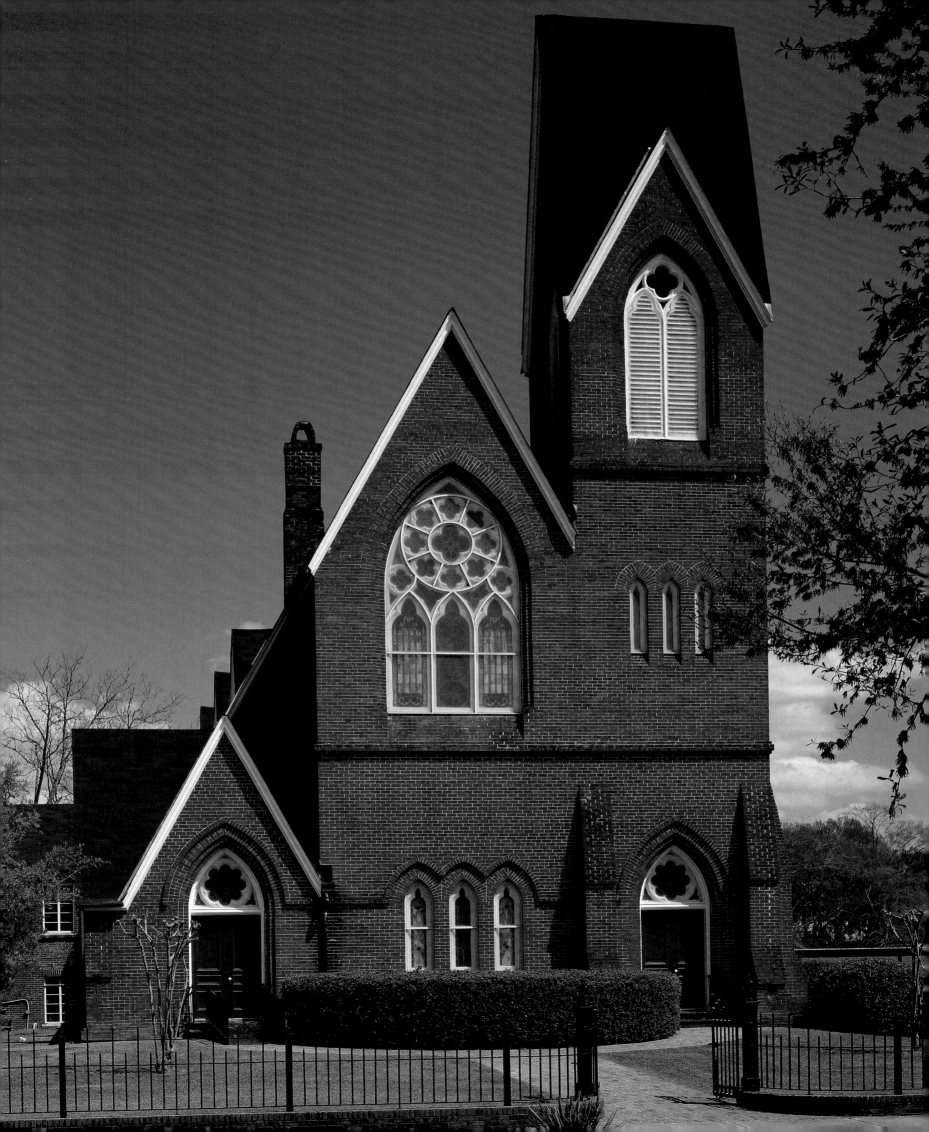

*M*any of Eufaula's commercial buildings and churches, such as the First Presbyterian Church, 1869 (opposite), *the Old City Jail* (below), *1882, and the Reeves Peanut Company, 1903* (right), *were built after the Civil War.*

reputedly had only one job, to clean the cupola's windows and keep an eye on approaching bad weather. A whimsical touch is found in the cupola atop the Cato-Smith house which is a replica of the house itself.

Though there is still some commercial traffic on the river, the creation of Lake Eufaula in the mid twentieth century led to a boom in recreational water sports which replaced the commercial shipping of the once busy port. But Eufaula's three-day pilgrimage with its 700 volunteers and year-round organization keeps the spirit of the past alive. For visitors, departure from Eufaula at pilgrimage time is never easy. There's always one more story to hear, or one last listen to the gospel choir from St. Luke's A.M.E. Church. Or there's another of the 700 historic sites to drive by on the way out of town. As the title of local author Jim Buford's book indicates, Eufaula embodies *The Kindness of Strangers, the Best of Times*. This delightful town is, indeed, a hard place to leave.

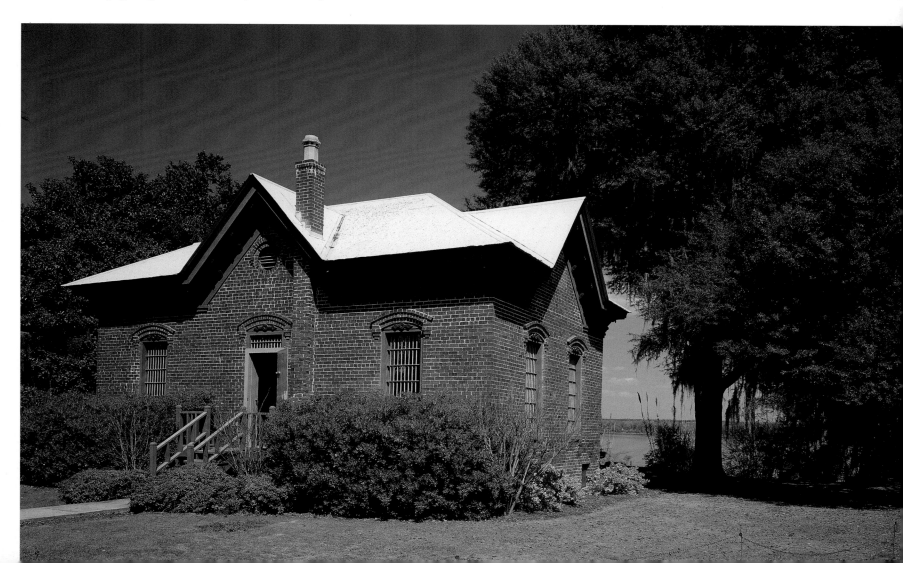

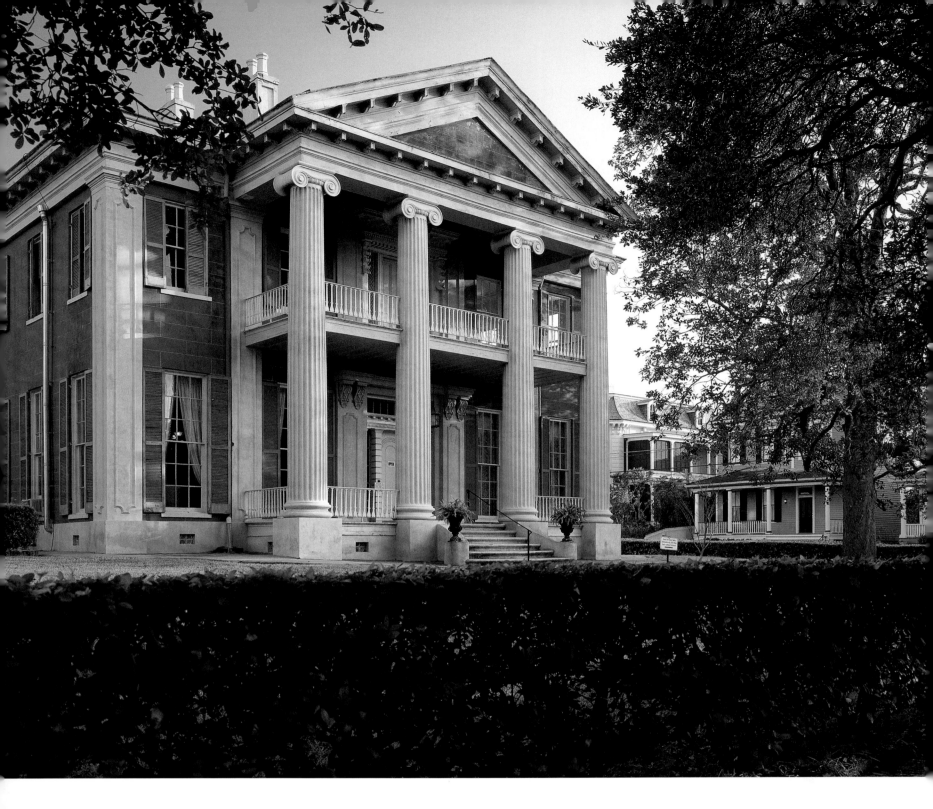

Natchez
MISSISSIPPI

NATCHEZ FIRST FLOURISHED IN THE cotton boom of the early 1800s, and by mid-century was the one of the wealthiest cities per capita in America. Natchez in Mississippi, and Charleston in South Carolina, stood as civilized bookends to the entire South. For the most part, Natchez citizens engaged in the trade of cotton from their perch on the Mississippi River, and built "suburban estates," massive town houses set on twenty or more splendidly landscaped acres. They have no equal, anywhere, when taken as a collection.

The richness of this town's heritage has evoked a latter-day wave of pilgrimages, publishing, antiques

forums, and opera festivals. All of it draws energy from the houses. The houses are beautifully preserved and passionately attended to by their owners, and are the fortunate beneficiaries of the Natchez Pilgrimage. In 1931 a handful of local garden club members started a simple tour of homes that has evolved into one of America's outstanding cultural tourism events, the famous Natchez Pilgrimage. For the last fifty years, the Natchez Garden Club and the Pilgrimage Garden Club have received the world each spring and fall. Often in antebellum dress, the women of Natchez welcome visitors on the beautiful porches,

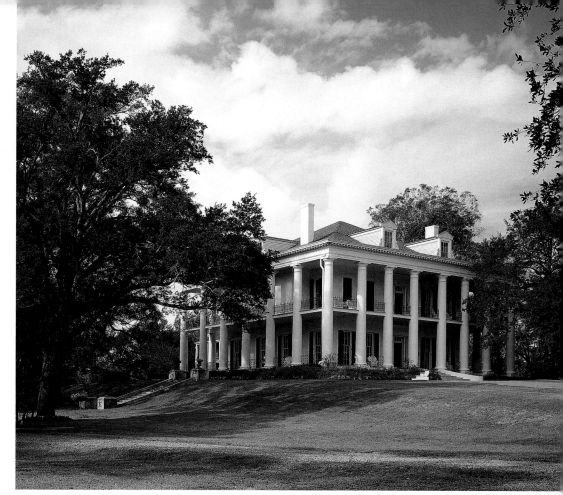

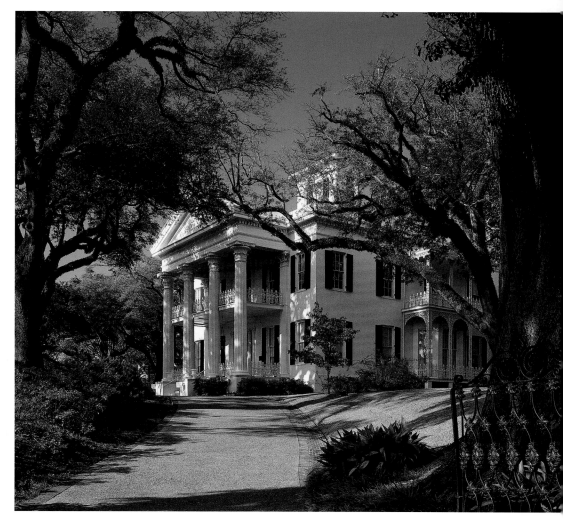

*C*ompleted in 1858, Magnolia Hall (above) was the last of the great mansions built in Natchez before the Civil War and is now owned by the Natchez Garden Club. Houses like Dunleith (above right), 1856, represent the maturity of the Greek Revival period in Natchez. Stanton Hall (right) was completed in 1857 and is beautifully preserved and owned by the Pilgrimage Garden Club.

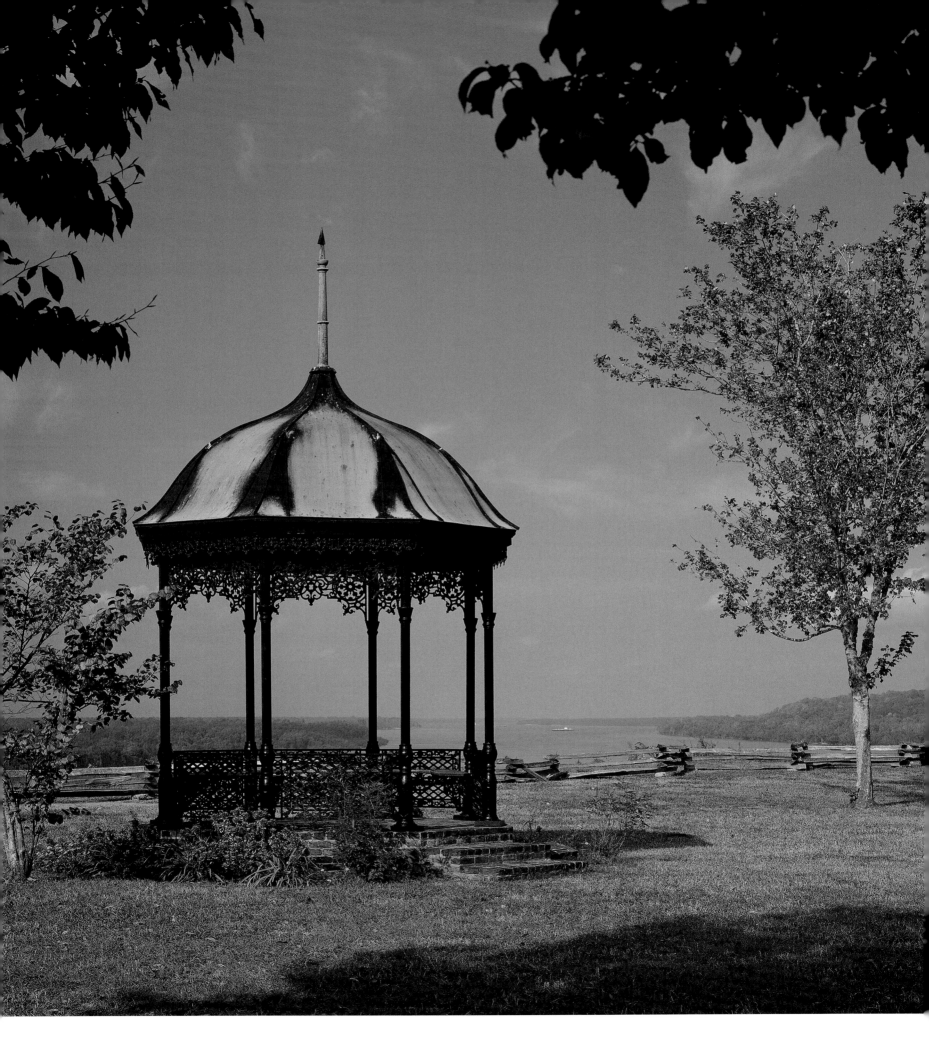

or galleries, as they are called in Mississippi and Louisiana.

Natchez's eight National Register districts are filled with beautiful architecture from the Federal period to the Victorian. But it is the massive white-columned mansions of the Greek Revival period which seductively lure lovers of historic houses from all over the world. Without the efforts of the Pilgrimage volunteers and the diligent Historic Natchez Foundation, Natchez and its houses could well have yielded to a post-bellum decline, suffering the peeling of white paint and rotting columns. But as with the venerable Natchez Trace, an ancient buffalo trail now preserved as a national parkway, the town persists in its splendor and charm because of the dedication of its people.

A perfect view of the Mississippi River flowing past Natchez is offered from this Victorian bandstand (left).

Linden (below), 1800, is renowned in Natchez as an architectural gem of the Federal period which lasted in America from 1780 until 1820.

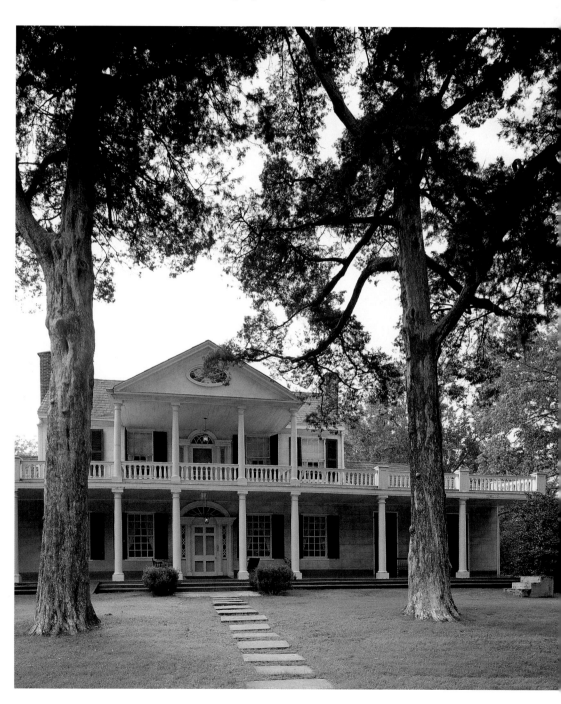

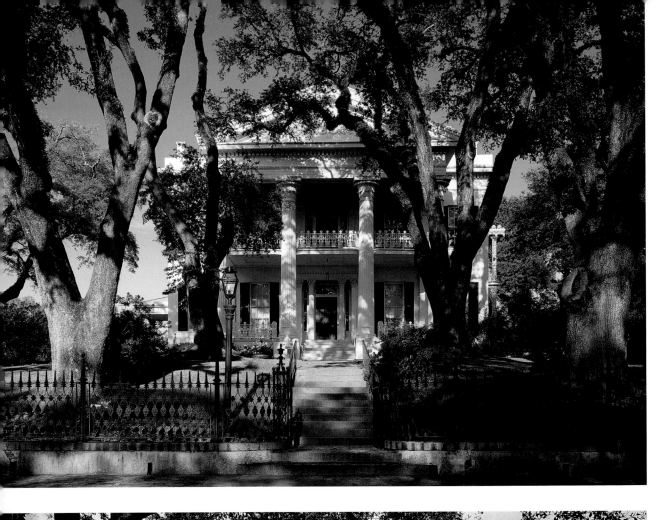

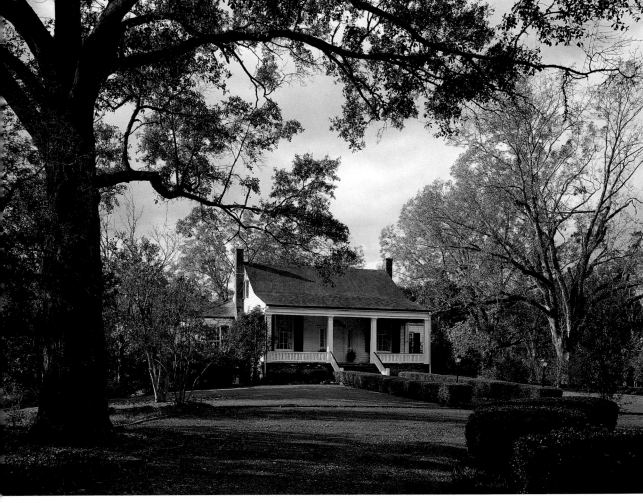

Stanton Hall (front view) (above left) is a National Historic Landmark and occupies a city block in Natchez. It took over five years to build. Mistletoe (left and opposite), 1811, is compact in size, yet appreciated for its perfect scale. The peaceful grounds provide a natural place for a walk on a fine day.

St. Francisville

LOUISIANA

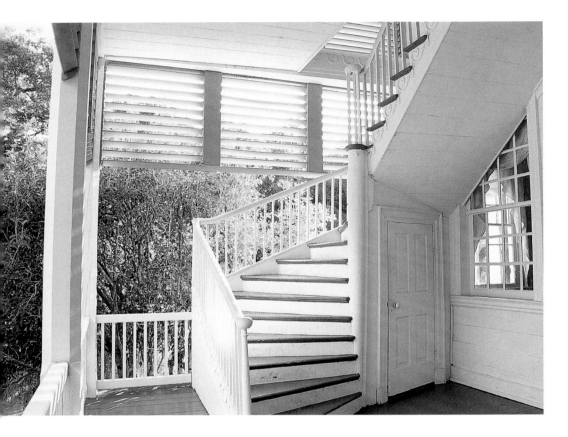

WEST FELICIANA PARISH, IN Louisiana's romantic plantation country, blends a unique mix of Spanish and English heritage with a predominant French influence. Part of the vast and wealthy early nineteenth-century culture that followed the River Road from New Orleans to Natchez, St. Francisville is Louisiana's second oldest town. It is rich in historic structures, some of which have become so romanticized that it is difficult to distinguish myth from fact. Is Myrtles Plantation really the most haunted house in America? Would azaleas only grow as tall here? Who knows.

Spanish monks from nearby Point Coupee Parish first used the bluffs above the river for burial grounds as early as 1730, and named it for their patron saint, St. Francis. Later, when the king of Spain opened the area, known as Spanish West Florida, for settlement, newcomers arrived from Virginia and other colonies of the Eastern seaboard. By the late eighteenth century, plantation houses such as Oakley, built in 1795, exhibited another strong cultural influence, that of shuttered galleries used in the West Indies to protect houses from the elements. These "raised cottages" also protected the main living area of the house from flooding.

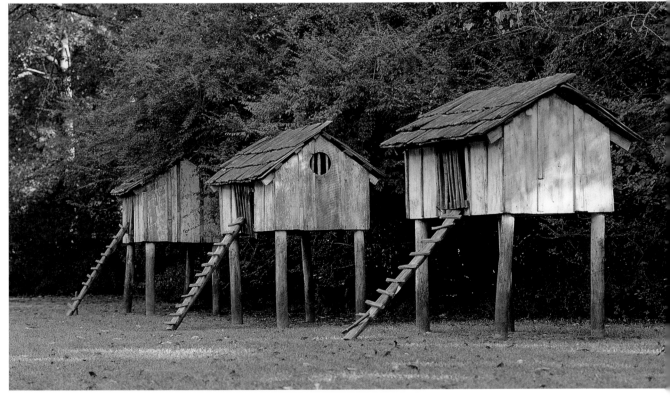

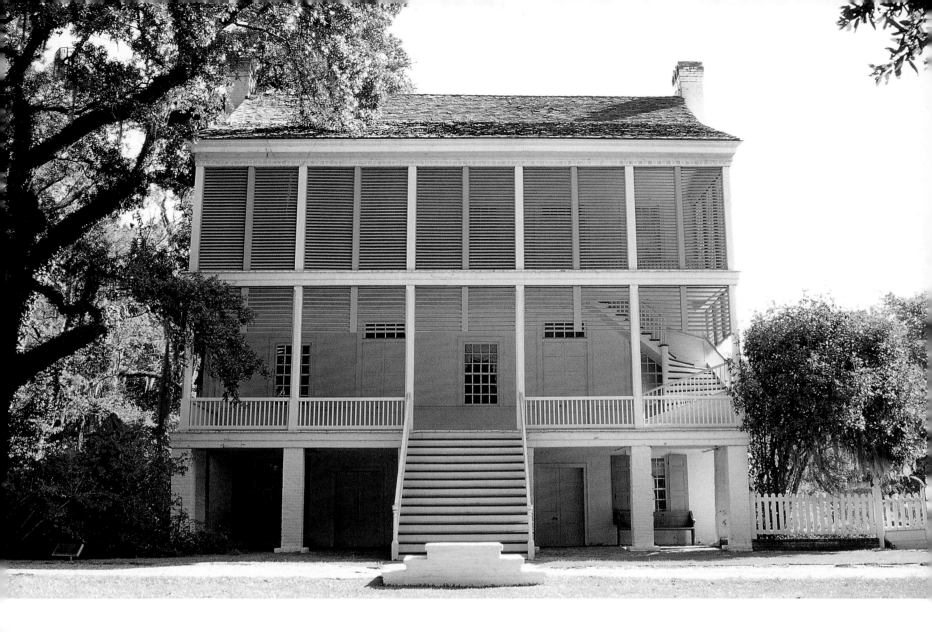

*O*akley House (above *and* opposite above) *at Audubon State Park is a vernacular French Colonial house with grounds, open for visitors. Perched on stilts, the old peacock houses at Oakley (opposite below) are reminders of more colorful times. An elaborate system of shutters protected residents from the stifling heat of south Louisiana (above).*

*A*ll that remains at Afton Villa are these steps leading nowhere (right). After the house burned, the gardens were opened to the public.*

Many of St. Francisville's houses are open daily and others are open each March during the Audubon Spring Pilgrimage. The historic area lists 146 structures on the National Register. The area has been dubbed "Audubon Country" even though John James Audubon, the legendary nineteenth-century naturalist painter, only lived and worked in the area for a short time. He completed 80 magnificent drawings of birds here during the early 1800s, recognizing the region's importance as an incredible panorama of nature where a rich combination of river, flowers, trees, and birds creates one of contemporary America's lushest and best-preserved landscapes.

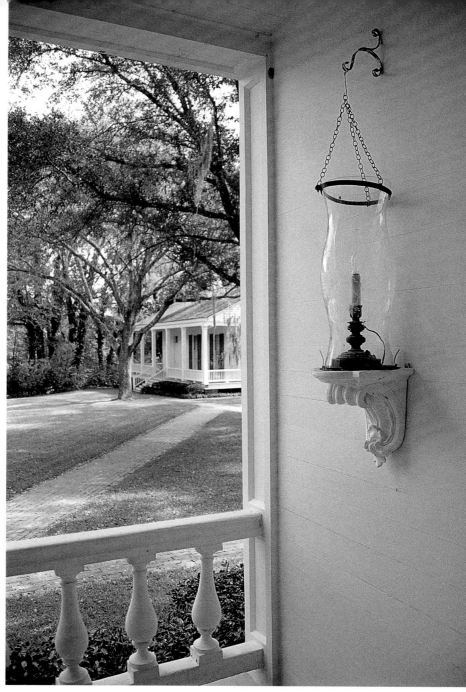

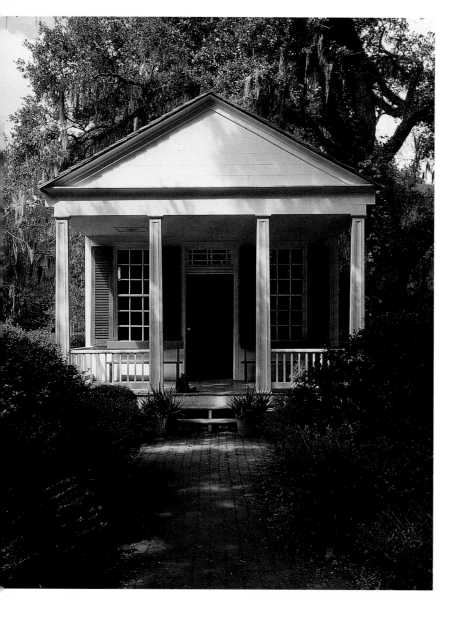

*R*osedown (opposite) *is legendary among the romantic Greek Revival houses in Louisiana's Plantation Country where a small dependency* (left) *served as the doctor's office. A vast sweep of Rosedown's lawn is visible from this porch view* (above).

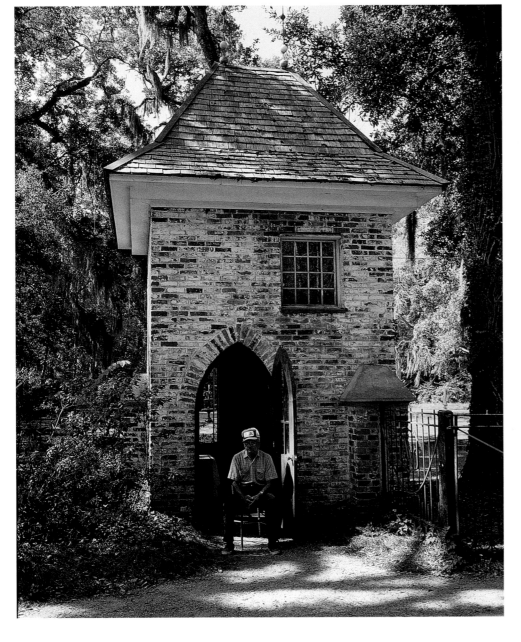

*O*akley's weathered stable (left above) *stands in the cool shade of St. Francisville. Another small structure, this one in brick, marks the entrance to the gardens at Afton Villa (left).*

*T*he cement benches from the Julius Freyhan School
(above) frame the old First Presbyterian Church in
St. Francisville. Neither the church nor the school is
in operation as such; both structures are in use as offices.

Churches and Cemeteries

Churches and Cemeteries

Every Saturday night at six o'clock, church bells in Fredericksburg peal above the town and resound through the surrounding Texas Hill Country. Church has always been important in the everyday life of the small-town South.

The earliest churches were Roman Catholic, founded by Spanish and French explorers in the coastal areas of the Gulf of Mexico and the Atlantic. Before long, however, the Anglican Church established parishes along the Atlantic Coast and built churches like the tiny, yet exquisite, St. Thomas Church, 1734, in Bath, North Carolina, the state's oldest existing church structure. In the churchyard stands a bust of an Anglican bishop brought from Longleat House near Bath, England.

Smaller sects such as the Quakers and Shakers found favor in the early nineteenth-century South, but had all but disappeared by the early twentieth century. Known as the Fairfax Meeting, the Quaker congregation in Waterford, Virginia, continued until 1929 when the meeting was "laid down." Today the Meetinghouse has been a private residence for two generations, but the solid, unembellished Meetinghouse at the Shaker village of Pleasant Hill, Kentucky, has been restored as an historic site and is open for visitors.

Most of the South's temple-like Greek Revival and Gothic Revival churches and synagogues, built in the late nineteenth century and the early twentieth century, have endured throughout the South as active houses of worship for Baptists, Methodists, Presbyterians, Episcopalians, Jews, and Catholics. Architectural historians point out that churches and other institutions are generally more stylistically correct than houses and, indeed, the churches of the Piedmont reflect the influence of men like Robert Mills, one of America's most acclaimed nineteenth-century architects. He designed the Washington Monument as well the Presbyterian Church in Camden, South Carolina. George Edwin Walker, Charleston architect, designed York's First Presbyterian Church in 1846, although the construction of the Gothic Revival building was not completed until after the Civil War.

Preceding pages The Confederate Cemetery is shielded by protective trees in Fayetteville, Arkansas.

This statuary angel (below) watches over the grounds of Grace Episcopal Church in St. Francisville.

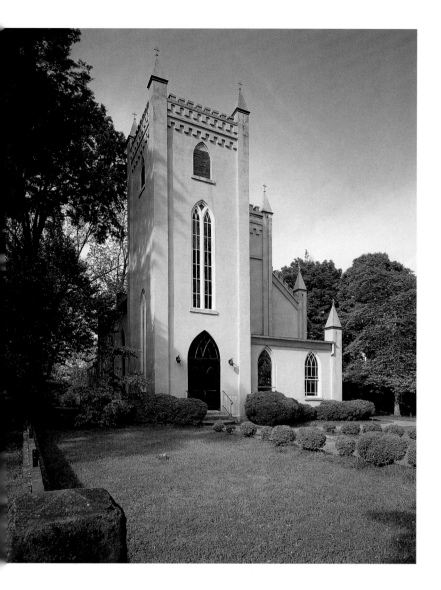

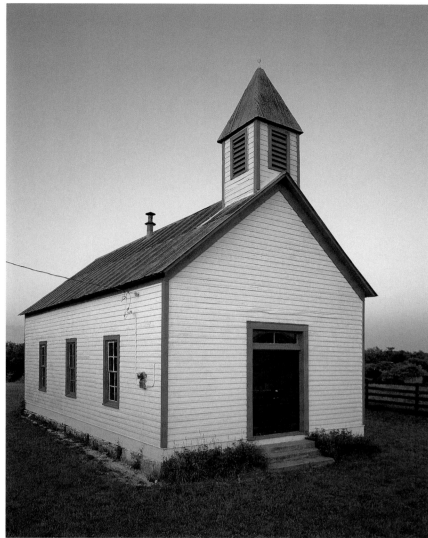

Wednesday night suppers, dinner in the grounds, and home-comings were common occurrences at churches throughout the South, such as Fredericksburg's Christian Methodist Episcopal Church, built in 1877 on land given to the town's black congregation. Until the late twentieth century, Bath's tiny St. Thomas' Church hosted an annual reunion each June for all the brides married there.

Each church, of course, has its own history, including many stories which have survived for centuries, often defying reason. Grace Episcopal Church in St. Francisville, Louisiana, was completed just two years before the Civil War. Damaged by Union gunboats after the war's start, the church members, even so, were able to set aside their understandable resentment when a Union gunboat captain took his own life. Both sides ceased fire long enough to bury him in the church's cemetery. Just for a moment, in a churchyard, the war stopped.

The Episcopal Church of the Good Shepherd (above left) is in York, South Carolina. The simple beauty of the Christian Methodist Episcopal Church (above) adorns the Texas countryside in Fredericksburg.

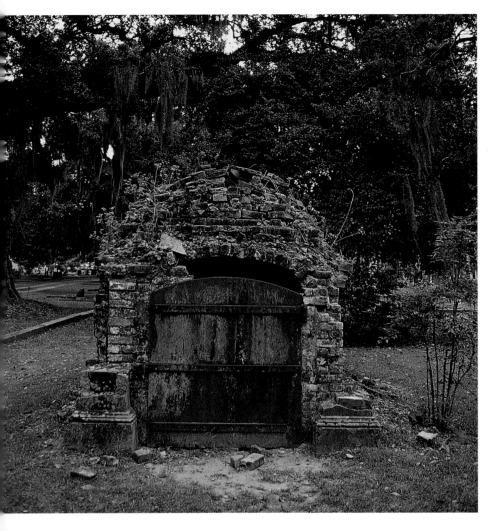

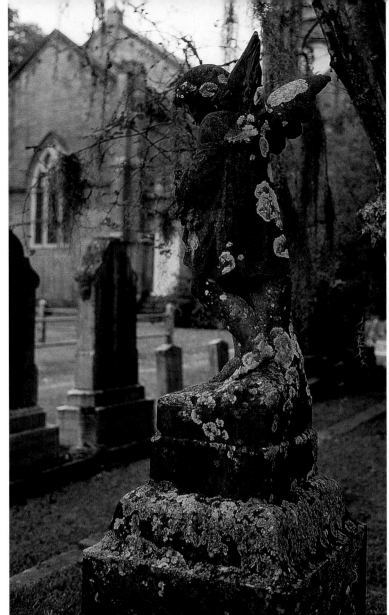

A nineteenth-century brick burial vault (above left) and a cemetery angel (above) can be found in the peaceful cemetery at Grace Episcopal Church in St. Francisville. The gravestones of unknown Confederate soldiers (left) stand in a Madison cemetery; this Confederate Cemetery (opposite) is outside Fayetteville.

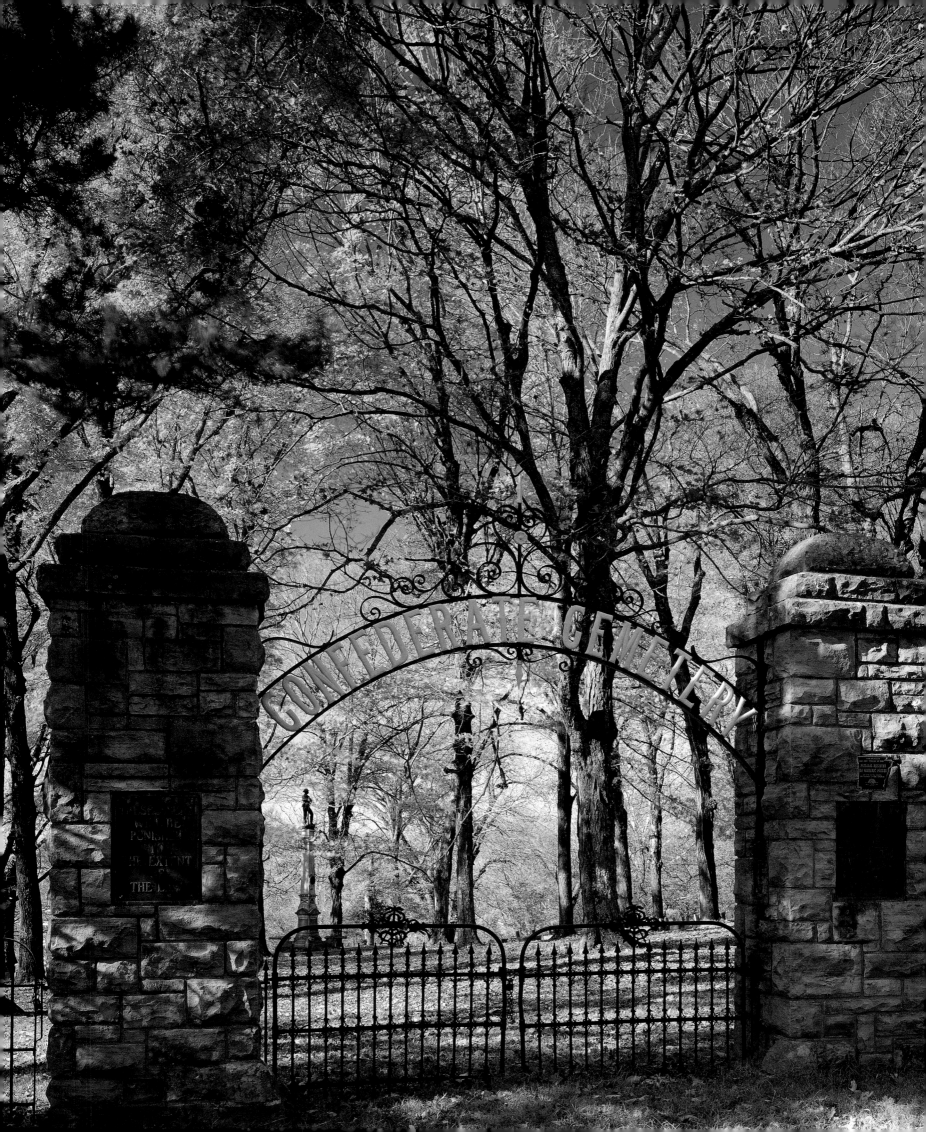

*S*t. Peter's Episcopal Church (left), completed in 1860, is the oldest existing church in Oxford. The octagonal Seney-Stovall Chapel (below) stands on the grounds of what once was the Lucy Cobb Institute, a highly proper finishing school for young ladies in Athens, Georgia. The rich foliage of the Cumberland Plateau provides a backdrop to the cemetery at Beersheba Springs (opposite).

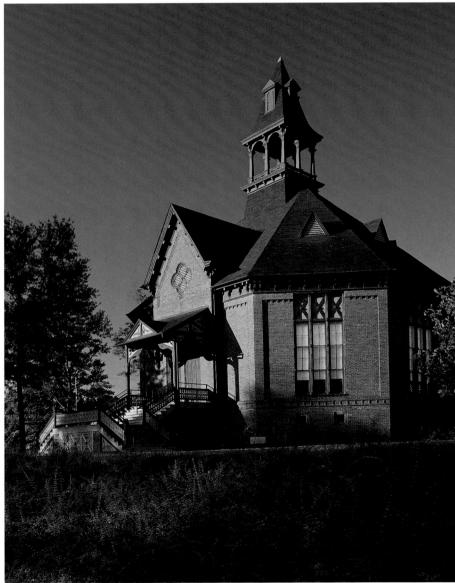

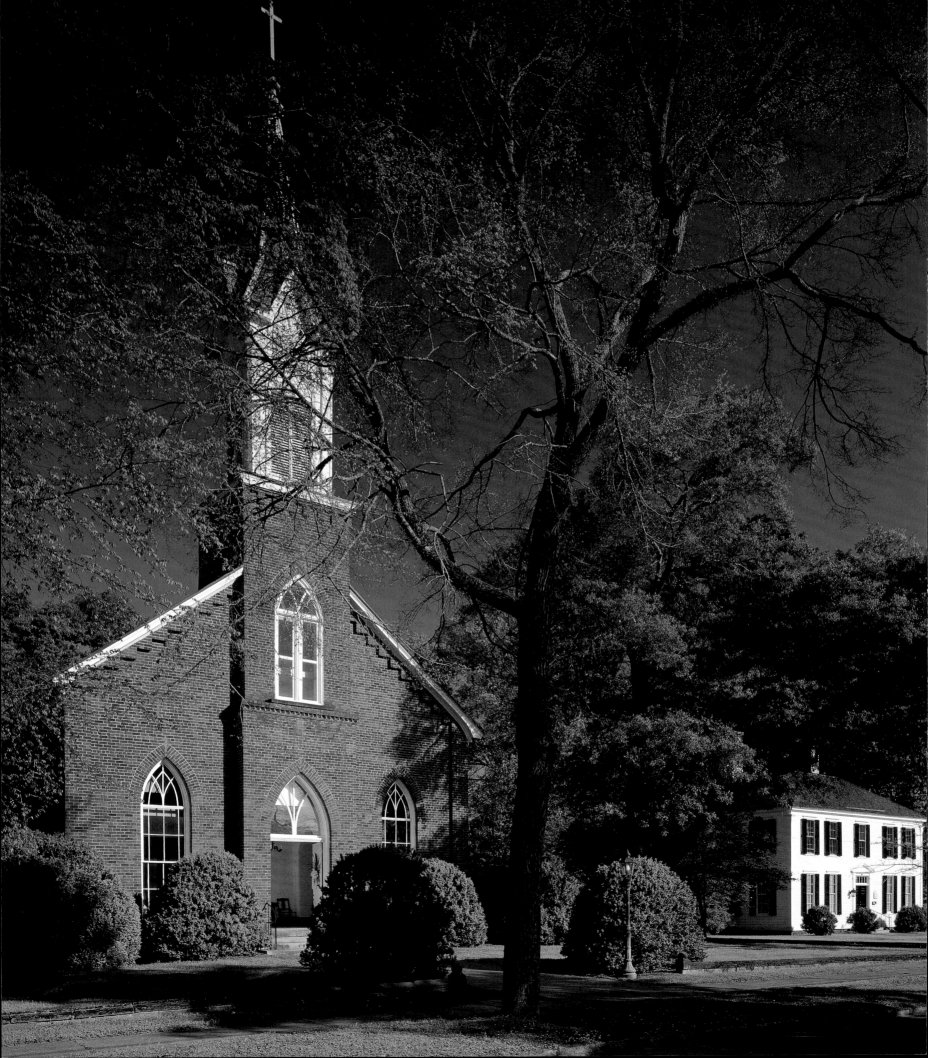

*C*hurches of the Georgia Piedmont include the *Episcopal Church of the Advent in Madison* (opposite) *and the Episcopal Church of the Mediator in Washington* (below).

THE UPCOUNTRY

As evanescent as the sweet aroma of barbecue, Southern culture often vanishes under too close inspection. Yet, even in this indefinable region which extends from the Appalachian Mountains to the Texas Hill Country, falling into no natural category and loosely termed "the Upcountry," a shared spirit does most definitely live. Whether born in the fierce pioneer effort required of their ancestors to establish outposts during the nineteenth-century westward migration or in an intangible, like the linguistic line that separates hill-country and plantation speech, a fierce independence holds fast generation after generation.

Most of the towns and villages were founded in the early nineteenth century. Fayetteville, Arkansas, was settled by Appalachian residents who arrived about the time Arkansas achieved statehood in 1836. Beersheba Springs, Tennessee, was also discovered in the 1830s when an explorer traveling the Cumberland Plateau happened upon the area's mineral-laden springs; and soon the area was known as one of the South's mystical nineteenth-century healing places. Later the welcome mountain coolness of the Cumberland Plateau enticed summer visitors from Louisiana and Mississippi.

For the most part, the people settling these areas were Protestant, uncompromising in their religion, values and sense of family, and fiercely democratic in principle. It comes as no surprise that many of these Southern mountain villages became home to summer religious assemblies where the faithful could gather for a week of worship and renewal. Debate on political issues was so hotly contested in small towns like Waxahachie that Chautauqua assemblies were created where such famed orators as William Jennings Bryan spoke.
The later settlement of these areas means that most, in comparison to the eighteenth-century coastal and Piedmont areas, are architectural teenagers. In Fayetteville only two Greek Revival houses stand among neighborhoods full of Victorian architecture. Waxahachie, Texas, celebrates its ornate Victorian porches, colors and cupolas with an annual Gingerbread Trail. Fredericksburg, Texas, settled in the 1840s, is home to two indigenous forms of regional architecture, the rock houses built by early German settlers, and the "Sunday house," a small house built for weekend use by hill-country farmers when they came into town for church and shopping.

At the Center for the Study of Southern Culture in Oxford, scholars research the Upcountry, along with the Piedmont, the coastal South, and the river towns, examining their cuisine, history, and heroes. They continually find that there can never be a definitive answer to what is Southern, that it is not one state or region. It is a state of mind.

Exquisite fall color graces a view of the Cumberland Plateau from Beersheba Springs, Tennessee (opposite).

Beersheba Springs TENNESSEE

EVERY YEAR AS THE LEAVES TURN COLOR and the nights grow cooler, the summer residents of Beersheba Springs, Tennessee, face the seasonal closing of their Victorian homes and log houses to return to Nashville, Birmingham, Atlanta, and the twenty-first century. Generations of the same families have retreated to Beersheba Springs for the past one hundred seasons, forming bonds as enduring as the chinking in the old log cabins. Their days on the Cumberland Plateau are filled with hikes to places named Stone Door or afternoons on the porch with ten thousand acres of the Savage Gulf State Natural Area stretched out below them.

Had it not been for Beersheba Cain, who was accompanying her husband on horseback through the mountains in 1833, Beersheba Springs might have

Folk art and porches (below *and* right) *are indigenous to life in Beersheba Springs. Its log cabins are almost a folk-art form unto their own.*

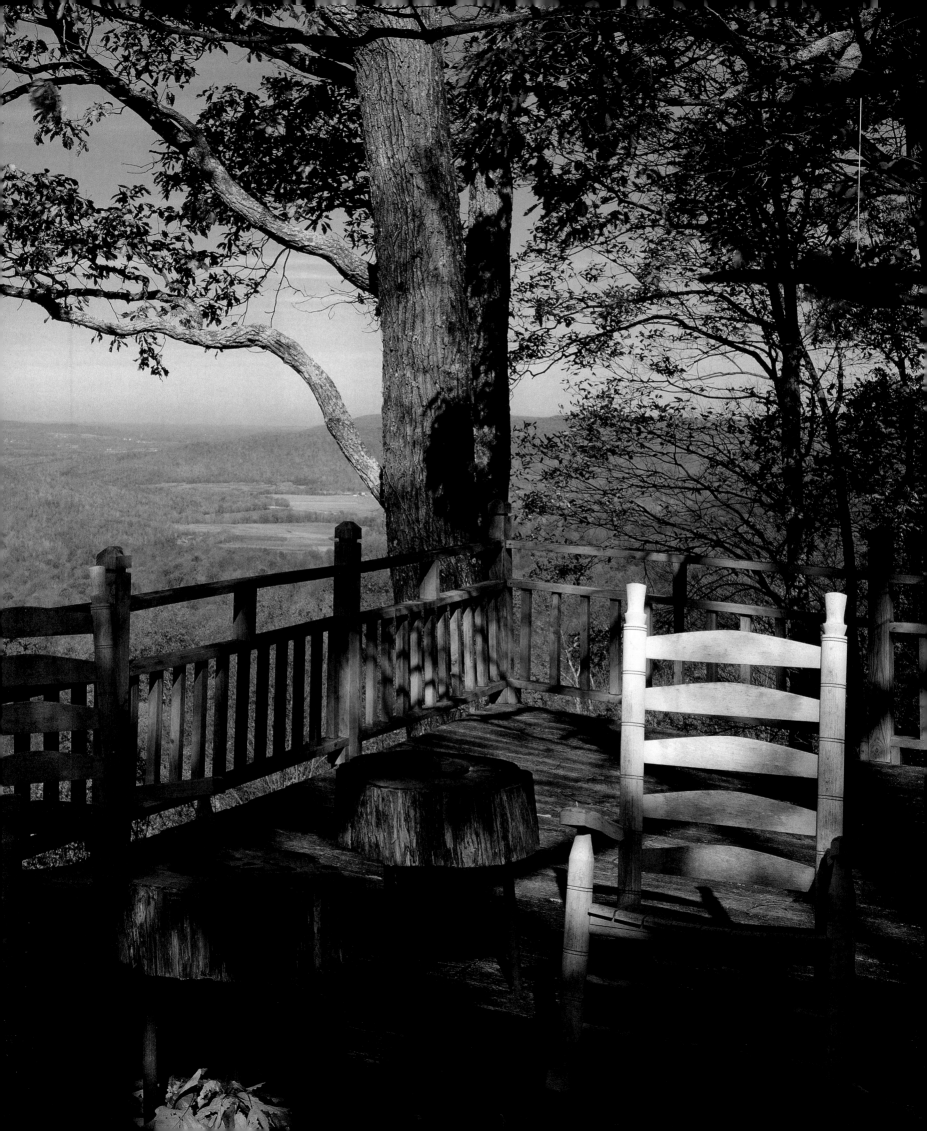

remained nothing more than an isolated land of overwhelming natural beauty. But her discovery of a spring containing chalybeate, a mineral known for its iron content and healing qualities, and other similar springs nearby, quickly earned Beersheba notoriety. Visitors were attracted not only to the springs, but also to the welcome coolness of the Appalachian summer. The Methodists also established an assembly.

Over the years a variety of Victorian and Gothic Revival houses appeared, and the inevitable Beersheba icon, the log cabin, became synonymous with summers on the Cumberland Plateau. The Beersheba Library is a log building constructed in the 1920s with labor from the town's citizens and a donation of books and logs from the Beersheba Library Association.

In the early twentieth century people made the last leg of the trip to Beersheba from the lowlands by ox cart, parents and children with suitcases full of clothes and barrels filled with flour, ready for the summer's stay. Children swam in Blue Hole and at night would head to the old hotel near the Methodist Assembly or to Balancing Rock to watch for shooting stars.

*S*imple *Beersheba pleasures of hiking the mountains or strolling over to Big Don's Market for an ice cream await the residents at Dogwood Hill* (above). *The Beersheba Springs Library* (below) *was built in the 1920s with labor from the town's citizens and a donation of books and logs from the Beersheba Library Association. There are no golf courses or shopping centers in Beersheba Springs, only the rustic beauty of its legendary log cabins* (opposite), *fresh summer vegetables and the ever present spectacular views from the porch.*

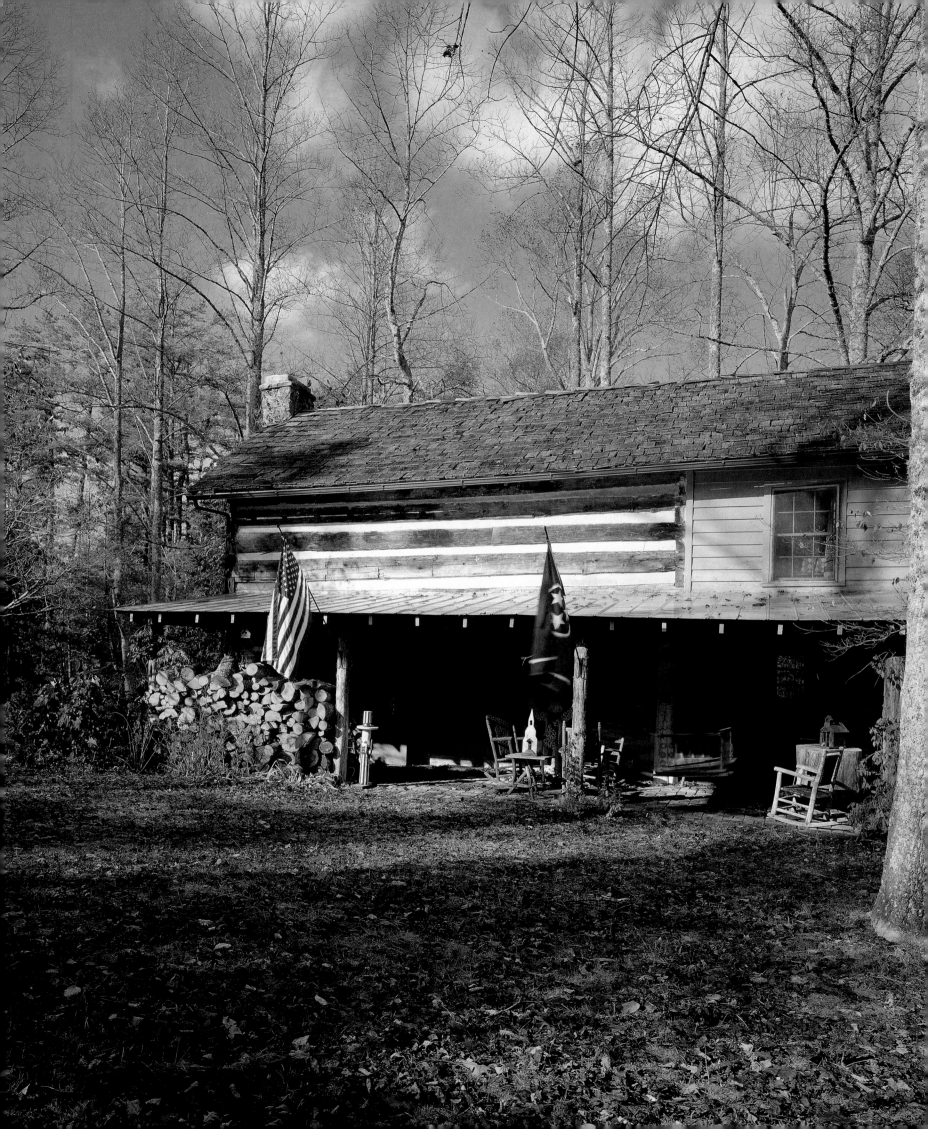

Oxford
MISSISSIPPI

A TOWN JUST CAN'T GET MUCH MORE Southern than Oxford, Mississippi. Hometown to Nobel-Prize-winning author William Faulkner, Oxford, with tongue-in-cheek, calls itself a "novel town." But for all its literary eminence, considering the town's annual Oxford Conference for the Book and the Faulkner and Yoknapatawpha Conference, what is truly novel about the town of Oxford is that it is Southern to the core.

On the campus of the University of Mississippi at Oxford is a repository of the most extensive collection

Farley Hall (below) *on the campus of the University of Mississippi houses the Ole Miss Blues Archive, the most extensive collection of Blues recordings and related material in the world. Built in 1873, the Courthouse* (opposite) *is located on Oxford's famous square.*

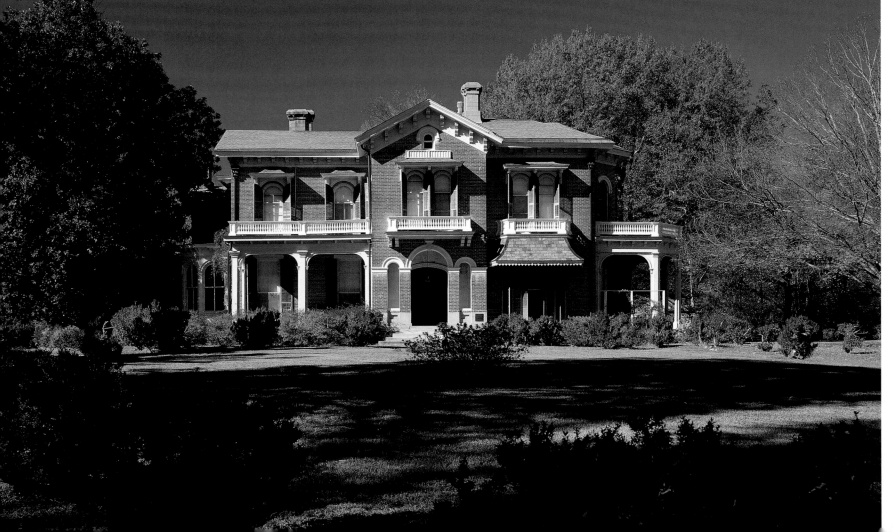

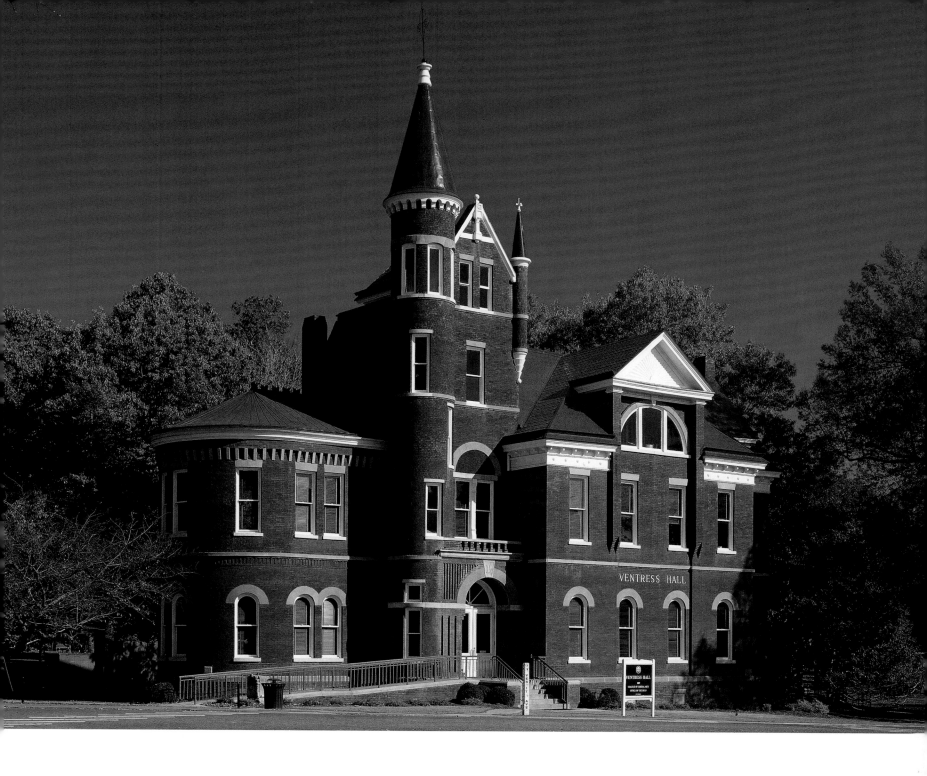

of Blues recordings, books, posters, and photographs in the world. Modestly called the Blues Archive, it documents that most indigenous form of American music which rose from the soul of the South. Since 1977 the Center for the Study of Southern Culture at the university has turned a microscopic eye on the South, examining its mores, folkways, and history. The publication of the Center's *Encyclopedia of Southern Culture* in the late 1980s elevated regionalism to an academic plateau not yet achieved by any other area in America, and authenticated the Center's mission to be the finest academic program in the nation with a focus on Southern studies. The Center has

sponsored symposia on diverse topics such as "Syllabub and Sin: Drinks and Drinking in the South."

If the mere mention of such topics were not enough to whet the palates and imagination of participants, they would have only to turn to any one of Oxford's local restaurants, likely to have the word 'Rebel' somewhere in its name, where the menu will include biscuits, barbecue ribs, fried chicken and catfish. It is not difficult to understand why Oxford, a small campus town in the heart of Mississippi, shows up on just about everyone's list of the "Best Small Towns in America." This town is certainly one of the most concentrated expressions of Southern style.

The University of Mississippi was founded in the dining room of the Barksdale-Isom House (opposite above), *1835. The house is a National Historic Landmark. Ammadelle* (opposite below) *also has National Historic Landmark status; this Italianate villa was built in 1859. Originally built as the library for the University of Mississippi in 1889, Ventress Hall* (above) *is today the home of the school's art department.*

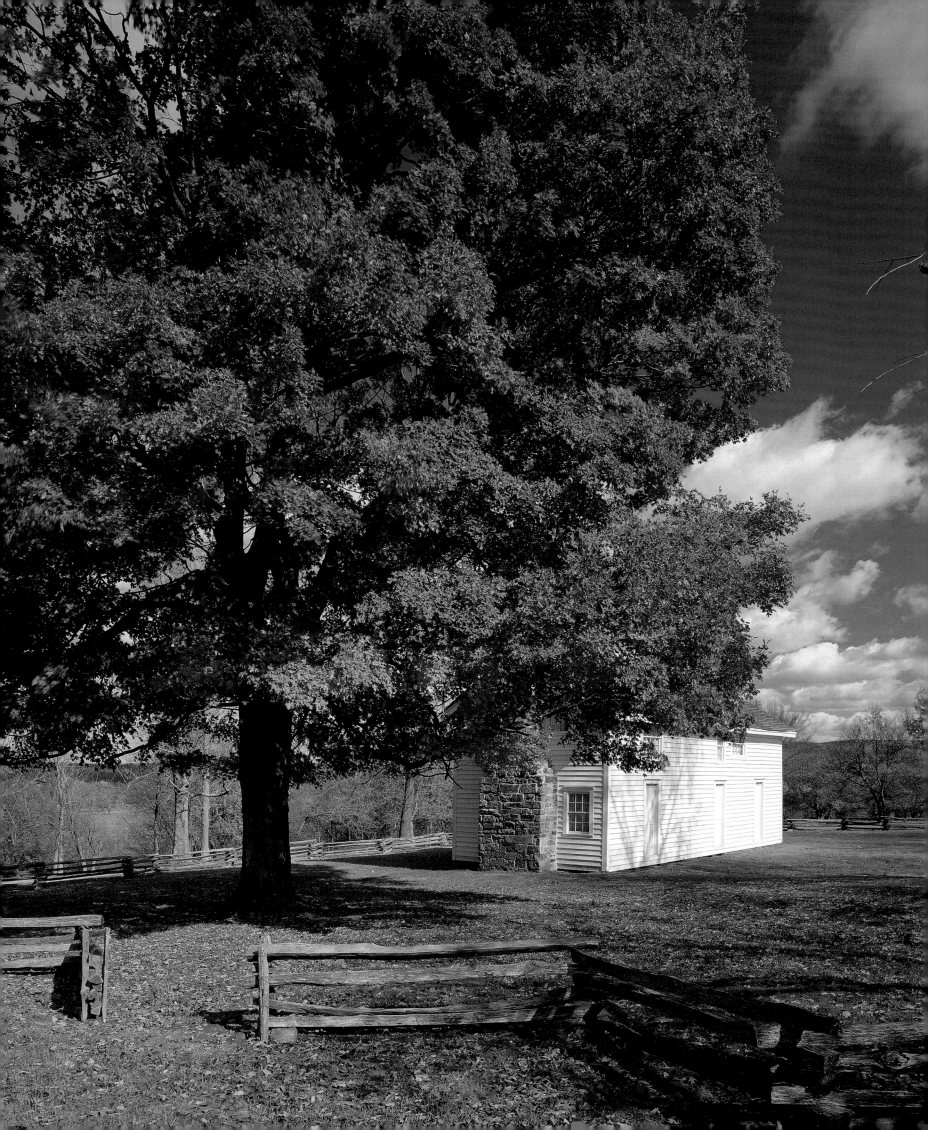

Fayetteville

ARKANSAS

Located in Prairie Grove Historical Park, outside of Fayetteville, Arkansas, the Latta House (below), c. 1840s, is a fine example of the early log architecture of Arkansas. The Borden House at Prairie Grove (opposite) is also part of the park's architectural museum.

ORIGINALLY PART OF THE MAMMOTH Louisiana Purchase, Fayetteville nestles comfortably in the foothills of the Ozark Mountains where the first settlers built new homes in 1830 at the same period that Arkansas obtained statehood.

Fayetteville has kept intact a wealth of historical buildings and houses to be enjoyed by visitors to the area, many of which date from the Civil War period. A 306-acre park on the outskirts of Fayetteville, which marks the Battle of Prairie Grove, fought in 1862, is an

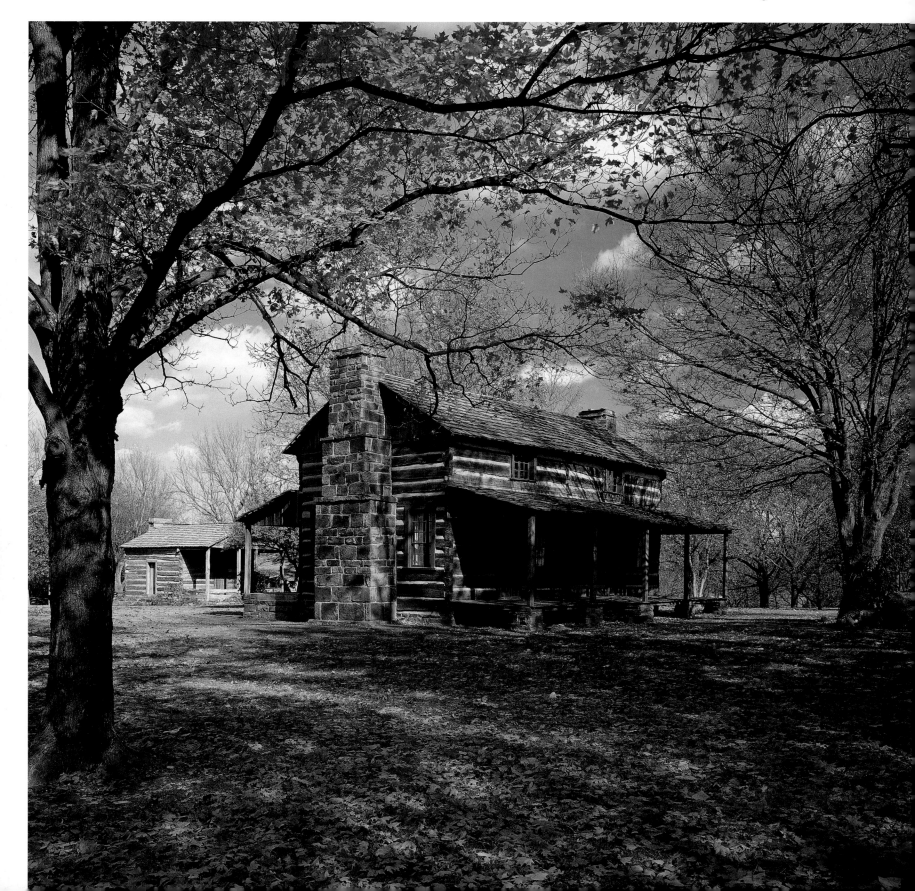

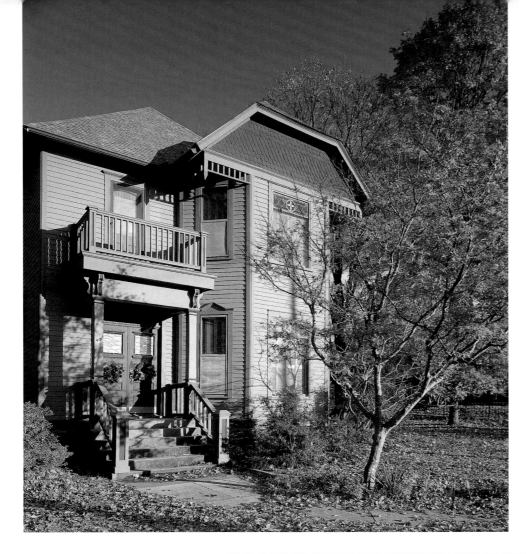

architectural museum with such Arkansas treasures as the Latta House, an outstanding example of early Arkansas log construction.

In town, Headquarters House, 1853, which served as headquarters for both Union and Confederate forces during the Civil War, is maintained by the Washington County Historical Society and open to visitors. The historic neighborhoods in Fayetteville are predominantly Victorian, with later examples of the Neoclassical style mixed in. Many of the houses are surrounded by sturdy walls of locally mined limestone.

Downtown, Central Square hums with market-days on Tuesdays, Thursdays, and Saturdays from April through October. A fixture since 1975, the colorful open-air market is held under a canopy of maples, sweet gums, and oaks. But not even the colors of the autumn market can compete with the wave of red and white around Old Main and the football stadium on a fall afternoon when the University of Arkansas's Razorbacks are playing football at home.

No longer a brash frontier town, Fayetteville has become essentially American as well as Southern.

The Webster-Hunnicutt House (above), 1895, is a Fayetteville example of the late Victorian form of architecture known as the Eastlake style.

The Washington County Historical Society operates Headquarters House, 1853, as a house museum (right).

The Milburn-Appleby-Ambrose-Lewis House (above), 1887, and the Cravens-Lewis House (right), 1889, are two of Fayetteville's many examples of late nineteenth-century architecture.

Overleaf Fayetteville lies at rest in the foothills of the Ozark Mountains.

The sturdiness of the Texas Hill Country town of Fredericksburg is well expressed in the limestone blocks of these two buildings.

Fredericksburg

TEXAS

FREDERICKSBURG EMBRACES ITS German heritage. But for more than 150 years, the town has also glorified the gutsy pioneer spirit that all Texans rightfully think of as their own. Named for the King of Prussia, Fredericksburg was settled by German immigrants who negotiated a treaty with the Comanche Nation that opened up 3,800,000 acres of land for settlement.

The German pioneers quickly became prosperous farmers and an agricultural tradition began in Gillespie County which has made it, among other things, the largest peach producing county in what is now the great state of Texas. They built their sturdy houses out of Texas stone and to this day those rock façades symbolize the Hill Country. Festivals such as Bundes Schuetzenfest, an annual German shooting contest, Zweite Weihnachten, "second Christmas," and Kinderfest, a children's festival, still evoke the area's German influence.

Vignettes of pioneer life can be discovered throughout the county. The Pioneer Museum Complex includes a stone smokehouse, a typical area limestone house, the White Oak one-room schoolhouse, and the Walton-Smith log house. One of the most unusual components of this architectural collection is the Weber Sunday House, an architectural style unique to

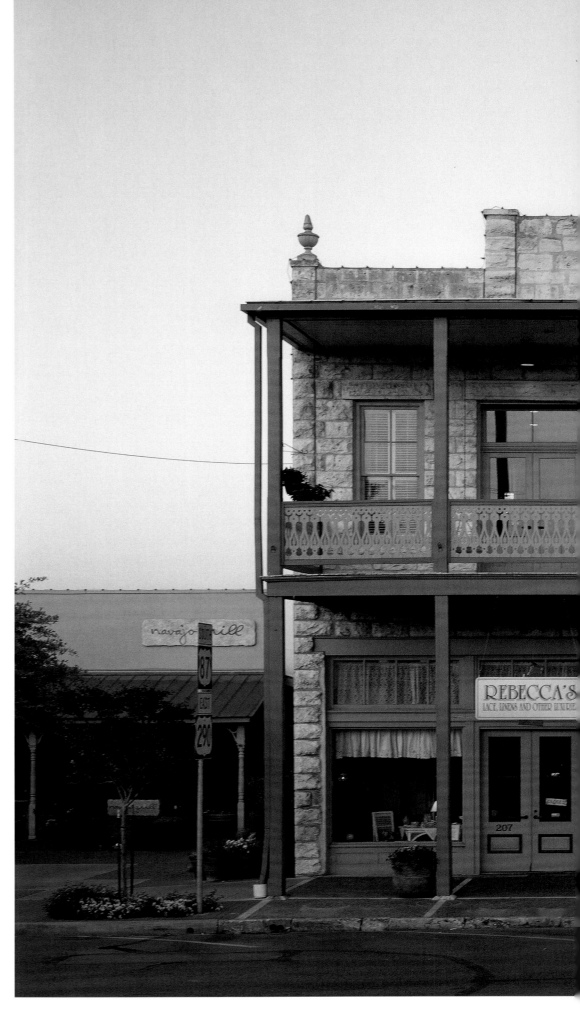

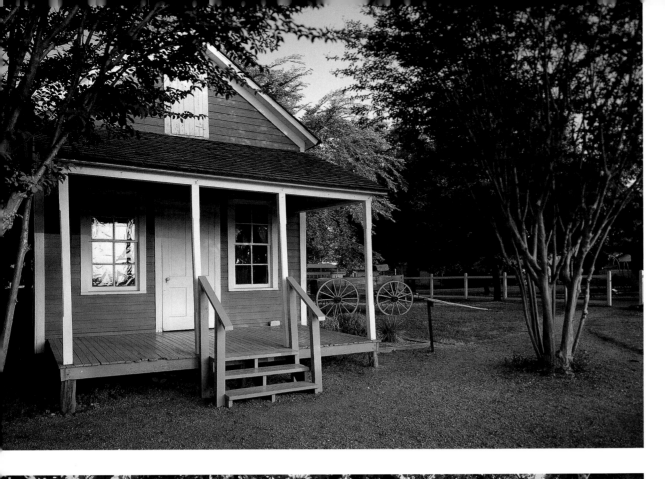

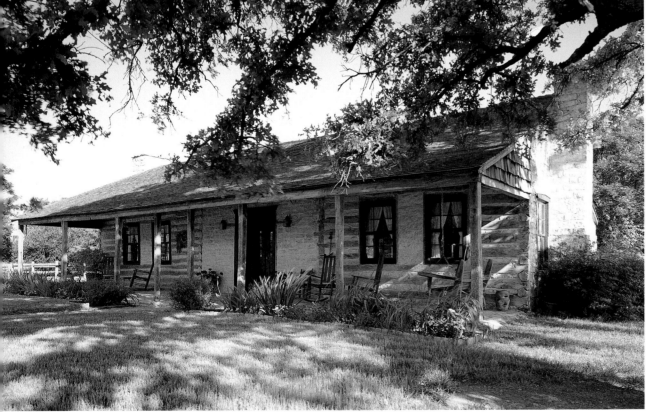

The Weber Sunday House (top), c. 1904, is typical of the small in-town houses built by farmers and ranchers for their trips to church or the shops. Places such as the Pioneer Homestead (above), c. 1850, were the birthplaces for many independent Texans who enriched the Southwest with their pioneer spirit.

Fredericksburg. Sunday houses were small dwellings used by farmers when they came to town to attend church or conduct business.

Area history is also highlighted at the nearby Lyndon B. Johnson State Historical Park where a working turn-of-the-century German Hill Country

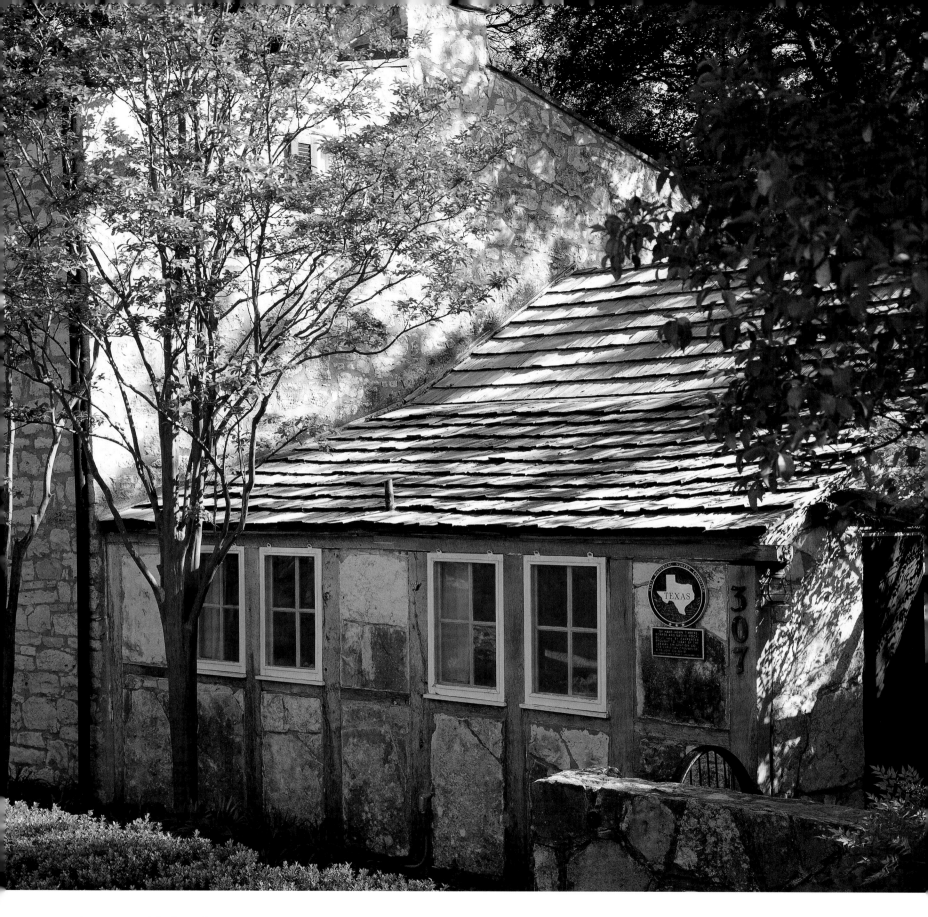

farm is given life through interpreters in period dress. Johnson, the Hill Country's best known native son, was the thirty-sixth President of the United States.

Almost three hundred bed-and-breakfast inns dot the surrounding countryside, and they are as true to the area heritage as the town itself. There are enviable choices, including a 1917 Texas ranch house, a log cabin, a renovated stone barn or a Sunday house. But the best way to see the Hill Country is to saddle up with any one of the local trail rides and experience a countryside that is as lasting as the local rock and as colorful as the Texas bluebonnets.

The Christian Crenwelge House (above), c. 1855, is made of half-timber construction with stone.

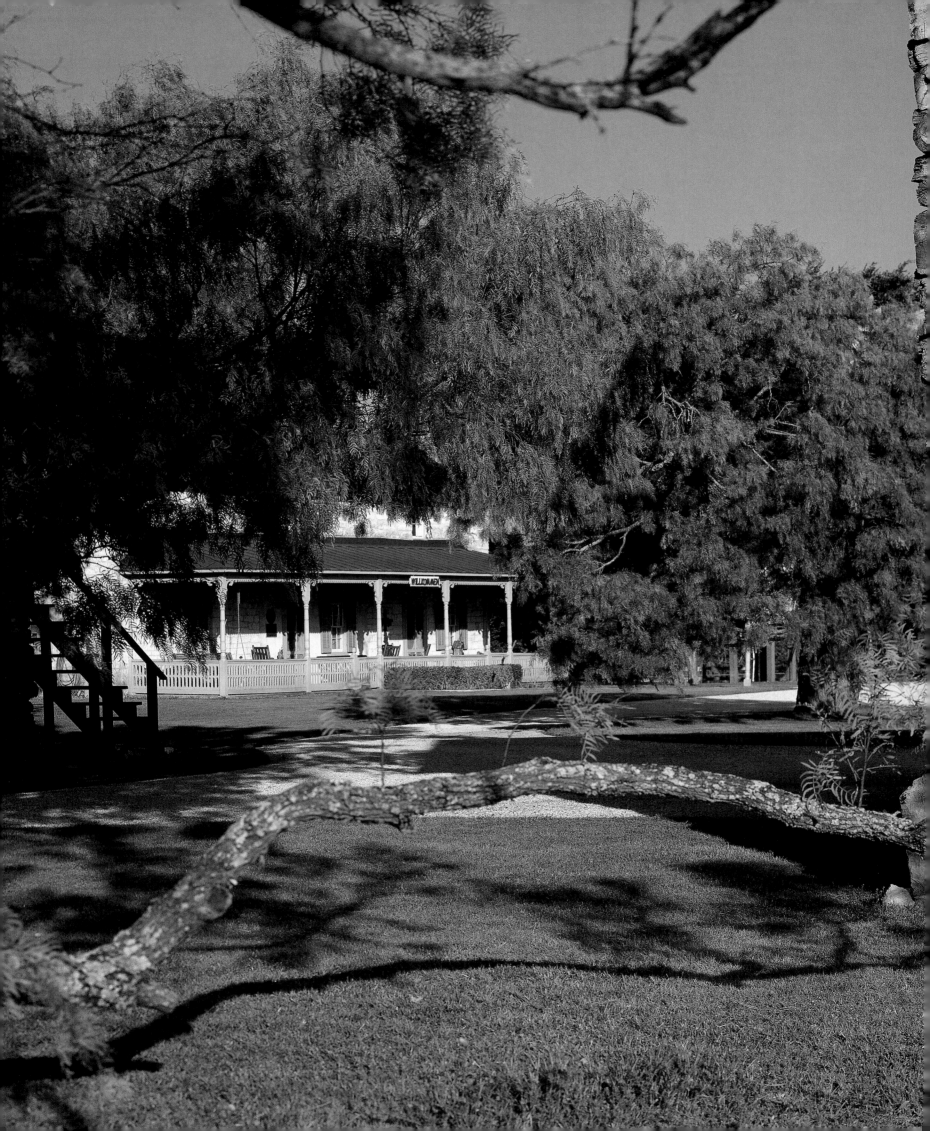

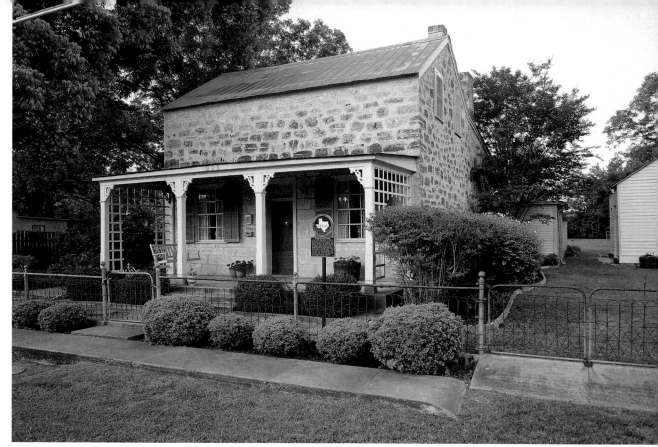

*T*he house at Crabapple Creek Ranch (left), *built between 1850 and 1890, is a Texas Historic Landmark. The Charles Jung House (above), 1871, and the H. Bierschwale House (below), 1872, are good examples of the use of stone in Fredericksburg.*

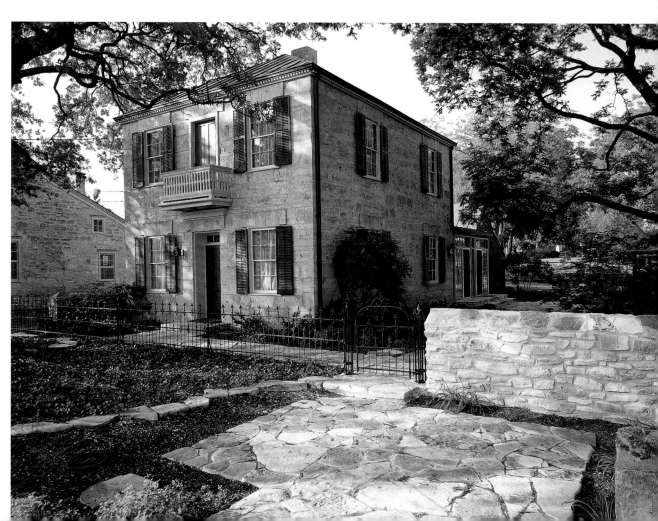

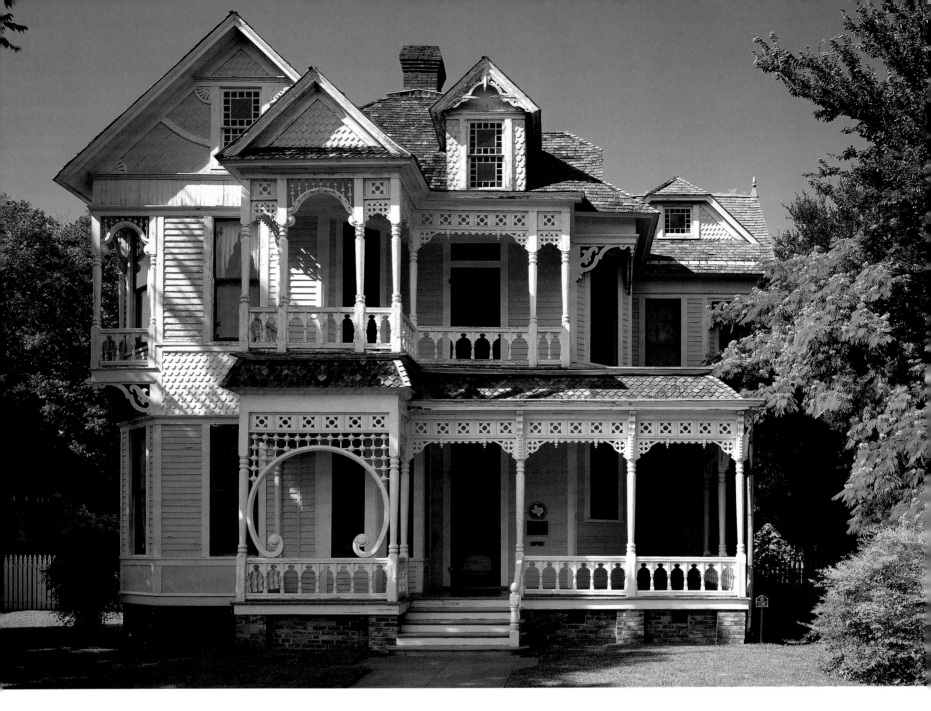

These examples of the front porches of Waxahachie, Texas, show how the town became famous for its Gingerbread Trail. Reddington House (above), 1893, is a Victorian symphony of arches and porch trim. The porches of the smaller Hudgins House (left), c. 1895, are less ornate but no less unmistakably Victorian.

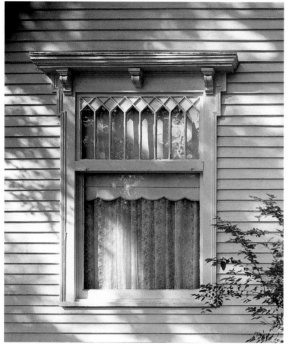

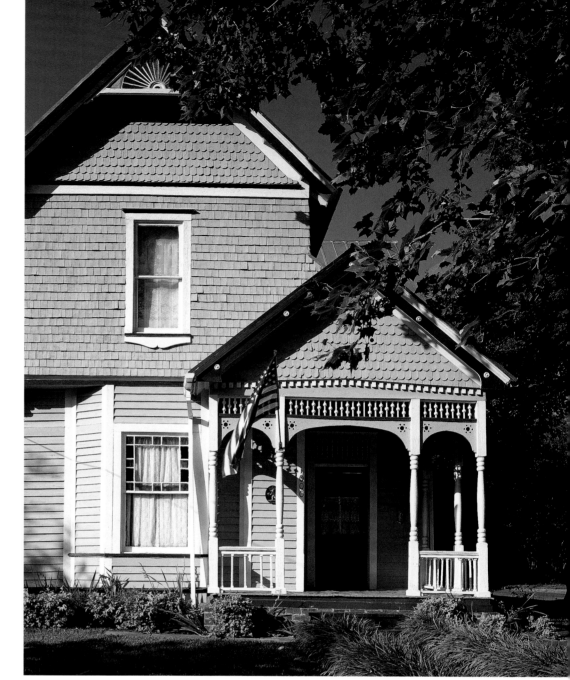

Waxahachie

TEXAS

In the mid 1800s, Waxahachie, Texas, was one of the stopping-places on the way west for families leaving the Piedmont region looking for richer land. Many of them found what they were looking for in this small Texas prairie town which, only a half century later, was known as the "Banner Cotton County of the World." And for those who did not find riches, they found a way of life rich in the goodness of small-town America at its best. Late twentieth-century Hollywood mirrored this big-heartedness in such touching films as *Places in the Heart*, *Tender Mercies*, and *The Trip to Bountiful*, all filmed in Waxahachie.

Waxahachie is Texas to its roots. The legendary Shawnee Trail, on which cattle plodded from Kansas

As with the porches (above), *the windows of Waxahachie* (above left) *are also often stamped with Victorian identity.*

*T*his quiet yard in Waxahachie (opposite) *is only interrupted by the sounds emanating from the Victorian fountain. The water theme is continued with fish-scale shingles. The Queen Anne style is put to elegant effect in Waxahachie's Reynolds House* (below), *1891.*

City to South Texas, went right through what is now the middle of town. Waxahachie is derived from the Indian word meaning Buffalo Creek. Native Americans belonging to the Tonkawa, Kickapoo, Bidai, Anadarko, and Waco tribes all settled the land before the arrival of the first white pioneers who found that the rich black waxy soil of the prairie nurtured fine cotton crops.

Because Texans build reputations and fortunes on talking big, it was only natural that in 1902 the town built the unique Waxahachie Chautauqua Auditorium. The octagonal-shaped amphitheater is where such orators as William Jennings Bryan, and later the humorist Will Rogers, gave their best, mesmerizing city and country folk alike.

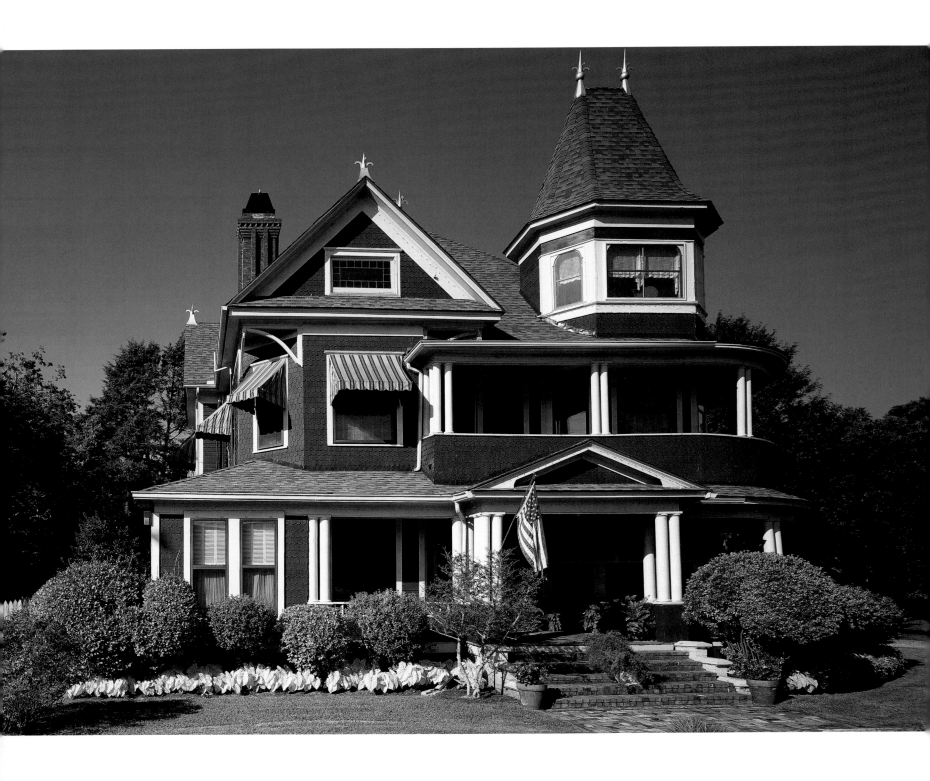

Today the Texas of Dallas and Fort Worth are only 35 minutes away, but the Texas of Waxahachie remains true to the portrait so accurately painted in its movie postcards. Its Fourth of July celebration is a weekend of flowers, fireworks and music that could probably be held nowhere other than Waxahachie. And when information on the annual Gingerbread Tour of Homes and the local chainsaw sculpture is given in the same breath, you know this town is Texas to the core.

Three of Waxahachie's towering Victorians are a collection of turrets, finials and ornate porches: Cole House (above), 1888-1897; Dunlap-Simpson House (opposite above), 1891; and Rosemont House (opposite below), 1894.

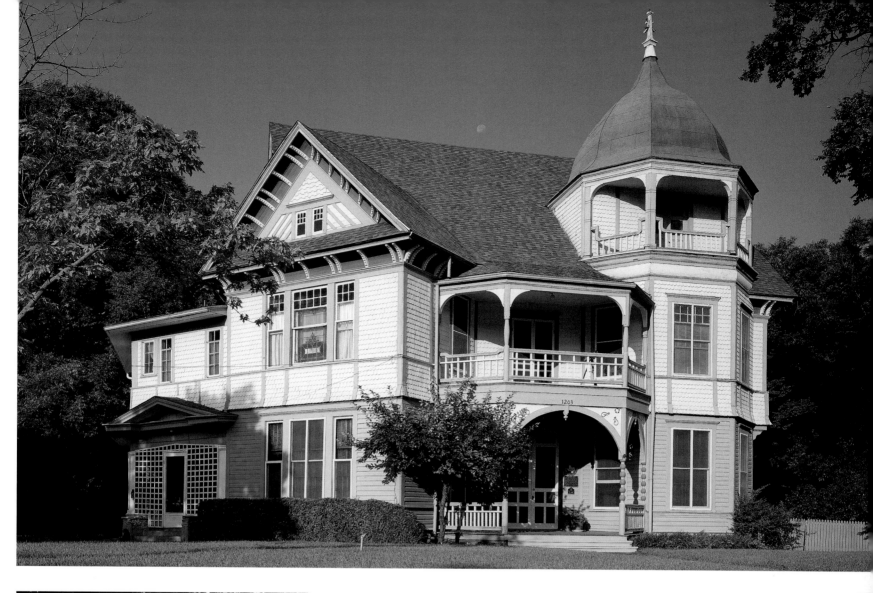

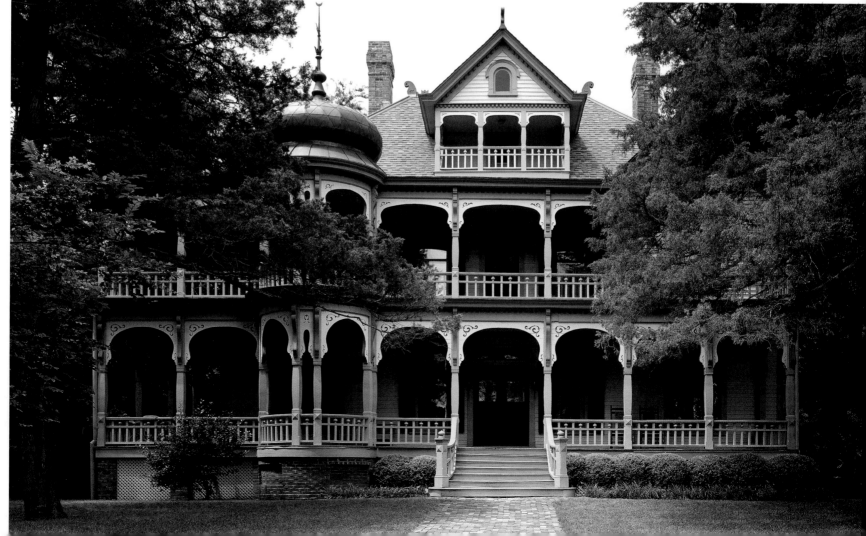

Travelers' Guide

THE COAST

Bath

NORTH CAROLINA

General Information
HISTORIC BATH VISITOR CENTER; 252-923-3971.

Lodging
BATH HARBOR MOTEL AND MARINA; 252-923-5711.

Sites
BONNER HOUSE; located on a peninsula between Bath Creek and Back Creek, the house, *c.* 1830, is furnished with American antiques dating to the early 19th century, guided tours available; 252-923-3971.

HISTORIC BATH STATE HISTORIC SITE; the Visitor Center and the Van Der Veer House, *c.* 1790, trace the history of Bath with exhibits and artifacts; 252-923-3971.

PALMER-MARSH HOUSE, 1751; National Historic Landmark furnished with late eighteenth-century antiques, guided tours available; 252-923-3971.

ST. THOMAS CHURCH, 1734; oldest church structure in North Carolina, open for visitors, please call Historic Bath Visitor Center for information.

Events
ANNUAL CHRISTMAS OPEN HOUSE; historic Bath sites are decorated for the holidays, second Sunday in December; 252-923-3971.

Website:
www.ah.dcr.state.nc.us/sections/hs/bath/bath.htm

Edenton

NORTH CAROLINA

General Information
HISTORIC EDENTON; 252-482-2637.

EDENTON TOURISM DEVELOPMENT AUTHORITY; 1-800-775-0111.

Lodging
ALBEMARLE HOUSE; bed-and-breakfast inn, *c.* 1900, bikes available, sailing lessons and cruises offered; 252-482-8204.

THE LORDS PROPRIETORS' INN; bed-and-breakfast inn with full-course dinner included; 252-482-3641.

Sites
VISITOR CENTER; late nineteenth-century Victorian house serves as Visitor Center for introduction to Historic Edenton; 252-482-2637.

CUPOLA HOUSE; National Historic Landmark; 252-482-2637.

JAMES IREDELL HOUSE; late eighteenth-century house museum, former home of a U.S. Supreme Court justice; 252-482-2637.

Events
BIENNIAL PILGRIMAGE; please call for dates; 1-800-775-0111.

CHRISTMAS HOME TOUR; please call for dates; 1-800-775-0111.

Website: www.edenton.com

A view of the Mississippi River (opposite) from Natchez, Mississippi.

Beaufort

SOUTH CAROLINA

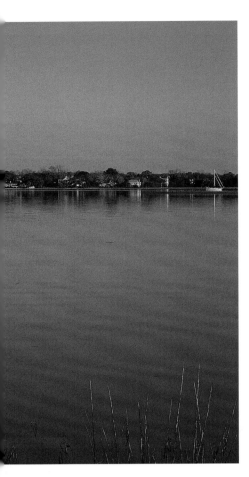

Beaufort's calm shoreline evokes the laid-back atmosphere of the coastal South.

General Information
BEAUFORT CHAMBER OF COMMERCE; 843-524-3163.

HISTORIC BEAUFORT FOUNDATION; 843-524-6334.

Lodging
BEAUFORT INN; located in historic district with gourmet restaurant, 1933; 843-521-9000.

RHETT HOUSE INN; antebellum bed-and-breakfast inn, 1820, located in historic district; 843-524-9030.

Sites
VERDIER HOUSE; headquarters and gift shop for Historic Beaufort Foundation, tours can be scheduled by phone; 843-524-6334.

YORK W. BAILEY MUSEUM AT PENN CENTER; maintains the history of Penn School, which was one of the first schools founded for free slaves, in 1862; 843-838-2474.

Events
GULLAH FESTIVAL; celebrates Gullah heritage with food and crafts, Memorial Day weekend; 843-524-6334.

WATER FESTIVAL; nine days of entertainment, including low-country suppers, boat races, and air shows, second and third weekend of July; 843-524-3163.

FALL FESTIVAL OF HOUSES AND HISTORY TOUR OF BEAUFORT'S HISTORIC HOMES; third and fourth weekend of October; 843-524-6334.

Shopping
Many fine antique shops.

Website: www.beaufortsc.org

Fernandina Beach

FLORIDA

General Information
AMELIA ISLAND CHAMBER OF COMMERCE; 904-261-3248.

Lodging
FAIRBANKS HOUSE; Italianate house, 1885, decorated in Victorian style, two blocks from Centre Street, pool and bikes available; 1-800-261-4838.

FLORIDA HOUSE INN; dating from 1857 and located in downtown Fernandina, flying the "eight flags of Amelia Island" and known for Southern home-style cooking; 1-800-258-3301.

WILLIAMS HOUSE; bed-and-breakfast inn, 1856, in Victorian house in the historic district; 1-800-414-9258.

Sites
FORT CLINCH STATE PARK; Civil War outpost, brick fort on the water; 904-277-7274.

MUSEUM OF HISTORY; history museum located in the island's old jail; 904-261-7378.

Events
SHRIMP FESTIVAL; first weekend in May; 904-261-3248.
CHRISTMAS TOUR OF BED-AND-BREAKFAST INNS; second weekend in December; 904-261-3248.

Shopping
Restored downtown area leads to docks and offers nice mix of resort shopping, antiques, and restaurants.

Website: www.ameliaisland.org

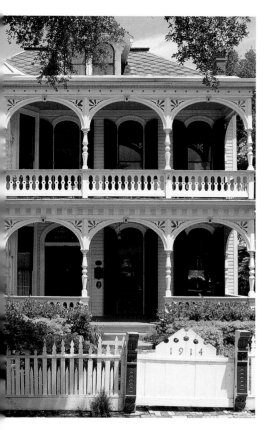

*T*he Howard Carnes House,
1887, in Galveston, Texas.

Galveston

TEXAS

General Information

Galveston Island Convention and Visitors Bureau; 1-888-425-4753.

Galveston Historical Foundation; 409-765-7834.

Lodging

Hotel Galvez, 1911; across the street from the Gulf of Mexico, this early twentieth-century hotel has been restored to its original grandeur, including its grand loggia, music hall, and veranda; 409-765-7721.

Moody Gardens Hotel; adjoins the Attractions of Moody Gardens in Galveston's West End; 1-888-388-8484.

The Queen Anne Bed-and-Breakfast Inn; 1905; six blocks from the famous Strand Historical District, bikes available for guests; 409-763-7088.

Sites

Galveston County Historical Museum; exhibits highlighting history of Galveston, including the 1900 hurricane, pirates, lighthouses, and the role of African Americans and Native Americans in the area's history; 409-766-2340.

Moody Gardens; attractions include the Colonel Paddlewheel boat, the Rainforest Pyramid, and the Aquarium at Moody Gardens; 1-800-582-4673.

The Strand National Historic Landmark District and the Post Office Street Arts and Entertainment District; both districts are filled with art galleries, shops, and historic structures; 1-888-425-4753.

Events

Mardi Gras! Galveston; parades, entertainment, and merrymaking, the two weekends preceding the Tuesday before Ash Wednesday; 1-888-425-4753.

Historic Homes Tour; privately owned homes in Galveston's renowned Victorian Historic District are open, first two weekends of May; 409-765-7834.

Galveston Harbor Parade of Lights; lighted boats parade through Galveston Harbor, Saturday following Thanksgiving; 409-763-7080.

Dickens on the Strand; Queen Victoria's London is recreated in the Strand Historic District, first weekend of December; 409-765-7834.

Website: www.galvestontourism.com

THE PIEDMONT

Waterford

VIRGINIA

General Information

The Waterford Foundation; 540-882-3018.

Lodging

Milltown Farm Inn; inn with beautiful landscapes and antiques; 540-882-4470.

Pink House Bed-and-Breakfast; elegant with courtyard; 540-882-3453.

Sites

The Waterford Foundation; explore history of the town here with The Waterford Foundation offices above; 540-882-3018.

Events

Annual Homes Tour and Crafts Fair; 150 craftsmen placed throughout Waterford with music and entertainment, first full weekend in October; 540-882-3018.

Website: www.waterfordva.org

York

SOUTH CAROLINA

General Information
OLDE ENGLISH DISTRICT TOURISM COMMISSION; Chester, South Carolina; 1-800-968-5909.

YORK COUNTY CONVENTION AND VISITORS BUREAU; 1-800-866-5200.

GREATER YORK CHAMBER OF COMMERCE; 803-684-2590.

Lodging
DAYS INN; 803-684-2525.

Sites
MUSEUM OF YORK COUNTY; world's largest collection of mounted African hoofed animals, a planetarium and nature trails; 803-329-2121.
THE MCCELVEY CENTER; archives and museum of York County; 803-684-3948.

Events
SUMMERFEST; one-day festival held in downtown Historic York; 803-684-2590.

CHRISTMAS IN OLDE YORKE; historic houses in holiday dress open for tour, second weekend of December; 803-684-2590.

Camden

SOUTH CAROLINA

General Information
KERSHAW COUNTY CHAMBER OF COMMERCE; 803-432-2525.

OLDE ENGLISH DISTRICT; 803-385-6800.

Lodging
GREENLEAF INN; built in 1805 as a store, this building was owned by Mary Todd Lincoln's brother, a Confederate surgeon, during the Civil War; 1-800-437-5874.

LORD CAMDEN INN; Plantation-style house, from 1832, decorated in antiques with acre of ground and swimming pool, in Historic District; 1-800-737-9971.

Sites
CAMDEN HISTORICAL MUSEUM AND ARCHIVES; items relating to history of Camden with research material for South Carolina genealogy; 803-425-6050.

HISTORIC CAMDEN REVOLUTIONARY WAR SITE; park-like setting with replica of the Federal-style Kershaw-Cornwallis House and four other eighteenth-century houses; 803-432-9841.

NATIONAL STEEPLECHASE MUSEUM; the only museum in the U.S. devoted to steeplechase racing; 803-432-6513.

Events
THE CAROLINA CUP; the larger of the Camden steeplechase races attracts 50,000 fans, end of March or beginning of April; 803-432-2525.

COLONIAL CUP; one of Camden's two annual premier steeplechase events, third weekend in November; 803-432-2525.

Shopping
Numerous antique shops in the downtown Camden area.

Website: www.sctravel.net

*S*ign atop the Oconee Hill
Cemetery bridge in Athens,
Georgia.

Aiken

SOUTH CAROLINA

General Information

AIKEN CHAMBER OF COMMERCE; 803-641-1111.

AIKEN COUNTY PARKS, RECREATION AND TOURISM;
803-642-7559.

THOROUGHBRED COUNTRY; 803-649-7981.

Lodging

ANNIE'S INN; surrounded by cotton fields, this
plantation farmhouse of *c.* 1820 survived the Civil
War even though its third story was destroyed by a
cannonball, the inn includes the main house and six
cottages; 803-649-6836.

TOWN AND COUNTRY INN; typical of Aiken's
hospitality for horses, this bed-and-breakfast inn
offers guest rooms and lodging for horses, and a pool,
three miles outside of town; 803-642-0270.

Sites

AIKEN COUNTY HISTORICAL MUSEUM; located in
Banksia, one of Aiken's most photogenic houses, the
museum features the history of Aiken and is a giant
scrapbook of the winter colony's heyday;
803-642-2015.

HITCHCOCK WOODS; beautiful park with 2200 acres,
in middle of Aiken.

RYE PATCH, HOPELAND GARDENS, AND
THOROUGHBRED HALL OF FAME; gardens and exhibits
devoted to legendary Aiken horses; 803-642-7630.

Events

TRIPLE CROWN HORSE RACES; spring horse event
includes thoroughbred, steeplechase, and harness
races, three successive weekends in the spring;
803-641-1111

Website : chamber.aiken.net

Athens

GEORGIA

General Information

ATHENS-CLARKE HERITAGE FOUNDATION;
706-353-1801.

ATHENS WELCOME CENTER; 706-353-1820.

UNIVERSITY OF GEORGIA VISITORS' CENTER;
706-542-0842.

Lodging

ASHFORD MANOR; Victorian bed-and-breakfast, 1893,
set on large, manicured estate, five miles outside of
Athens in village of Watkinsville; 706-769-2633.

MAGNOLIA TERRACE; bed-and-breakfast inn, 1912,
located in the historic Cobbham district of Athens,
short distance from downtown; 706-548-3860.

Sites

BRUMBY HOUSE, ATHENS WELCOME CENTER; one of
Athens' first houses, *c.* 1820, now restored and
beautifully furnished as the Athens Welcome Center;
706-353-1820.

FOUNDERS MEMORIAL GARDEN; located on the
campus of the University of Georgia, dedicated to the
founders of the first garden club in the United States
which was started in Athens; 706-542-1816.

GEORGIA MUSEUM OF ART; impressive museum
housing the permanent collection of the Georgia
Museum of Art and rotating exhibitions, known for
fine collection of nineteenth- and twentieth-century
American art; 706-542-GMOA.

TAYLOR-GRADY HOUSE; Greek Revival mansion,
c. 1844, furnished with antiques and art;
706-549-8688.

Events

ATHENS-CLARKE HERITAGE FOUNDATION SPRING
TOUR OF HOMES; annual tour of homes in one of
Athens' historic neighborhoods, last weekend in April;
706-353-1801.

Website: www.visitathensga.com

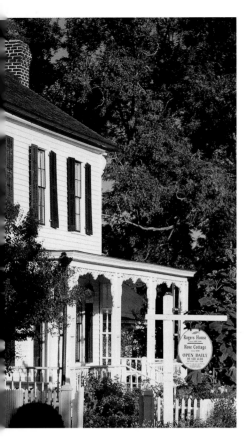

*V*aried shops and businesses in Madison, Georgia, have their home in the historic district.

Washington

GEORGIA

General Information
WASHINGTON-WILKES CHAMBER OF COMMERCE; 706-678-2013.

Lodging
JAMESON INN; 706-678-7925.

MAYNARD'S MANOR BED-AND-BREAKFAST; columned home in the heart of Washington's historic district; 706-678-4303.

Sites
CALLAWAY PLANTATION; 56-acre historic plantation, 1784, with three period houses, one-room schoolhouse and many outbuildings; 706-678-7060.

KETTLE CREEK REVOLUTIONARY WAR BATTLEFIELD; significant battle fought on 14 February, 1779, finally broke the British stronghold on Georgia, unattended site on War Hill Road, no phone.

ROBERT TOOMBS HOUSE STATE HISTORIC SITE; home of the Secretary of State of the Confederacy; 706-678-2226.

WASHINGTON HISTORICAL MUSEUM; museum featuring the Piedmont history of Georgia; 706-678-2105.

Events
WASHINGTON-WILKES TOUR OF HOMES; seven private homes opened as well as churches, museum, and other sites, first Saturday in April; 706-678-2013.

MULE DAY SOUTHERN HERITAGE FESTIVAL; celebration of plantation life with mule contests, food and craft show at Callaway Plantation, second Saturday in October; 706-678-2013.

CHRISTMAS DINNER AND HOLIDAY TOUR; tour of private homes and holiday dinner, early December, please call for dates; 706-678-2013.

Madison

GEORGIA

General Information
MADISON CONVENTION & VISITORS BUREAU AND WELCOME CENTER; 706-342-4454.

MORGAN COUNTY HISTORICAL SOCIETY; 706-342-9627.

Lodging
BRADY INN; Victorian bed-and-breakfast inn, *c.* 1895, located in Historic District; 706-342-4400.

BURNETT PLACE; antebellum home on Main Street; 706-342-4034.

Sites
MADISON-MORGAN CULTURAL CENTER; cultural center, *c.* 1895, offering permanent displays of period furnishings, nineteenth-century schoolroom and history galleries, also rotating visual arts exhibitions; 706-342-4743.

HERITAGE HALL; restored antebellum mansion, *c.* 1833, open for visitors daily; 706-342-9627.

Events
SPRING TOUR OF HOMES; outstanding collection of period houses on view with spring flowers, first weekend in May; 706-342-4454.

MADISON THEATRE FESTIVAL/MADISON FEST ON THE SQUARE; weekend of plays attracting top-notch casts and downtown arts festival, late July; 706-342-4454.

HOLIDAY TOUR OF HOMES; antebellum and Victorian houses resplendent in holiday finery, first weekend in December; 706-342-4454.

Website: www.madisonga.org

THE RIVERS

Pleasant Hill

KENTUCKY

General Information
SHAKER VILLAGE OF PLEASANT HILL; (hours and admission rates reduced November through March); 1-800-734-5611

Lodging
GUEST ROOMS AT SHAKER VILLAGE OF PLEASANT HILL; decorated in the beautiful and simple Shaker style; 1-800-734-5611.

Sites
SHAKER VILLAGE OF PLEASANT HILL; 15 restored buildings, including the Shaker Life Exhibit. Riverboat excursions on the Kentucky River, end of April through 31 October; 1-800-734-5611.

Events
PLEASANT HILL CRAFT FAIR; first weekend of August; 1-800-734-5611.

THE SIMPLE GIFTS OF CHRISTMAS; the week after Christmas; 1-800-734-5611.

Shopping
Two crafts stores offer a wide variety of handmade crafts and Shaker reproductions; 1-800-734-5611.

Website: www.shakervillageky.org

Eutaw

ALABAMA

General Information
GREENE COUNTY HISTORICAL SOCIETY; 205-372-9480.

Lodging
"SIPINN ON ASHBY"; bed-and-breakfast inn in a Federal-style dependency, a self-contained cottage located in the grounds of Sipsey, one of Eutaw's Greek Revival houses; 205-372-3516.

Sites
VAUGHN-MORROW HOUSE; raised Creole cottage, 1841, serves as Eutaw's Welcome Center and is open for tours by appointment, headquarters of the Greene County Historical Society; 205-372-9480.

Events
ANNUAL TOUR OF HISTORIC HOMES AND CHURCHES; second weekend of October; 205-372-9480.

BLACK BELT FOLK ROOTS FESTIVAL SOCIETY; fourth weekend of August; 205-372-3344.

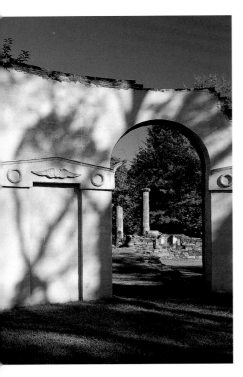

*T*he grounds at Capitol Park in Tuscaloosa, Alabama.

Tuscaloosa

ALABAMA

General Information
HERITAGE COMMISSION OF TUSCALOOSA COUNTY; 205-752-2575.

TUSCALOOSA CONVENTION AND VISITORS BUREAU; 205-391-9200.

Lodging
CRIMSON INN; bed-and-breakfast inn, 1928, located in Dutch Colonial-style home, halfway between University of Alabama and downtown Tuscaloosa; 205-758-3483.

THREE BEARS INN; bed-and-breakfast house, 1925, across Black Warrior River in Northport, five minute drive to Tuscaloosa; 205-752-2534.

Sites
GORGAS HOUSE; house museum on University of Alabama campus, 1829; 205-348-5906.

MOUNDVILLE ARCHAEOLOGICAL PARK; 300-acre park with two dozen Indian mounds, 13 miles south of Tuscaloosa; 205-371-2234.

PAUL W. BRYANT MUSEUM; museum featuring 100 years of University of Alabama football; 205-348-4668.

Events
TUSCALOOSA ARTS HOTLINE; 1-800-239-1611.

KENTUCKY FEST OF ARTS; hailed as the best of all things Southern, delivers folk and contemporary art, musical performances and childrens' activities, third weekend in October; 205-758-1257.

MOUNDVILLE FESTIVAL; celebrates culture and heritage of Southeastern Native Americans through a variety of arts, crafts and living history, please call for dates; 205-371-2234.

Eufaula

ALABAMA

General Information
EUFAULA/BARBOUR COUNTY TOURISM COUNCIL; 1-800-524-7529.

Lodging
KENDALL MANOR INN; bed-and-breakfast inn, 1872, in imposing Italian Renaisssance house capped with an observation tower where guests sign the walls before departure; 334-687-8847.

LAKEPOINT RESORT STATE PARK; lodge with campsites and cabins, offering swimming, golf, tennis, and hiking; 1-800-544-5253.

Sites
FENDALL HALL; house museum in Italianate mansion, 1860, graced by nineteenth-century murals; 334-687-8469.

SHORTER MANSION; Neoclassical Revival mansion now houses the Eufaula Historical Museum, tracing the history of the area with exhibits that include a vintage costume gallery; 334-687-3793.

TOM MANN'S FISH WORLD; known as a prime bass fishing site, Eufaula is also home to one of the world's largest freshwater aquariums, six miles north of town and stocked with fish from Alabama lakes; 334-687-3655.

Events
EUFAULA PILGRIMAGE; a spring tradition, Alabama's oldest tour of homes also features an antique show and art show and entertainment, please call for dates; 1-888-383-2852.

Website; www.ebcchamber.org

Natchez

MISSISSIPPI

General Information

HISTORIC NATCHEZ FOUNDATION; 601-442-2500.

NATCHEZ-ADAMS COUNTY CHAMBER OF COMMERCE; 601-445-4611.

NATCHEZ CONVENTION & VISITOR BUREAU; 1-800-647-6724.

NATCHEZ DOWNTOWN DEVELOPMENT ASSOCIATION; 601-442-2500.

NATCHEZ PILGRIMAGE TOURS; 1-800-647-6742.

Lodging

MONMOUTH PLANTATION; set on 26 acres in the heart of Natchez, this bed-and-breakfast inn, 1818, consists of a Federal-style mansion, with a later Greek portico added, restored dependencies, and period-style cottages in keeping with the original structures; 601-442-5852.

NATCHEZ EOLA HOTEL; restored hotel, 1927, in charming downtown Natchez near the antique shops and restaurants; 601-445-6000.

THE BURN; located in one of the town's favorite Greek Revival houses, 1832, this bed-and-breakfast inn is conveniently located for all activities in the Historic Districts; 601-442-1344.

Sites

AUBURN; famous for its spiral staircase, this mansion, 1812, introduced the classical orders of architecture to Mississippi; 601-442-5981.

LONGWOOD; its construction was interrupted by the Civil War, this architectural fantasia, 1861, is America's greatest octagonal mansion; 1-800-647-6742.

NATCHEZ UNDER THE HILL; historic port on the Mississippi River, famous for riverfront revelry, its restored buildings offer fine dining and drinking with great views of the river; 1-800-647-6724.

ROSALIE; this columned Federal-style mansion, 1820, overlooks the Mississippi River and retains its original mid nineteenth-century furniture; 601-445-4555.

STANTON HALL; Greek Revival showplace, 1857, is town's most palatial and ornately finished mansion; 1-800-647-6742.

Events

SPRING AND FALL PILGRIMAGES; America's most recognized tour of historic homes featuring the best of Natchez's incredibly large and beautiful historic district; four weeks every spring in March and April, three weeks every fall in October and November; 601-446-6631.

PILGRIMAGE GARDEN CLUB ANTIQUES FORUM; annual fall antiques forum conducted by nationally recognized experts; Wednesday through Friday during the first two weeks of November, please call for dates; 1-877-442-9796.

CHRISTMAS IN NATCHEZ; historic houses decorated for the holidays; December, please call for dates; 1-800-647-6742.

GREAT MISSISSIPPI RIVER BALLOON RACE; hot-air balloon event in the city's historic district with festival adjacent to Rosalie Mansion overlooking the Mississippi River, third weekend of October; 1-800-647-6724.

Website: www.natchezpilgrimage.com

St. Francisville

LOUISIANA

General Information
West Feliciana Community Development
Foundation and Tourist Commission;
225-635-6767.

West Feliciana Historical Society; 225-635-6330.

Lodging
The Cottage Plantation; antebellum bed-and-breakfast inn, 1795, and restaurant five miles outside of town; 225-635-3674.

Hemingbough; bed-and-breakfast inn and conference center one mile south of St. Francisville; 225-635-6617.

The Myrtles Plantation; bed-and-breakfast inn and restaurant, 1796, in one of St. Francisville's most historic mansions, just one mile outside of town; 1-800-809-0565.

Rosedown Plantation; bed-and-breakfast inn, 1835, in renowned antebellum mansion; 225-635-3332.

Sites
Afton Villa Gardens; 1835 gardens on site where Gothic mansion burned in 1963, open seasonally, please check for dates; 225-635-6773.

Oakley House at Audubon Commemorative Area; plantation house, c. 1806, where Audubon tutored and park area; 225-635-3739.

Rosedown Plantation; 28 acres of gardens dating from 1835, open to visitors; 225-635-3332.

West Feliciana Historical Society Museum; introduction to history of West Feliciana Parish; 225-635-6330.

Events
Annual Audubon Pilgrimage; every third complete weekend of March, historic houses and churches on tour; 225-635-6330.

Christmas in the Country; Christmas tour of twentieth-century homes and parade, first weekend of December; 225-635-6330.

Website: www.saint-francisville.la.us

THE UPCOUNTRY

Beersheba Springs

TENNESSEE

Lodging
Edgeworth Inn; four-story bed-and-breakfast inn, 1896, on the grounds of Monteagle Assembly in Monteagle, Tennessee, 30 minutes from Beersheba; 931-924-4000.

North Gate Inn; bed-and-breakfast inn on the grounds of Monteagle Assembly in Monteagle, Tennessee, 30 minutes from Beersheba; 931-924-2799.

Sites
The South Cumberland State Park; includes the Stone Door, and numerous hiking trails with spectacular views; 931-692-3148.

Events
Beersheba Crafts Fair; handmade crafts fair held at the United Methodist Assembly grounds, fourth weekend of August.

Fourth of July Parade; townspeople meet at Big Don's Market and proceed through Beersheba Springs, arriving at the Methodist Assembly grounds, with a tremendous display of fireworks at the ball field after dark.

Fall Color; incredible leaf show in this Cumberland Gap area, usually last of October and first of November.

Oxford

MISSISSIPPI

General Information
OXFORD TOURISM COUNCIL; 1-800-758-9177.

Lodging
OLIVER BRITT HOUSE; bed-and-breakfast inn, 1905, within walking distance of town square; 662-234-8043.

PUDDIN' PLACE; Victorian house, 1892, within walking distance of town square; 662-234-1250.

Sites
BLUES ARCHIVE; world's largest Blues collection, on the campus of the University of Mississippi in Farley Hall; 662-232-7753.

ROWAN OAK; originally built in 1844, home of William Faulkner, Nobel-Prize winning author; please call for hours; 662-234-3284.

Events
OXFORD CONFERENCE FOR THE BOOK; conference bringing together book lovers and book experts; first weekend of April, please call to verify dates; 662-232-5993.

DOUBLE DECKER ARTS FESTIVAL; celebration of Southern cuisine, arts, and music; last Saturday of April; 1-800-758-9177.

FAULKNER AND YOKNAPATAWPHA CONFERENCE; conference on William Faulkner's contribution to American literature; late summer, please call for dates; 800-758-9177.

Shopping
SQUARE BOOKS; one of America's most renowned book stores; 662-236-2262.

e mail: tourism@oxfordms.com

*F*all color in Fayetteville, Arkansas.

Fayetteville

ARKANSAS

General Information
FAYETTEVILLE CHAMBER OF COMMERCE; 501-521-1710.

WASHINGTON COUNTY HISTORICAL SOCIETY; 501-521-2970.

Lodging
HILTON FAYETTEVILLE; over two hundred rooms in downtown Fayetteville; 501-442-5555.

INN AT THE MILL; inn embraces a historic landmark, Johnson Mill, listed on the National Register; 501-443-1800.

STAY-INN-STYLE BED-AND-BREAKFAST; turn-of-the-century restored bungalow; 501-582-3590.

Sites
HEADQUARTERS HOUSE FOR THE WASHINGTON COUNTY HISTORICAL SOCIETY; antebellum home, 1853, which served as local Civil War headquarters for both sides; 501-521-2970.

PRAIRIE GROVE BATTLEFIELD; 306-acre park where 1862 Civil War battle was fought; 501-846-2990.

Events
AUTUMNFEST; Fayetteville celebrates its most colorful season with music, parades and three days of special events; second weekend of October; 1-800-766-4626.

LIGHTS OF THE OZARKS; city gleams with millions of holiday lights; Thanksgiving through New Year's Day; 1-800-766-4626.

Website: www.fayettevillear.com

This small Texas house is most likely to have been built as a guest house or Sunday house.

Fredericksburg

TEXAS

General Information
FREDERICKSBURG CONVENTION AND VISITOR BUREAU; 1-888-997-3600.

Lodging
BACK FORTY OF FREDERICKSBURG; set on 40 acres one half-mile outside of Fredericksburg, guest facilities including a restored rock barn offering fly-fishing lessons and fishing on one's own for bass and blue gill; 830-997-1702.

HOFFMAN HOUSE; historic stone house with three separate buildings on Victorian courtyard; 830-997-6739.

SPRING LOG HAUS; 12 miles east of Fredericksburg, 1840s log house along banks of spring-fed pond in Hill Country; 830-997-5671.

Sites
LYNDON B. JOHNSON STATE HISTORICAL PARK; 830-644-2252
LYNDON B. JOHNSON NATIONAL HISTORICAL PARK; 830-868-7128
Both parks offer history of President Lyndon Baines Johnson and the Texas Hill Country.

PIONEER MUSEUM COMPLEX; walk through mid nineteenth-century pioneer life, collection of period buildings including the stone Kammlah House, 1849, the Weber Sunday House, a log cabin, smokehouse and wagon shed; 830-997-2835.

WILDSEED FARMS MARKET CENTER; one of the nation's largest working wildflower farms, including the famed Texas bluebonnets that bloom from late March until early May; 830-990-1393.

Events
EASTER FIRES PAGEANT; community pageant presented by a cast of 600, blending the history of Fredericksburg and the local fable of the Easter bunny; Saturday before Easter; 830-997-2359.

OKTOBERFEST; combines Old World traditions with the best of Fredericksburg music, dancing, food, childrens' activities, arts and crafts; first full weekend in October; 830-997-4810.

Website: www.fredericksburg-texas.com

Waxahachie

TEXAS

General Information
WAXAHACHIE CHAMBER OF COMMERCE AND CONVENTION & VISITORS BUREAU; 972-937-2390.

Lodging
CHASKA HOUSE; 1900 house within walking distance of town square; 972-937-3390.

THE HARRISON; dating from *c.* 1915 and three blocks from the Courthouse; 972-938-1922.

THE ROSEMARY MANSION; set on one acre with gardens, Georgian Revival house with guest house, c. 1916, four blocks from town square; 972-935-9439.

Sites
ELLIS COUNTY COURTHOUSE; built in 1895 and one of the most photographed structures in the state of Texas; 972-937-2390.

ELLIS COUNTY MUSEUM; history of life in Ellis County located on the town square; 1-888-428-7245.

Events
GINGERBREAD TRAIL TOUR OF HOMES; tour of Waxahachie's large Victorian District; first weekend of June; 1-888-428-7245.

CRAPE MYRTLE FESTIVAL; old-fashioned Texas Fourth of July celebration; weekend of July 4; 972-937-2390.

CANDLELIGHT CHRISTMAS TOUR OF HOMES; tour of historic Waxahachie in holiday greenery by candlelight; last weekend of November and first two weekends of December; 972-937-2390.

Website: www.waxahachie.com

Select Bibliography

A Guide to Historic Beaufort, Beaufort, Historic Beaufort Foundation, 1970.

Blumenson, John. G., *Identifying American Architecture: A Pictorial Guide to Styles and Terms, 1600-1945*, Nashville, American Association for State and Local History, 1977.

Cash, Wilbur Joseph, *The Mind of the South*, New York, Alfred A. Knopf, 1941.

Delehanty, Randolph, and Van Jones Martin, *Classic Natchez*, Savannah, Golden Coast Publishing Company, 1996.

Glass, Mary Morgan, ed., *A Goodly Heritage: Memories of Greene County*, Eutaw, Greene County Historical Society, 1977.

Lancaster, Clay, *Eutaw: The Builders and Architecture of an Ante-Bellum Southern Town*, Eutaw, Greene County Historical Society, 1979.

Lee, Edward, ed., *Historic Walking Tour, Yorkville Historic District*, York, Yorkville Historical Society, 1996.

Lewis, Taylor, and Joanne Young, *The Hidden Treasures of Bath Town*, Bath, Friends of Historic Bath, Inc., 1978.

Linley, John, *The Georgia Catalog: Historic American Buildings Survey: A Guide to the Architecture of the State*, Athens, The University of Georgia Press, 1982.

Marsh, Blanche and Kenneth, *Athens, Georgia's Columned City*, Asheville, Biltmore Press, 1964.

McClure, Harlan, and Hodges, Vernon, *South Carolina Architecture, 1670-1970*, Columbia, Clemson Architectural Foundation and the Columbia Museum of Art, 1970.

Miller, Mary Warren, and Ronald W. Miller, *The Great Houses of Natchez*, Jackson, University Press of Mississippi, 1986.

Milner, John, and Associates, eds., *The Beaufort Preservation Manual*, Beaufort, Historic Beaufort Foundation, 1979.

Pratt, Dorothy, and Richard Pratt, *A Guide to Early American Homes, South*, New York, McGraw-Hill Book Company, Inc., 1956.

Severens, Kenneth, *Southern Architecture: 350 Years of Distinctive American Buildings*, New York, E.P. Dutton, 1981.

Simkins, Francis Butler, *A History of the South*, Third Edition, New York, Alfred A. Knopf, 1963.

Symmes, Jane Campbell, and Elizabeth Reynolds Hammett, eds., *Madison, Georgia: An Architectural Guide*, Madison: Madison-Morgan County Foundation, 1991.

Wilson, Charles Reagan, and William Ferris, eds., *Encyclopedia of Southern Culture*, Vols 2 and 4. New York, Anchor Books, Doubleday, 1989.

Acknowledgments

When Trisha and Walter Griess were thinking about moving to tiny Eutaw, Alabama, they were warned by Roy Swayze, "The very fabric and tone of your life will change if you come to Eutaw and restore an old house." Swayze's promise can be fulfilled with just one visit to these special places where you will be reminded that hidden away in small towns and villages are the greatest treasures and the most wonderful people. My appreciation is endless to those lovers of small-town Southern life who eagerly helped make this book possible.

In Waterford, Virginia, the knowledgeable help of Jack Walter and the staff of the Waterford Foundation was invaluable as was the help of Mr. and Mrs. Henry A. Kitselman; Mr. and Mrs. Wayne Dennis; Mr. and Mrs. Robert Jackson; Allen Kitselman, Main Street Architects; and Calder Loth, Virginia Department of Historic Resources. The Olde English District Commission and The Greater York Chamber of Commerce were sources of great help in York, South Carolina. Allen and Camilla Watson and their daughter Sara introduced me to Camden, South Carolina, and their hospitality and kindness knew no bounds. Likewise, Florence Blackwell willingly opened the door to Camden and provided innumerable courtesies. Joanna Craig, Historic Camden, and the willing staff of the Kershaw County Chamber of Commerce were ready sources of information about Camden. Deborah Brooks of the Historic Aiken Foundation and Leslie Garnett of Aiken Tours were generous in sharing their knowledge of Aiken, as were Julian Peabody and the late Marilyn Riviere. In Athens old friends stepped in, John Waters, Charlotte Marshall, and Milton Leathers provided a rich oral history of one of the Piedmont's most beautiful towns. And Lee Epting was a source of gracious encouragement at every turn.

I am indebted to Veranda's own Deborah Merck Sanders for her insight into Washington, Georgia, and to Jane and Smythe Newsome. Madison's supply of intelligent sources included Ruth Bracewell and Cassandra Baker, Madison-Morgan Cultural Center; Bill Chapman, author of Madison's Preservation Manual; Marguerite Copelan, Madison Convention and Visitors Bureau; and the writers of Madison, Georgia: An Architectural Guide, Jane Symmes and Elizabeth Hammett.

Steve Allen, Historic Bath State Historic Site, willingly shared his knowledge of this picturesque village. Linda Jordan Eure at Historic Edenton supplied helpful knowledge as did the Tourism Development Authority, Edenton, and the Chowan County Tourism Development Authority. Coastal South Carolina was well represented by the staff of the Historic Beaufort Foundation; Stephen Wise, Parris Island Museum; Lawrence Rowland, University of South Carolina at Beaufort; and Cynthia Jenkins, preservation consultant. A special thanks in order to Jane Kidd. To John Trask our appreciation for the tour of the daffodil fields at Lady's Beach. Three people were key sources of help in Fernandina, James Perry, Amelia Island Museum of History; Dee Chaplin, Amelia Island Restoration Foundation; and Celeste Kavanaugh. To Cam, Cal and Winn Cato, a debt of appreciation for their hospitality in Fernandina and their friendship.

In Texas, appreciation is extended to Christine Hopkins of the Galveston Island Convention and Visitors Bureau; Debra Wakeland of the Waxahachie Chamber of Commerce, and Ernest Loeffler of the Federicksburg Convention and Visitor Bureau. Diana Ratliff of the Shaker Village of Pleasant Hill, Kentucky, supplied more than enough information on this quaint village, as did James E. Hanks. Thanks also go to Helen Williams in St. Francisville and the West Feliciana Parish Tourist Commission and the West Feliciana Historical Society. In Tuscaloosa, the Heritage Commission of Tuscaloosa County and the Tuscaloosa Convention and Visitors Bureau were a great help. Paige Dykes of the Barbour County Chamber in Eufaula was enthusiastic and professional in her assistance.

The town of Eutaw is fortunate to have the enthusiasm of Kathleen Banks and Tricia Griess backed by the Greene County Historical Society. I am indebted to Peggy Galis and Nancy Zechella for introducing me to Jimmy Faulkner whose tales of his uncle, William Faulkner, "Brother Bill," taught me almost as much about Oxford as the information gathered by the Oxford Tourism Council. Interviewing William Ferris in 1991 not only introduced me to the Encyclopedia of Southern Culture, but to the Center for the Study of Southern Culture in Oxford.

To visit Natchez is a treat, but to live there must be heavenly, and to these lucky residents goes a special debt of gratitude, Ronald and Mimi Miller, Historic Natchez Foundation; Alma Carpenter, Pilgrimage Garden Club; Ronald and Lani Riches, Monmouth Plantation; Elizabeth Bogess, Archaeologists Unlimited; and Courtney Taylor, former queen of the Natchez Pilgrimage.

Margaret Coppinger provided the history of Beersheba Springs from her tiny self-made museum, and Kay Horrell, Elizabeth Ralph, Suzanne Fassnacht, and Ann Street provided the color. In Fayetteville, my thanks go to Marilyn Johnson, Fayetteville Chamber of Commerce; Cyrus Sutherland, Professor Emeritus at the University of Arkansas; Tyler Hardman, Arkansas Department of Parks and Tourism; and Dee Dee Lamb, Washington County Historical Society.

To Peter Warner and Michael Washburn at Thames and Hudson, my appreciation for their guidance and editing skills. To Rosemary Hogan Taylor and the kind readers and researchers at the Georgia Museum of Art, Hillary Brown, Jennifer Freeman, and Sara Gaiero I owe many thanks. For the opportunity to work at Veranda magazine since 1995, I express my greatest appreciation to Lisa Newsom and Charles Ross, both of whom are the epitome of teamwork and admirable understatement. And to all of my other friends and colleagues at Veranda, a special thanks for their help and support.

And I am indebted to Dennis O'Kain who makes words superfluous when accompanied by his photographs. My personal thanks are reserved for Sea Willow Nichols, Daniel Uter, and Winston Morgan Ramsey, all of whom by now know the way to Eutaw and Eufaula, and especially to Henry Ramsey, editor and supportive friend. And for the example of kindness set by two women whose spirit should grace each village of the South, my infinite appreciation goes to Kathleen Banks and the late Marilyn Riviere.

Bonnie Nichols Ramsey

Whether a creative effort is ongoing, like Veranda magazine, or is completed, like this book, the result is a success because of the time and talents of numerous contributors. In addition to Bonnie Ramsey, author, and Dennis O'Kain, principal photographer, I want to acknowledge the other photographers whose images of the following towns first appeared in Veranda and are now in this book: Waxahachie, Texas – Richard Bradley; Galveston, Texas – Fran Brennan; Fredericksburg, Texas – James Fox; Virginia Hunt Country – John Hall; St. Francisville, Louisiana – Barry Lewis; Waterford, Virginia – Richard Robinson; Pleasant Hill, Kentucky – Paul Rocheleau.

Also, I wish to acknowledge the individuals who wrote or produced original towns articles which appeared in Veranda: Nancy Cornell, Vicky Moon, Debra Muller Price, June Sprigg, Frances Taliaferro Thomas and Cate Wyatt.

Heartfelt thanks to our loyal readers and advertisers and to the staff of Veranda: Charles Ross, Deborah Sanders, Tom Woodham, Mickey Thomas, Mindy Duncan, Mary Jane Ryburn, Sims Bray Jr., Lola Battle, Beverly Sauer, Charlotte DuPre, Linda Clopton, Linda Rye, Marilou Taylor, Jim Lewis, Walter Riley, Steve and Shirley Christopher, Kerry Delrose, John Willett, Christine Ashmore, Ed Fisher, Georgia Fleming, Michele Holloway, Adrian Jefferson, Howard Johnson, Liane Lane, Teresa Lowry, Steve Moser, Susan Hart Quinn, and Cassie Rinker. And to our contributing editors: Julie Baker, Marda Burton, Agnes Sarah Clark, Penny Coppedge, Betsy Crosby, Barbara Dinerman, Carol Glasser, Martha Rowan Hyder, Mary Lide Kehoe, Michael Lee, Jan Magids, Sarah McDaniel, Nancy Perot Mulford, Frances Schultz, Tara Shaw, Jan Shoffner, and Gannon Hunt Turner.

And a special thank you to my family – Neal, Bradley, Brigitte, Leslie, Chris, Andrew, Shannon, Ansley, Nora, E. George, Irene and Ken. Without their love and support Veranda would not have been possible.

Lisa Beckwith Newsom
Founder and Editor-in-Chief
Veranda Magazine
455 East Paces Ferry Road
Atlanta, GA 30305